COTTAGES: THE NEW STYLE

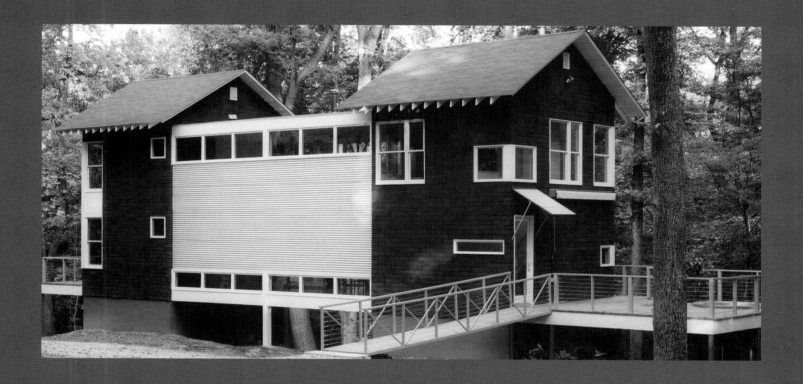

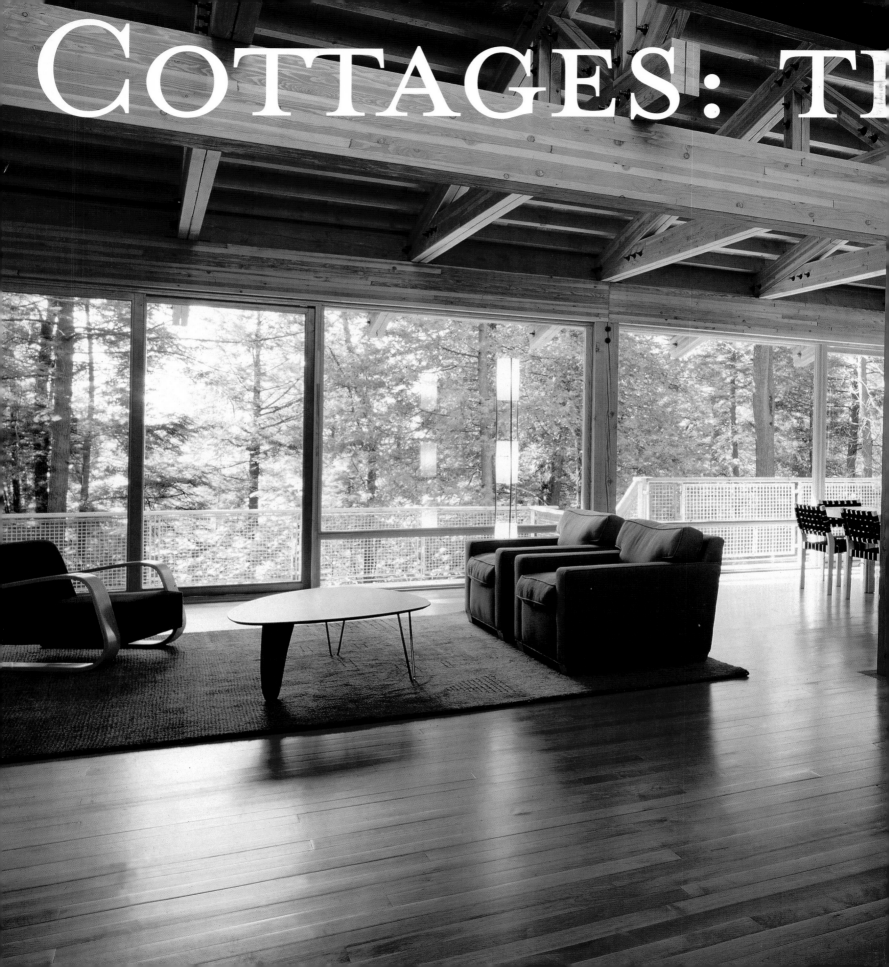

IE NEW STYLE

JAMES GRAYSON TRULOVE

HDi
HARPER
DESIGN
international

An Imprint of HarperCollins*Publishers*

COTTAGES: THE NEW STYLE

COPYRIGHT © 2004 BY JAMES GRAYSON TRULOVE AND

HARPER DESIGN INTERNATIONAL

FIRST PUBLISHED IN 2004 BY

HARPER DESIGN INTERNATIONAL,

AN IMPRINT OF HARPER COLLINS PUBLISHERS

10 EAST 53RD STREET

NEW YORK, NEW YORK 10022-5299

TEL: (212) 207-7000

FAX: (212) 207-7654

HARPERDESIGN@HARPERCOLLINS.COM

WWW.HARPERCOLLINS.COM

DISTRIBUTED THROUGHOUT THE WORLD BY:

HARPER COLLINS INTERNATIONAL

10 EAST 53RD STREET

NEW YORK, NEW YORK 10022-5299

TEL: (212) 207-7000

FAX: (212) 207-7654

PACKAGED BY:

GRAYSON PUBLISHING, LLC

JAMES G. TRULOVE, PUBLISHER

1250 28TH STREET NW

WASHINGTON, DC 20007

202-337-1380

JTRULOVE@AOL.COM

HARPERCOLLINS BOOKS MAY BE PURCHASED FOR EDUCATIONAL, BUSINESS, OR SALES PROMOTIONAL

USE. FOR INFORMATION, PLEASE WRITE: SPECIAL MARKETS DEPARTMENT, HARPERCOLLINS

PUBLISHERS INC., 10 EAST 53RD STREET, NEW YORK, NY 10022.

LIBRARY OF CONGRESS CATALOGING-IN-PUBLICATION DATA

TRULOVE, JAMES GRAYSON.

 COTTAGES : THE NEW STYLE / JAMES GRAYSON TRULOVE.

 P. CM.

 ISBN 0-06-057285-X (HARDCOVER)

 1. COTTAGES--DECORATION--UNITED STATES. 2. DECORATION AND ORNAMENT,

RUSTIC--UNITED STATES. I. TITLE.

 NK2195.C67T78 2004

 747--DC22

 2003021974

HALF TITLE PAGE: WITHERS COTTAGE; JULIA HEINE, PHOTOGRAPHER

TITLE PAGE: GEORGIAN BAY; MICHAEL AWAD, PHOTOGRAPHER

RIGHT: WENDEL/LYNDON; JIM ALINDER, PHOTOGRAPHER

MANUFACTURED IN CHINA

FIRST PRINTING, 2003

1 2 3 4 5 6 7 8 9 / 06 05 04 03

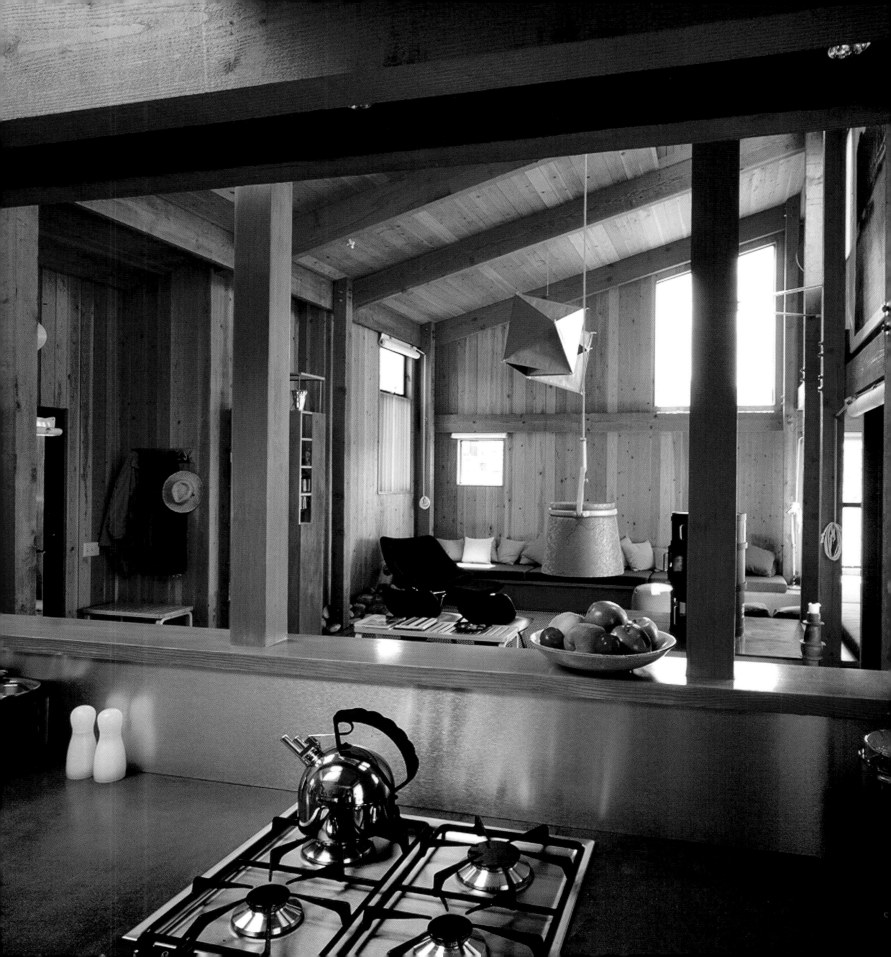

CONTENTS

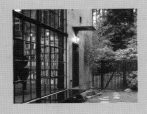
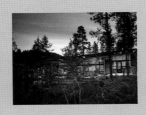
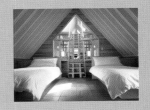
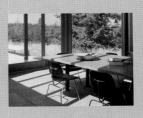
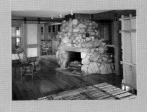
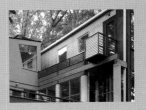

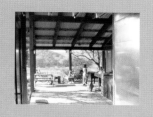
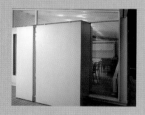
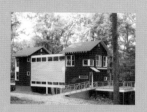
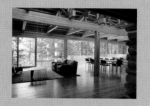
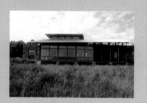
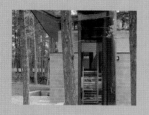
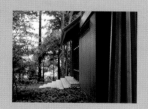
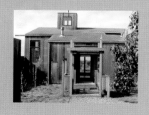

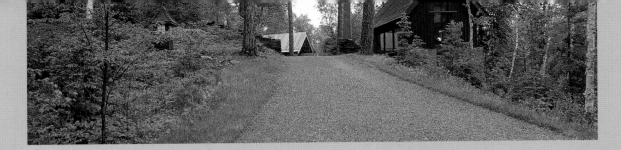

BRANDENBURG RETREAT

Minnesota

Located in northern Minnesota on the edge of a three-million-acre wilderness park and four miles from the Canadian border, this rustic retreat belongs to a widely published nature photographer and his wife. Two of his recent nature books were photographed in the immediate area. An existing log cabin is perched above a waterfall. The architect was asked to expand this very private retreat into a multipurpose cottage that would serve as a place for working, teaching, entertaining, and accommodating overnight guests.

The region surrounding the retreat has a rich Scandinavian vernacular heritage, and the design for the expansion was influenced by the Viking longhouse. It is also an assemblage of familiar yet inventive forms reminiscent of regional Scandinavian immigrant farms. Rich natural colors, textures, and materials are used throughout. Inside, the mystery of procession, the play of light, the comfort of warm floors, the drama of spatial transitions, and the richness of the surfaces complement and enhance the many activities enjoyed at this retreat.

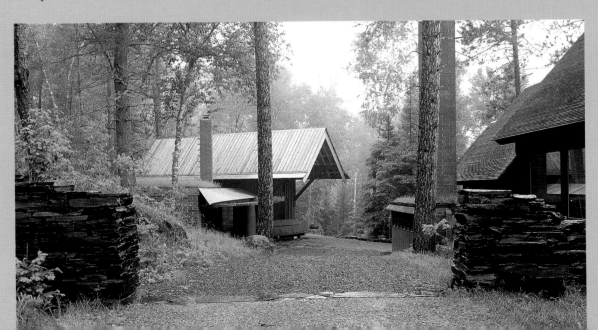

TOP AND LEFT: *Entrance to the retreat.*
RIGHT: *Stairway to sleeping loft.*

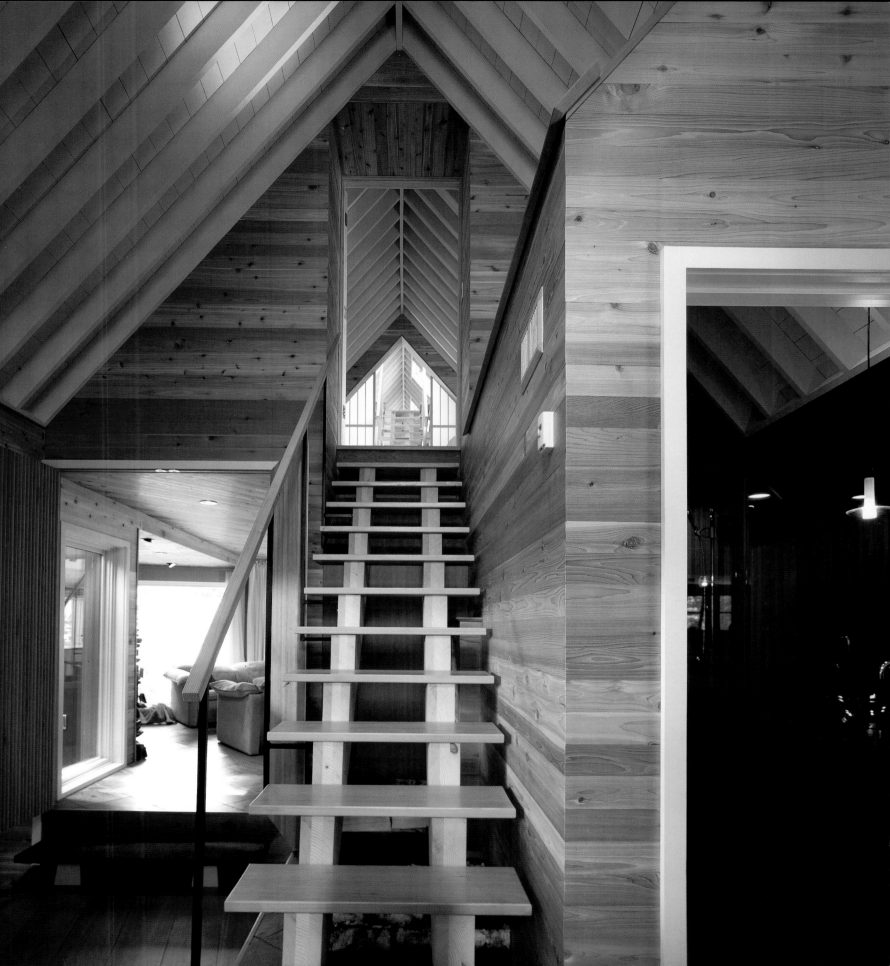

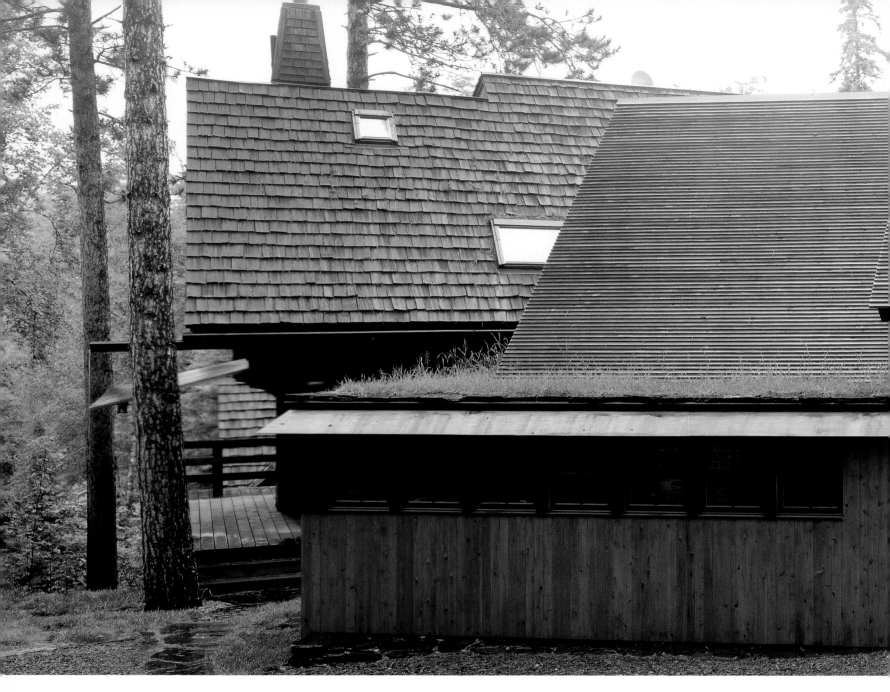

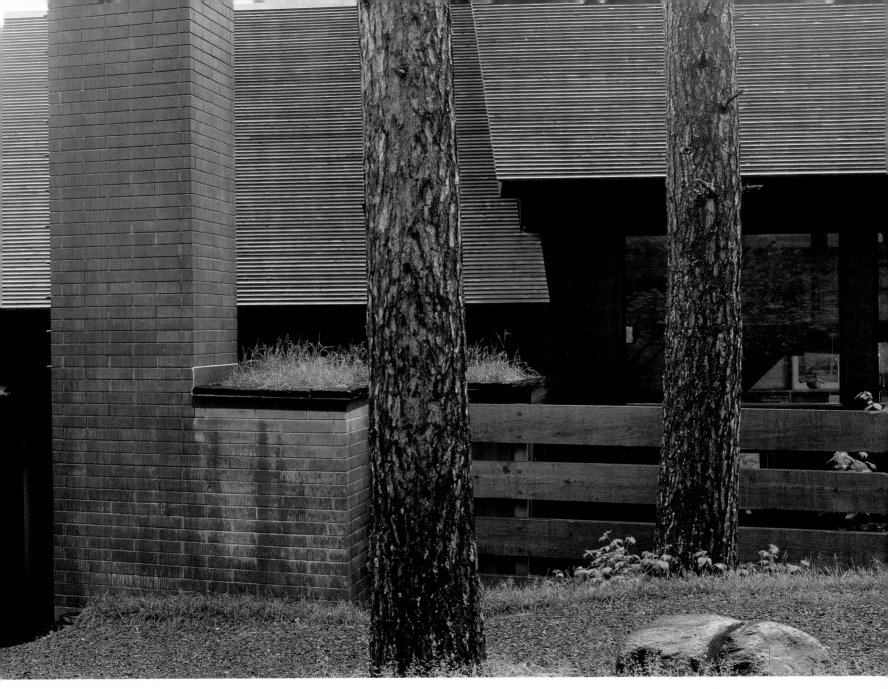

ABOVE: *The existing structures and the new addition are sited low and tight to the site, becoming part of the natural surroundings.*

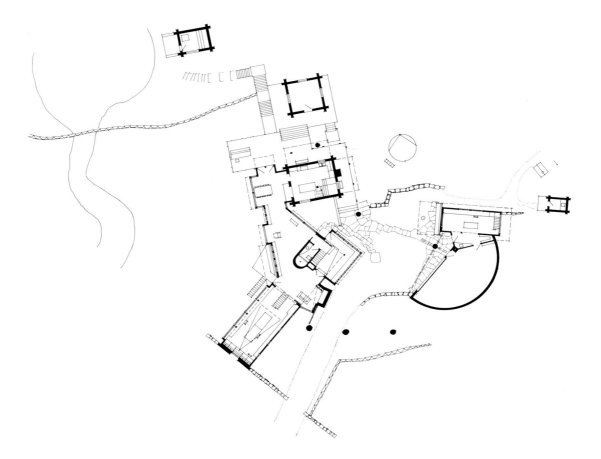

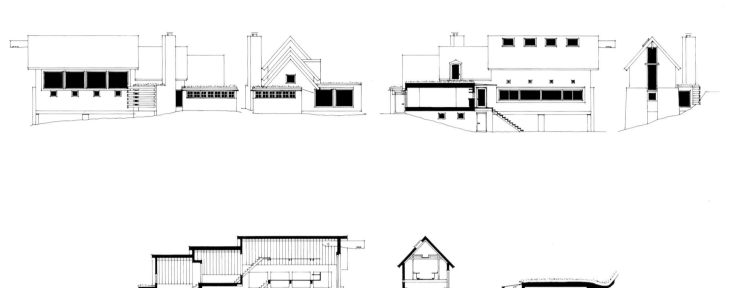

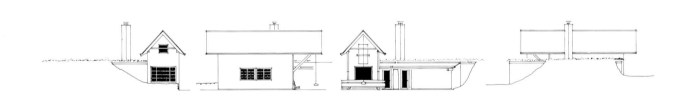

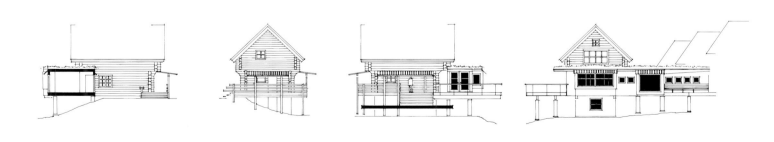

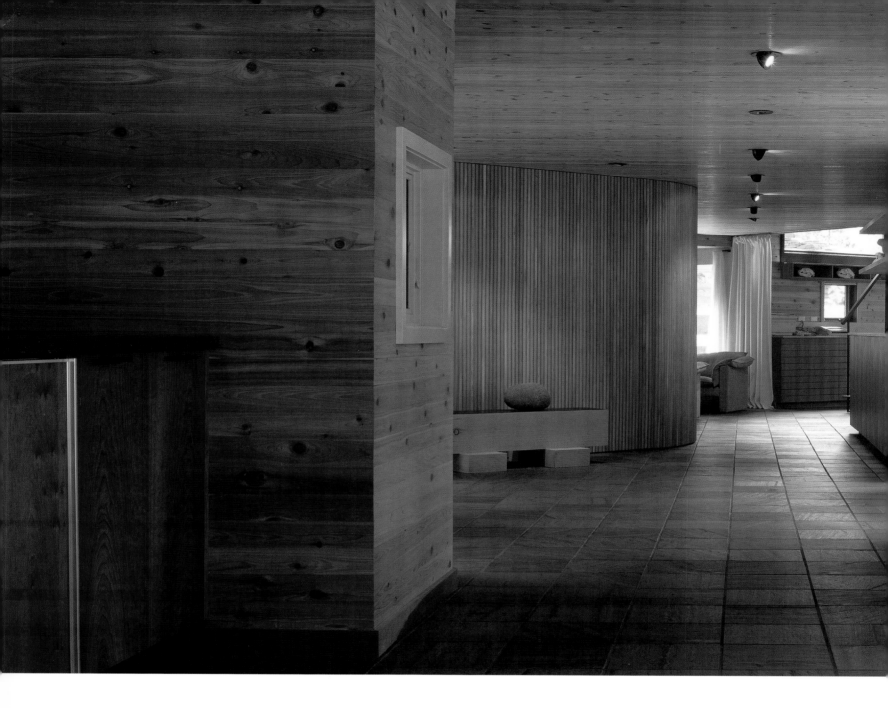

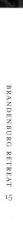

ABOVE: *Kitchen, dining, and entertaining areas.*

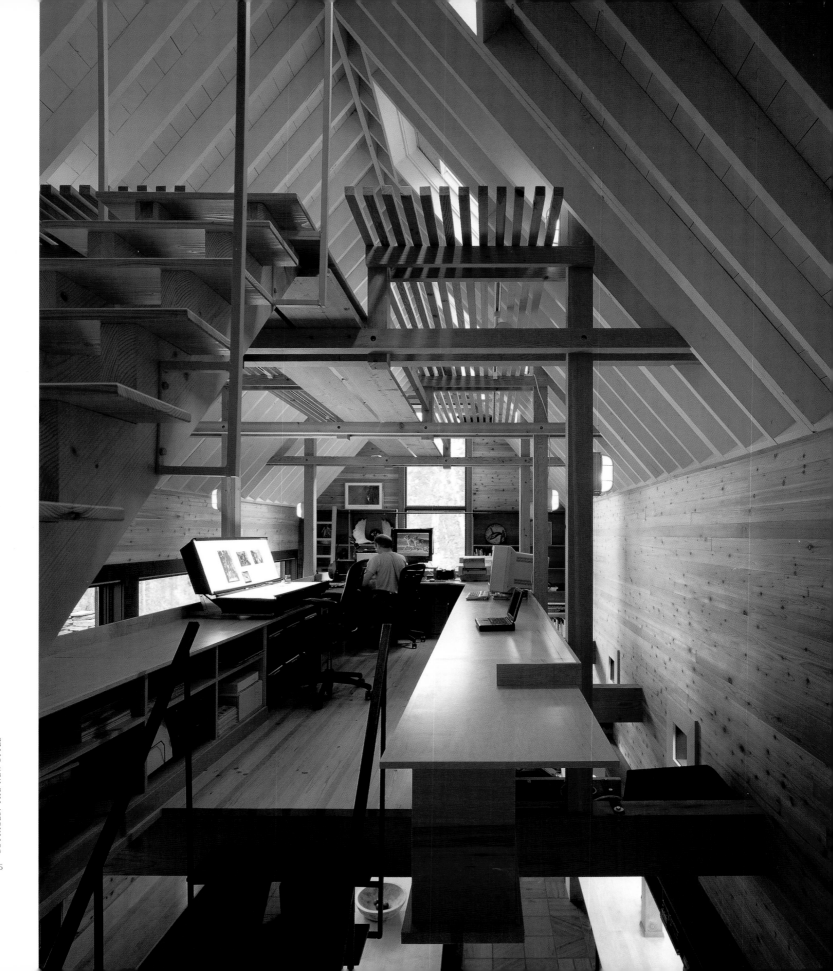

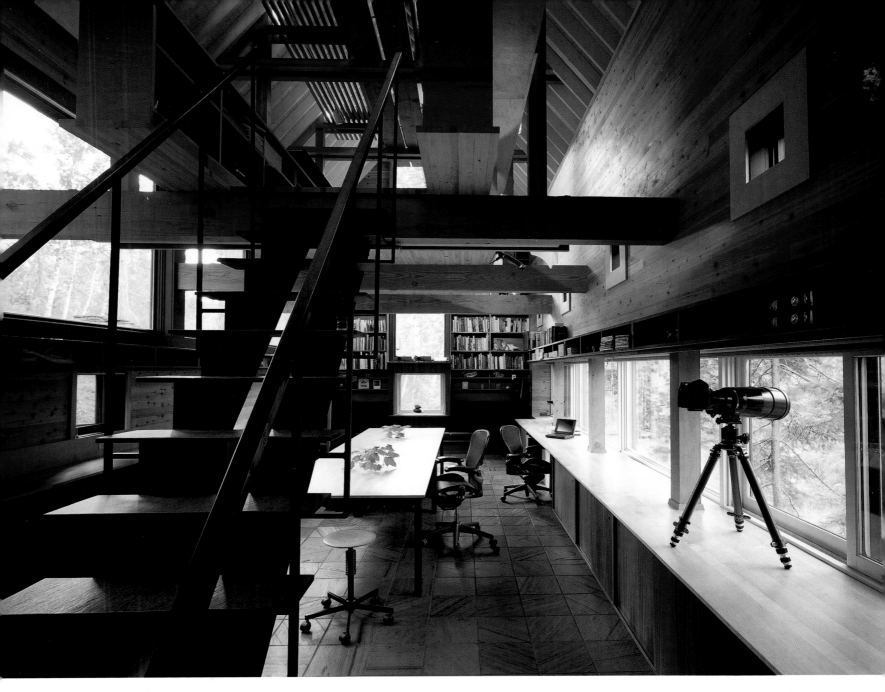

LEFT AND ABOVE: *Views of the studio and teaching space.* FOLLOWING PAGES: *The sleeping loft; view of retreat.*

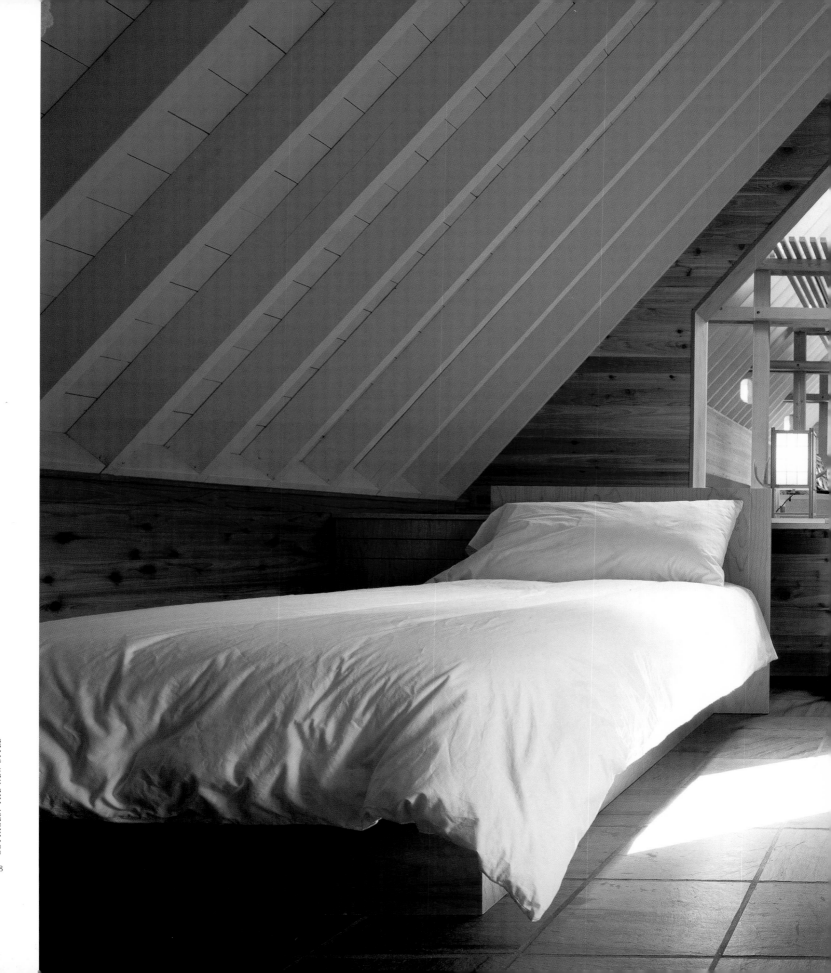

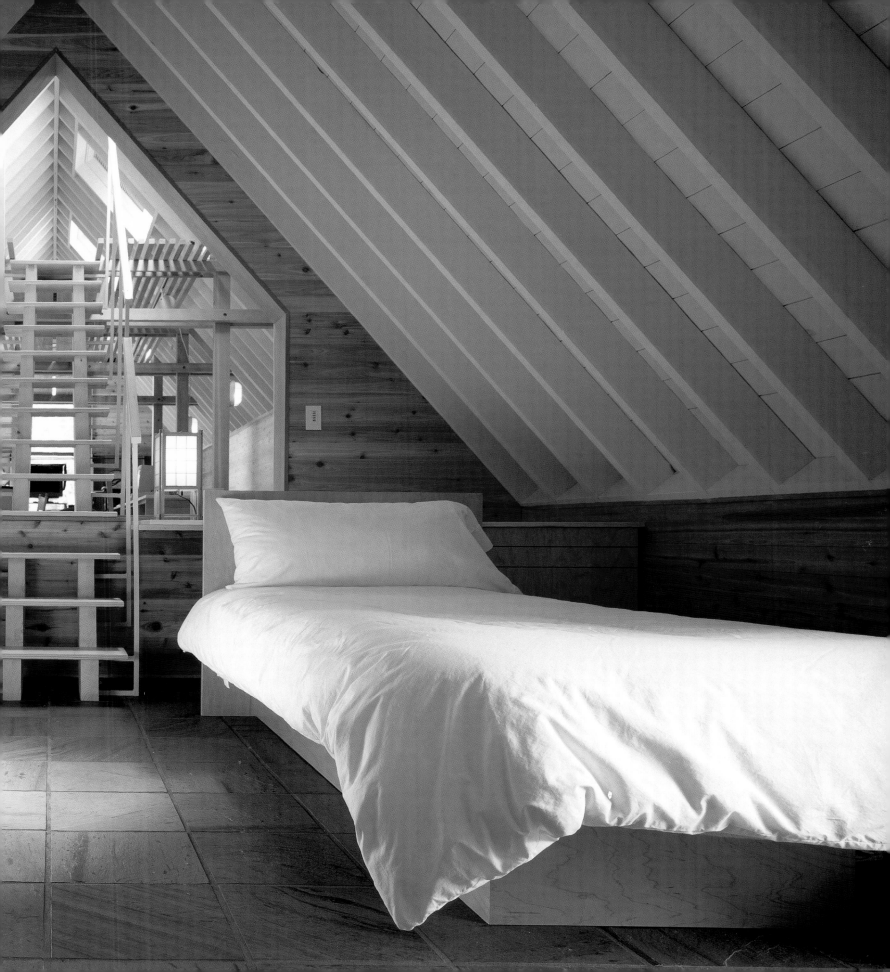

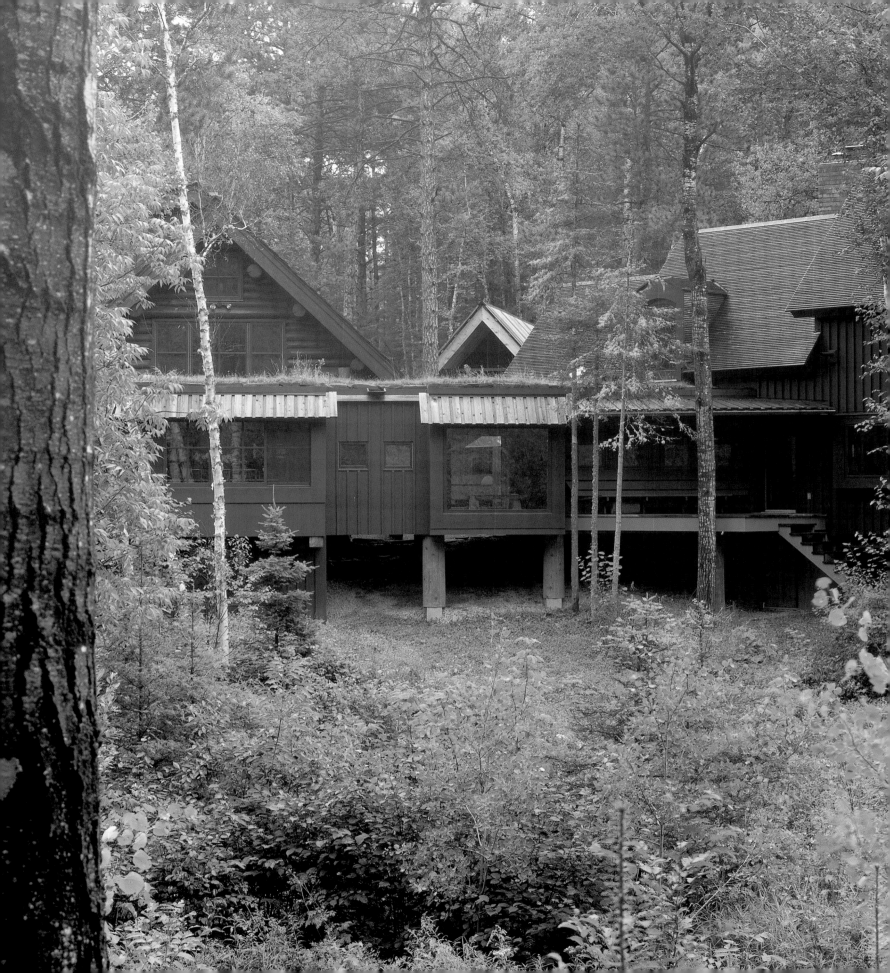

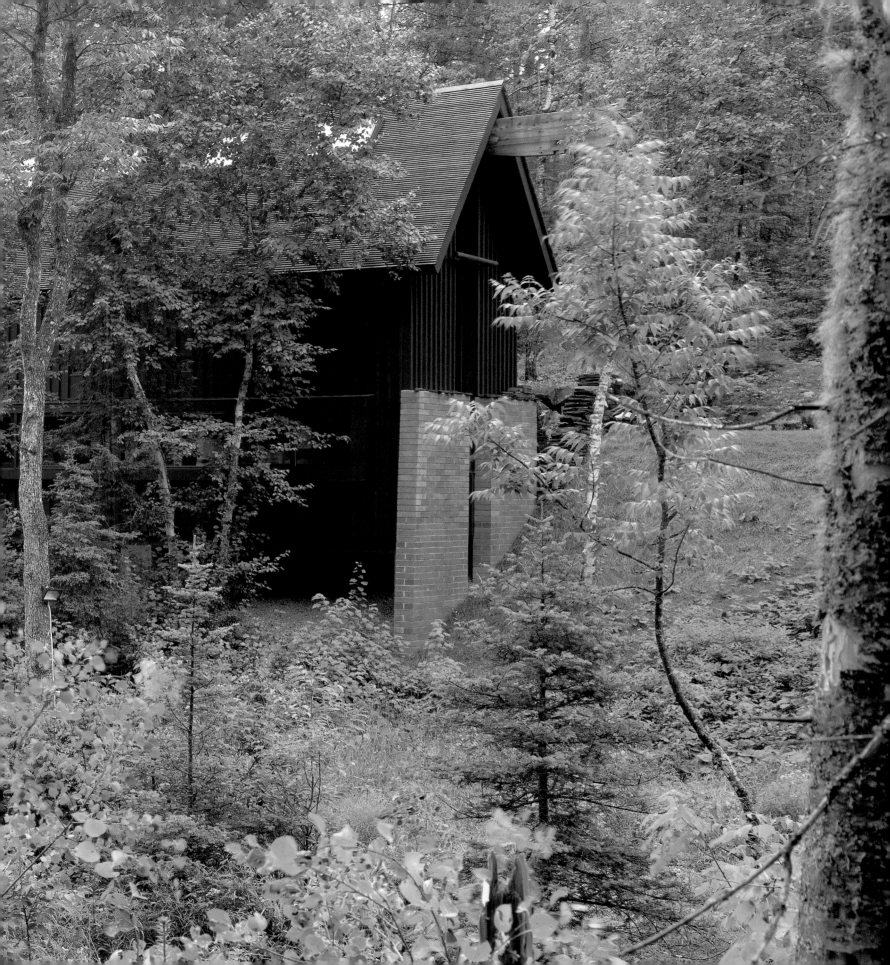

SUMMER COTTAGE

MICHIGAN

This summer cottage is situated seventy-five miles from Chicago on Lake Michigan in a community of primarily summer and weekend residents. The cottage consists of three distinct structures that are connected by an open veranda on the driveway side of the house, permitting outside circulation between the structures. On the lake side of the house they are united by a continuous wooden patio that provides generous space for outdoor dining, reading, and relaxing.

The living/dining space is in the center and has a strong relationship to the outdoors by virtue of the extensive use of glass overlooking the lake on one side and the entry court on the other. Structural components are left exposed in the attic/loft above. The attic houses mechanical equipment and two bedrooms and a bath.

The master bedroom and library are in the second structure, and the garage with the kitchen tucked behind and overlooking the lake is in the third. The post-and-beam construction provides a strong visual link between the inside and outside and gives the cottage the feeling of a true summer place.

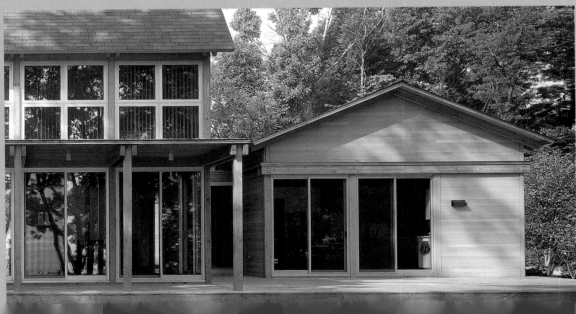

ABOVE: *View into living area at dusk.*
LEFT AND RIGHT: *Lakeside façade.*

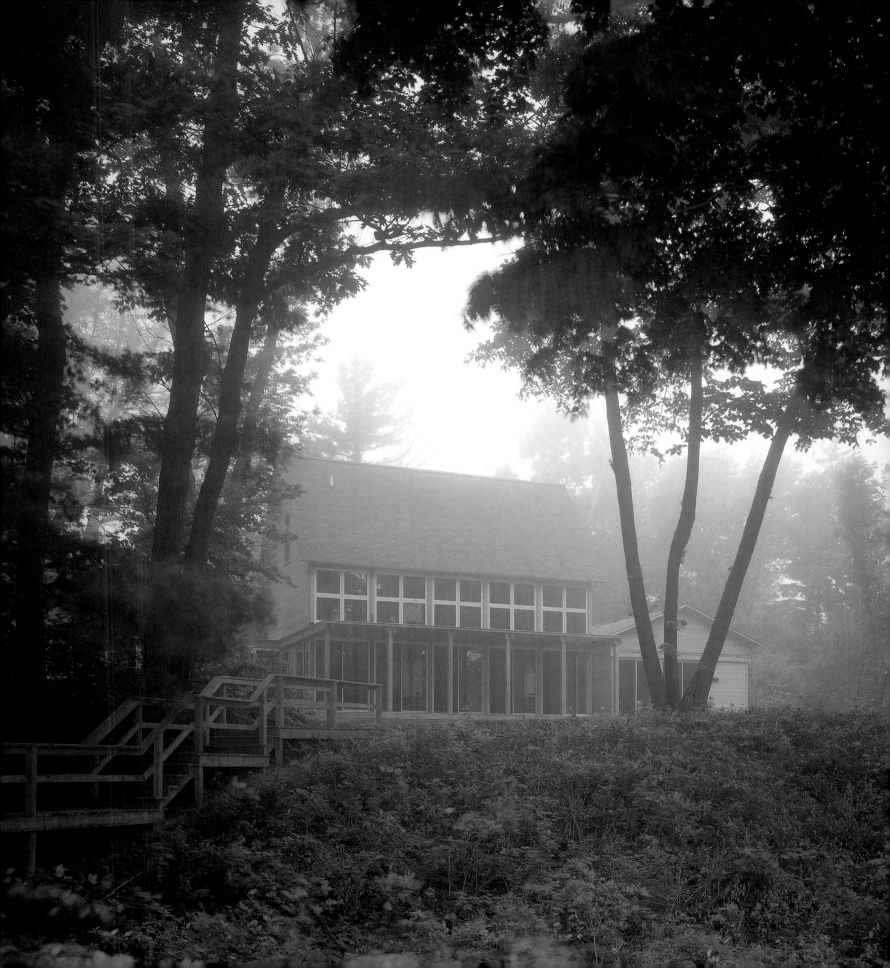

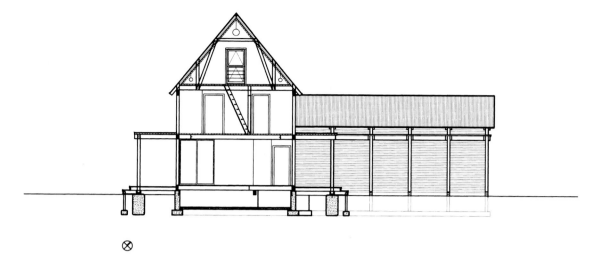

ATTIC/LOFT PLAN

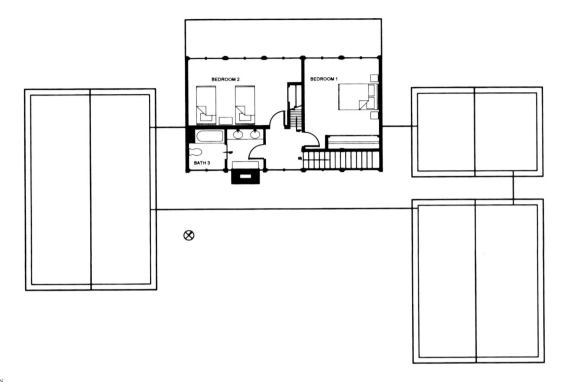

BEDROOM 2

BEDROOM 1

BATH 3

FIRST FLOOR PLAN

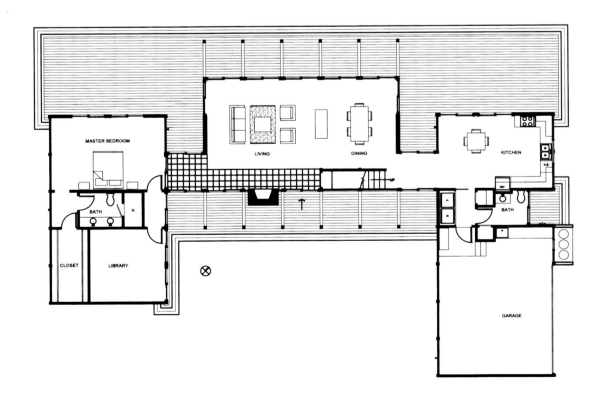

MASTER BEDROOM

LIVING

DINING

KITCHEN

BATH

CLOSET

LIBRARY

BATH

GARAGE

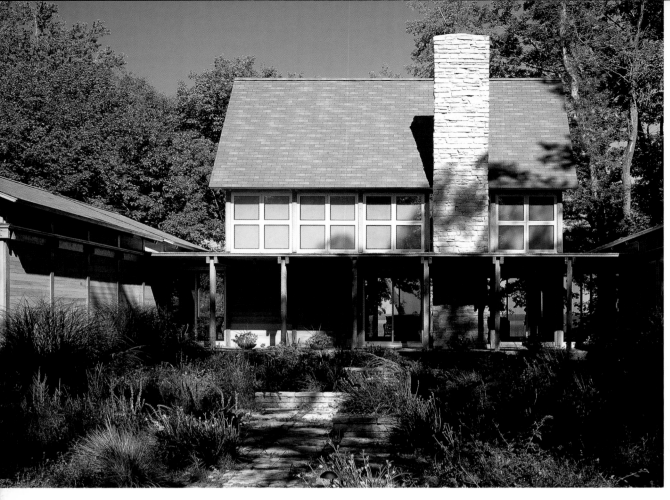

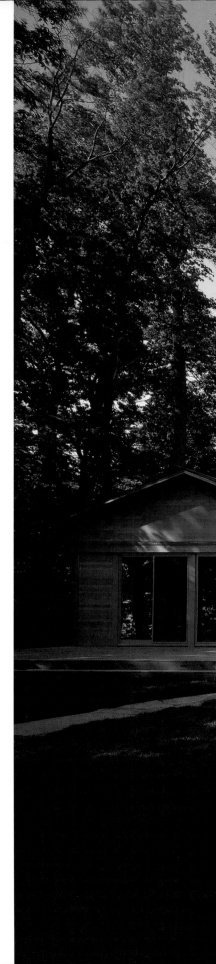

ABOVE: *View of the open veranda connecting the cottage's three sections.*
RIGHT: *A large patio that overlooks the lake provides generous entertaining space.*
FOLLOWING PAGES: *Attic; the veranda at night.*

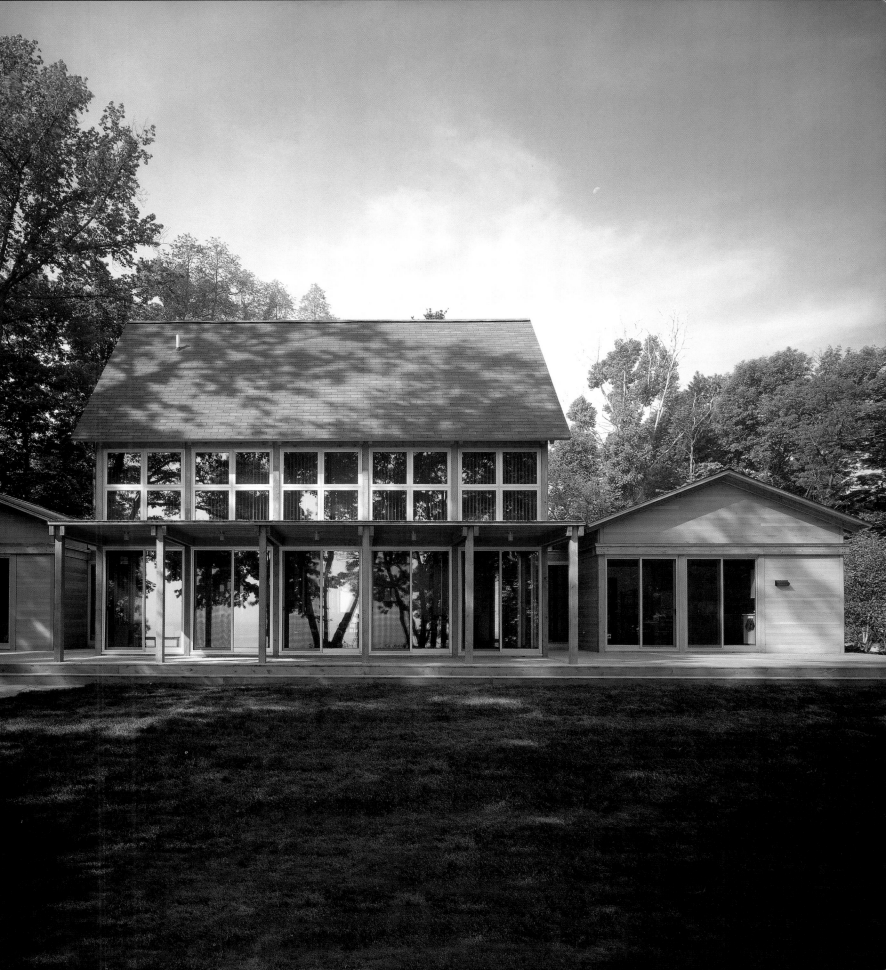

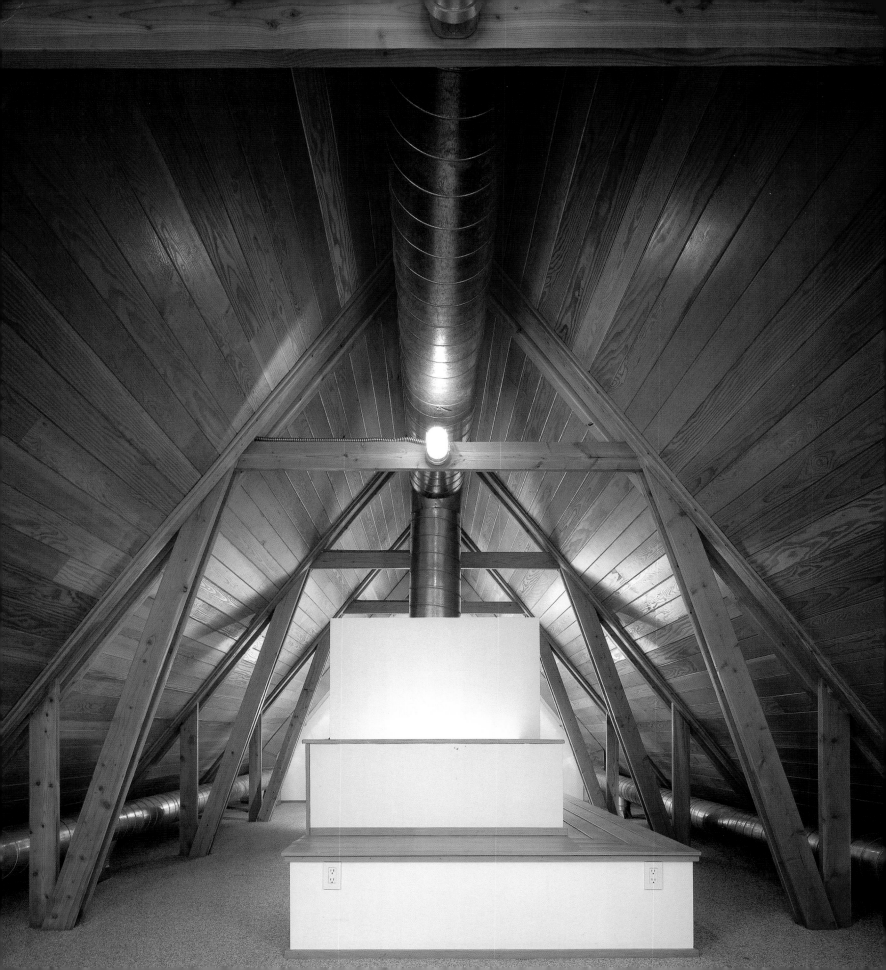

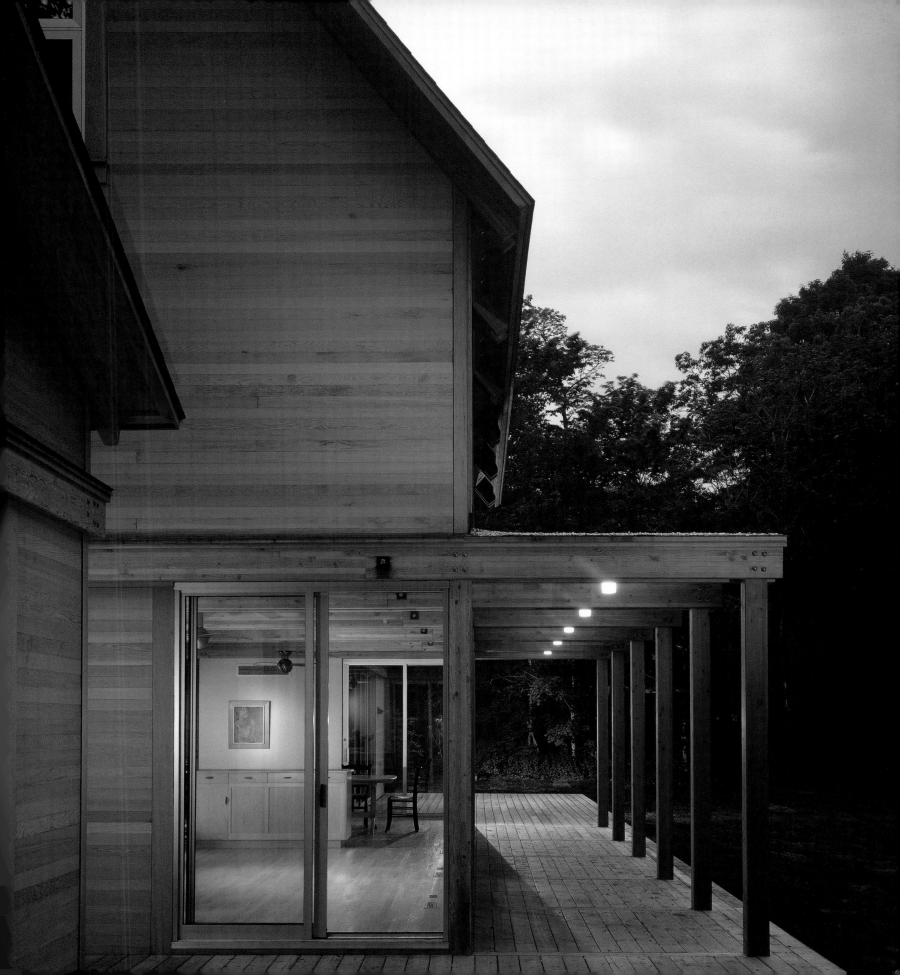

AGOSTA

SAN JUAN ISLAND, WASHINGTON

Located on San Juan Island, a small, largely rural island off the Pacific coast in Washington State, this 2,775-square-foot cottage was designed for a couple relocating from Manhattan. The site of the house is a grassy meadow, enclosed on three sides by a dense Douglas fir forest and open to the northwest with views below of rolling fields and across Haro Strait to the gulf islands of British Columbia.

The cottage is stretched across the ridge of the meadow, appearing as a spatial dam. The building section is "battered," walls and roof sloped, responding to the gentle, steady slope of the site. The spatial organization is the result of the extrusion of this simple section and by manipulating this extrusion either by erosion, to create exterior in-between spaces that subdivide the house programatically, or by insertion of non-structural bulkheads that organize the interior into more precise spatial areas. A garden is enclosed within a twelve-foot-tall fence to protect it from deer that run wild throughout the island.

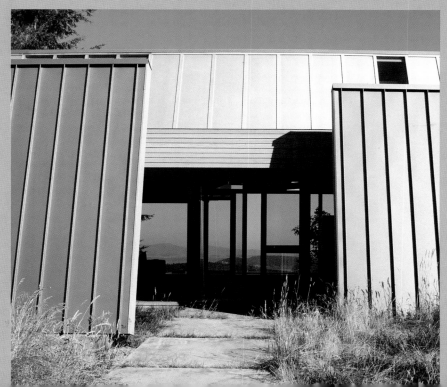

The exterior is clad in light gauged galvanized sheet-steel that not only protects the cottage from the normal effects of weather, but also from wildfires in an area with limited firefighting services.

ABOVE: *The dwelling was carefully sited to take advantage of the views.*
LEFT: *Entry.*
RIGHT: *Aerial view showing the surrounding Douglas fir forest.*
FOLLOWING PAGES: *View from the northwest.*

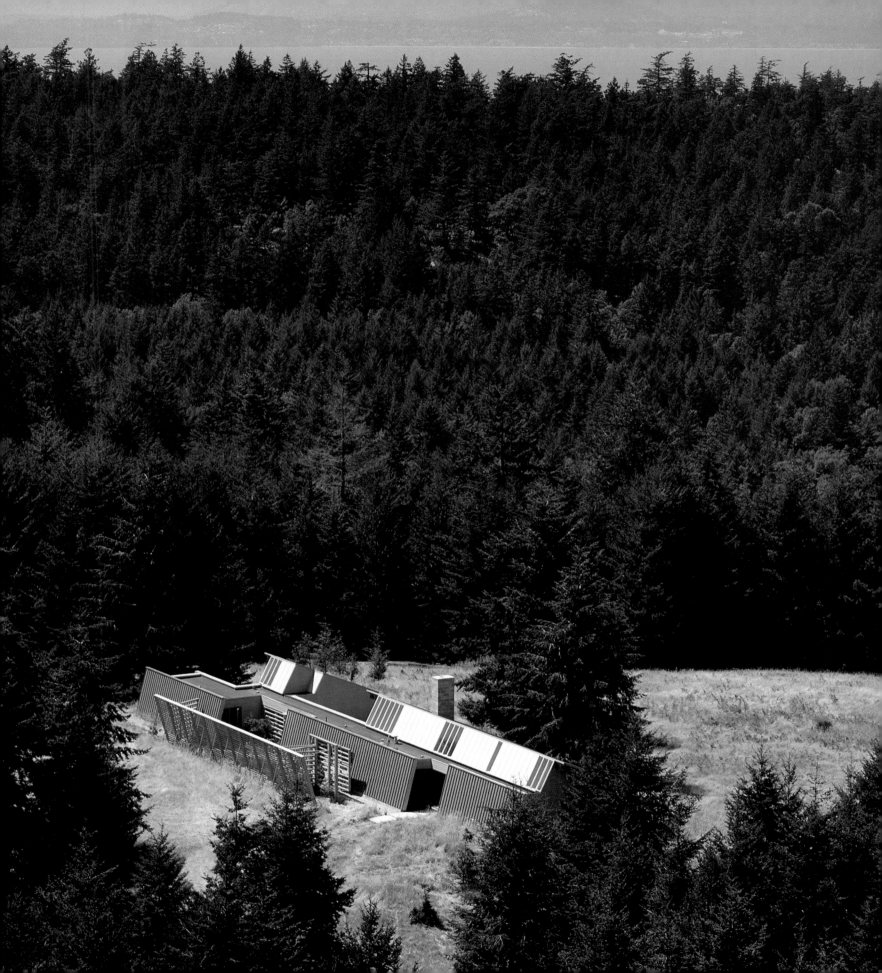

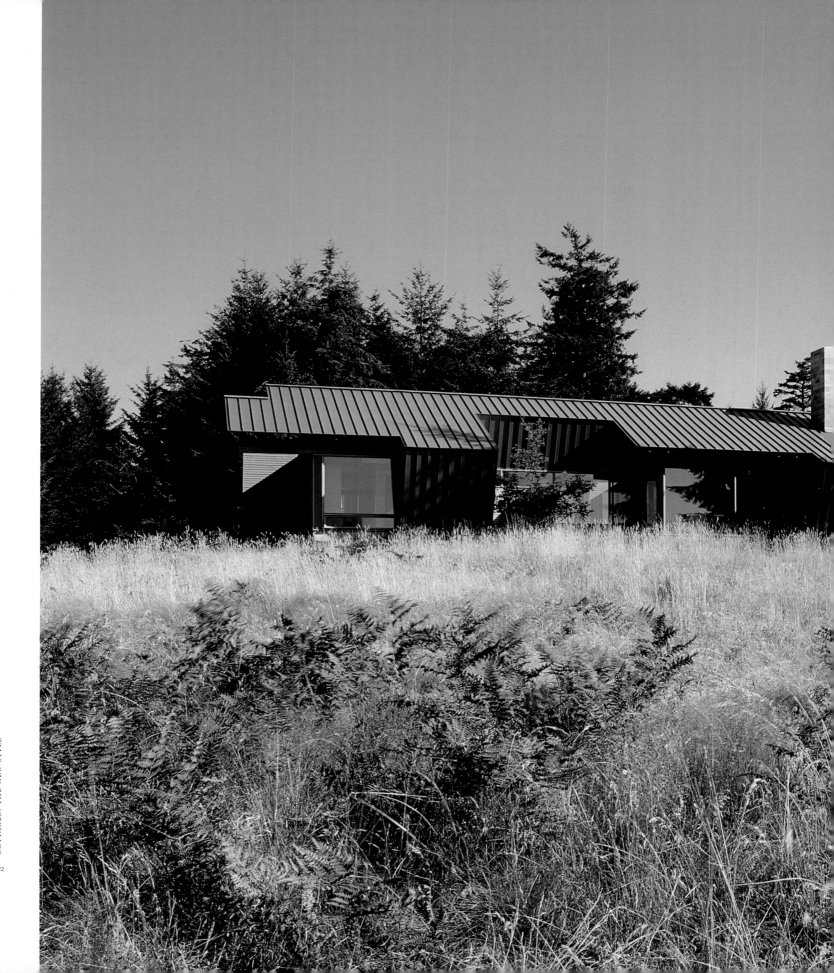

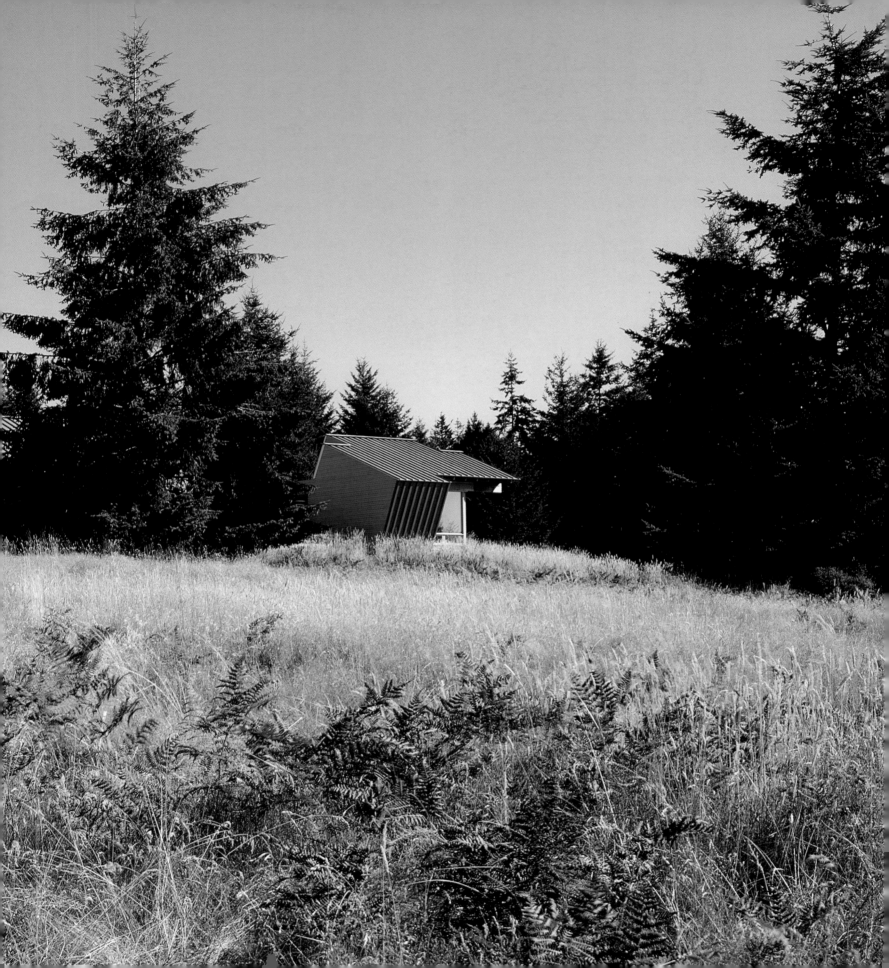

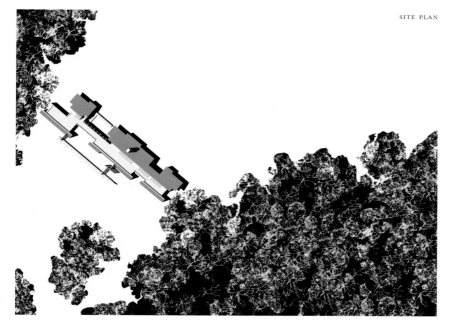

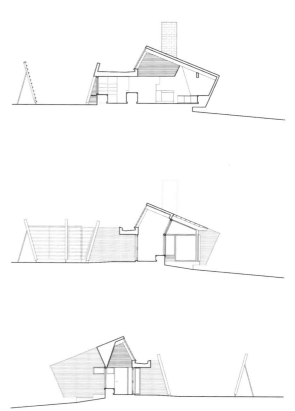

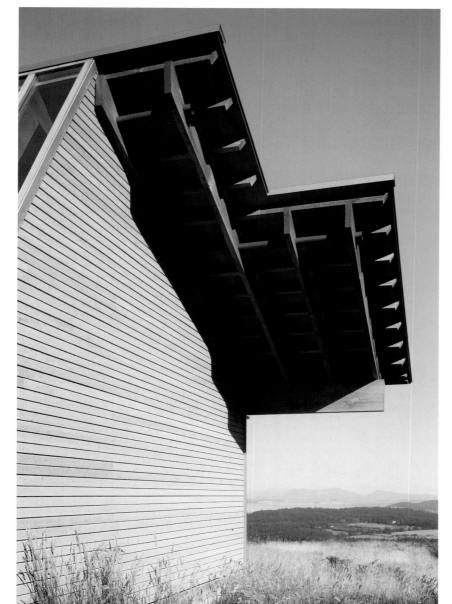

COTTAGES: THE NEW STYLE

LEFT: *Roof detail*

REFLECTED CEILING PLAN

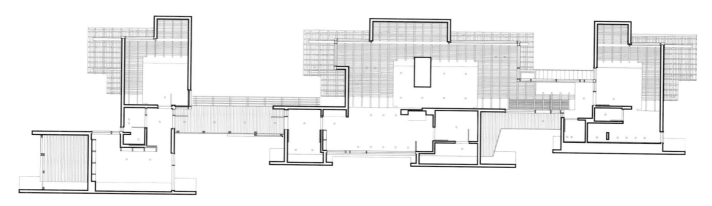

FLOOR PLAN

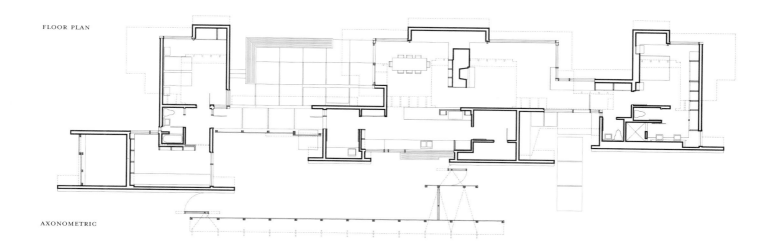

AXONOMETRIC

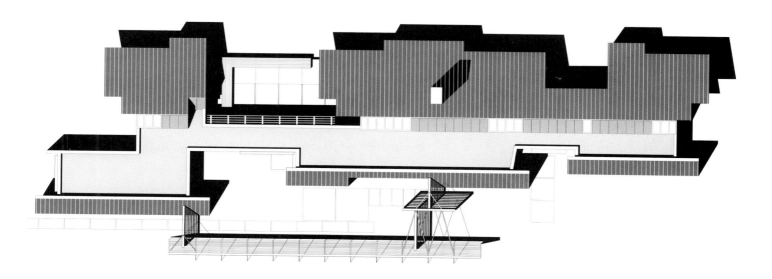

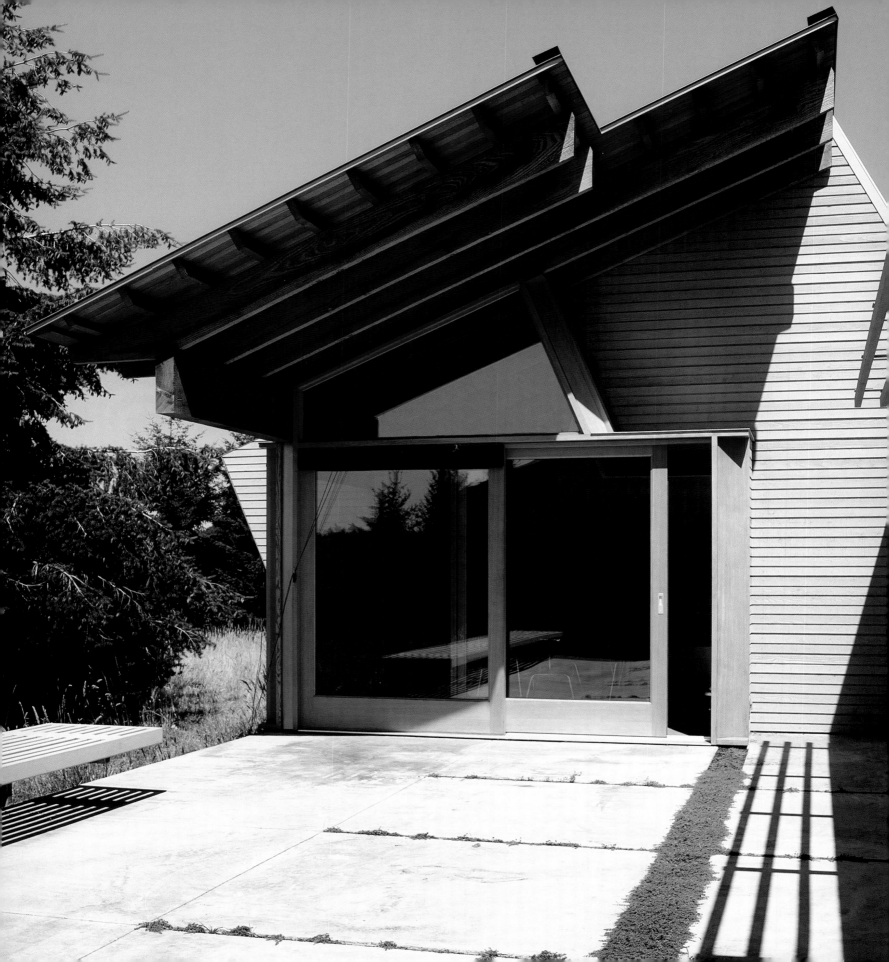

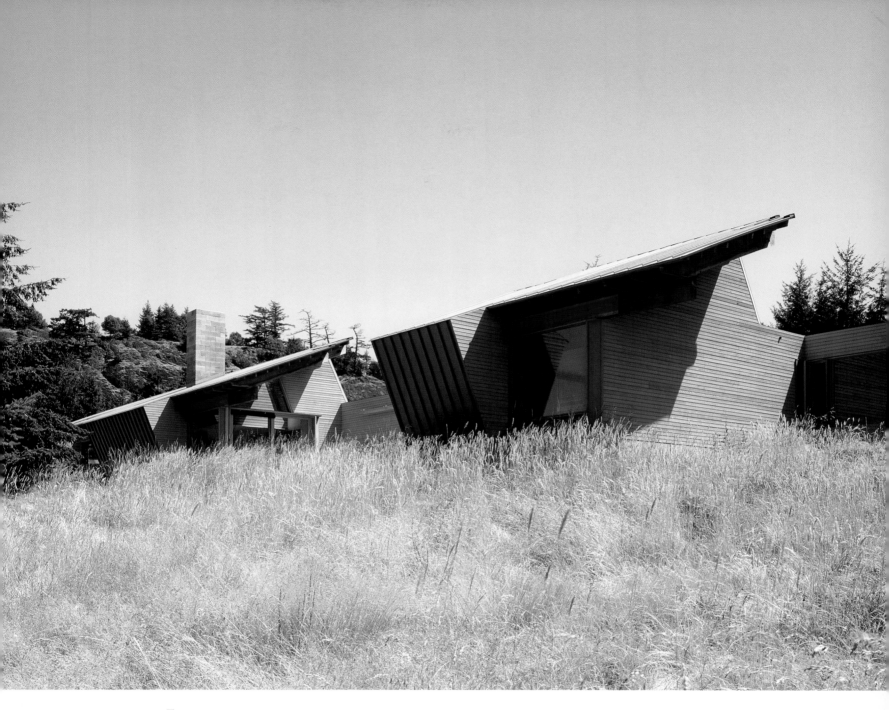

LEFT AND ABOVE: *The roof-line mimics the gentle slope of the hillside.*

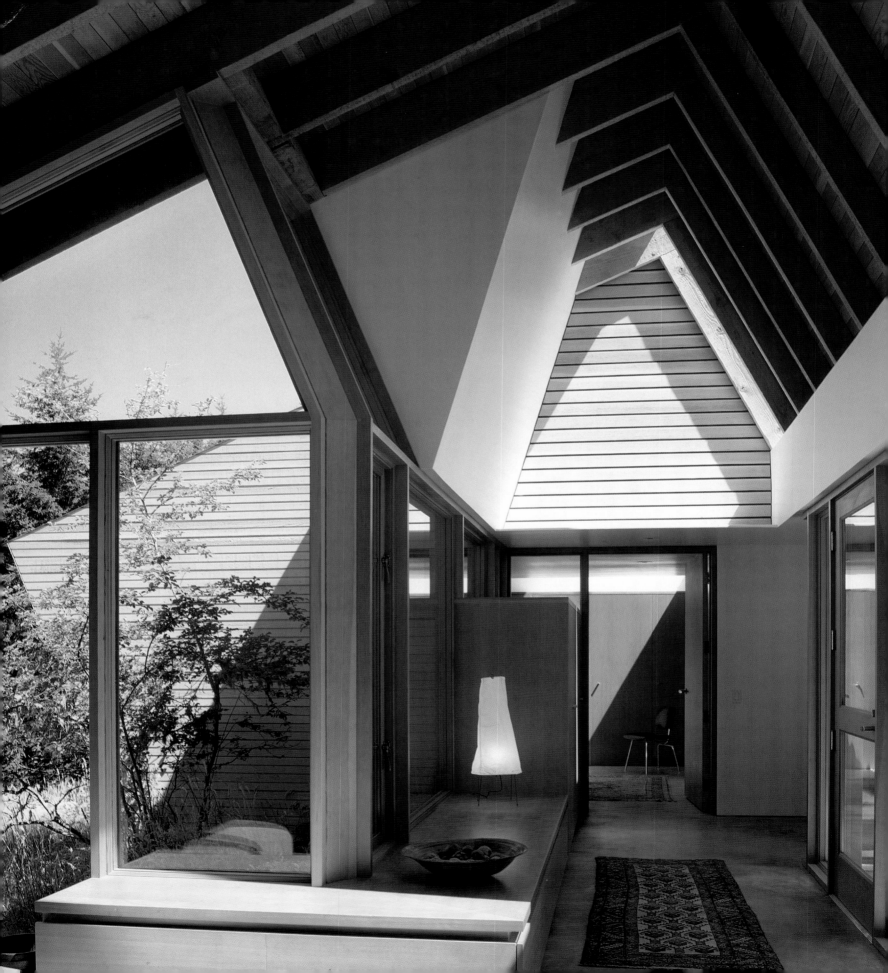

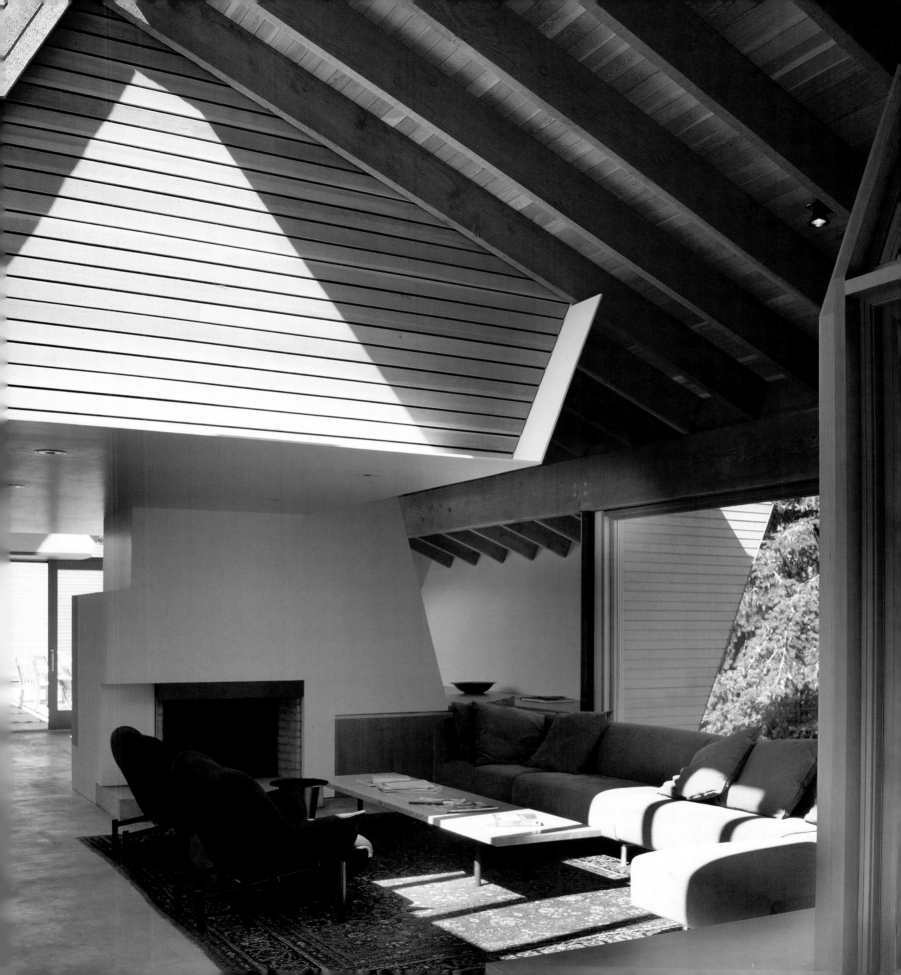

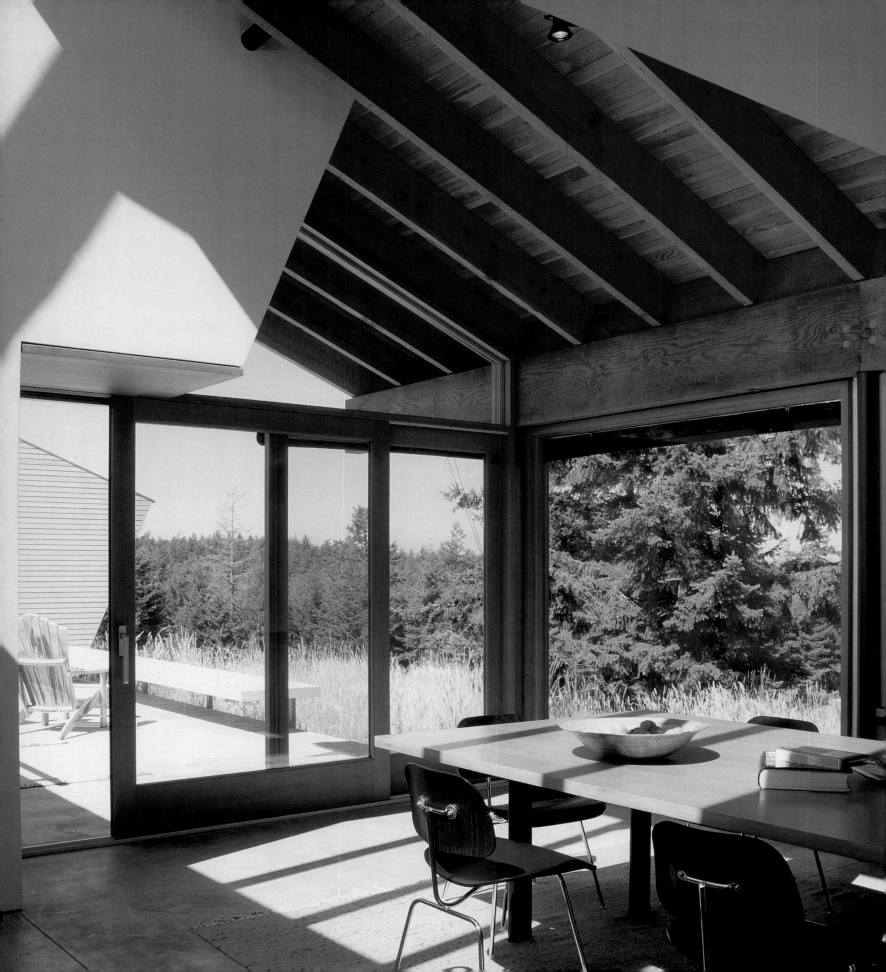

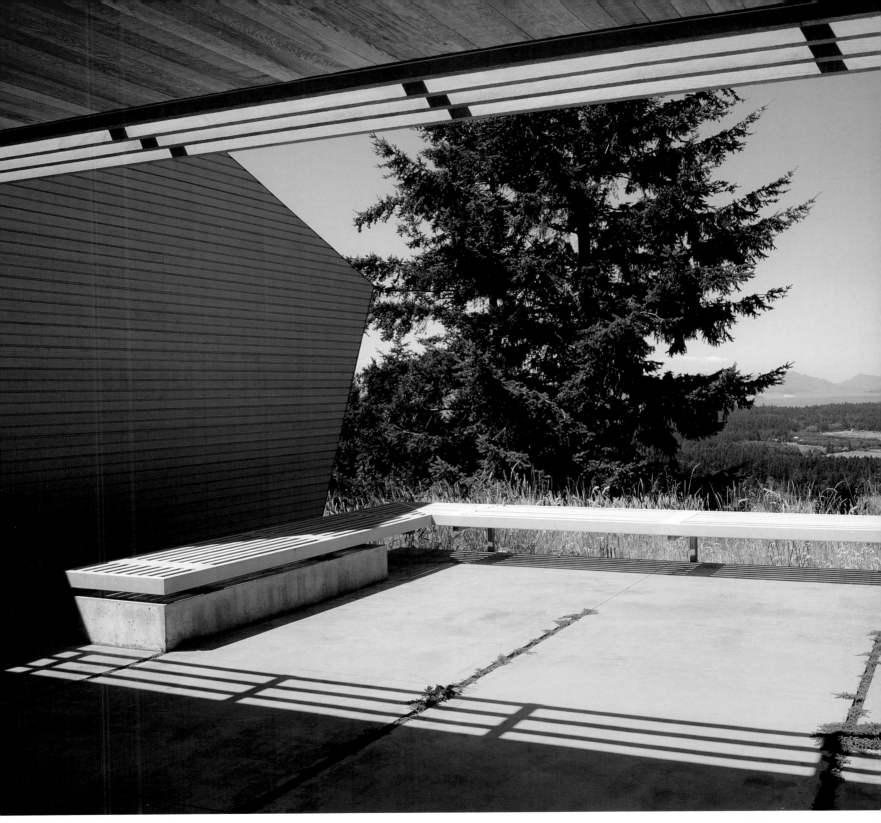

PREVIOUS PAGES: *Living area.*
LEFT: *Dining area.*
ABOVE: *A seating area defines the patio.*

COUCH COLLAGE

WEST VIRGINIA

Only one thousand square feet in size, this collage of buildings sits high on a steep wooded cliff in West Virginia, overlooking the Cacapon River some 300 feet below. Sited and organized to take advantage of this extraordinary panorama, the house is divided into three separate buildings—the domestic rooms for sitting, cooking, and sleeping, a work room/studio, and a tower of porches. The owner requested that the interiors of these spaces be spartan, almost monastic, with little furniture. Primary seating is provided by floor cushions and a ledge created by the two-level living room. The simple detailing of the interior is enhanced by the use of old, recycled barn beams that are used for interior posts, beams, railings, and the mantle.

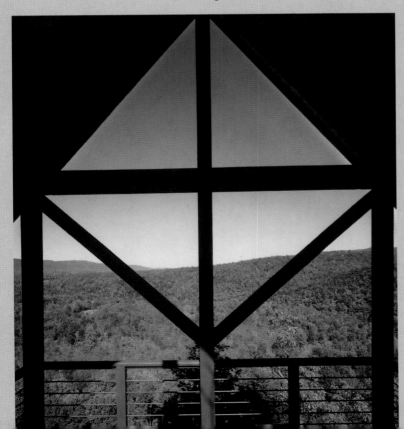

Outdoor walkways and bridges visually and physically connect the three buildings, which are structurally connected by an eighty-foot stone wall that follows the ridge line and supports a portion of each building. This wall appears to have always been on the site, while the three compact elements that make up the cottage seem temporary yet familiar to visitors as they arrive at this profoundly beautiful location.

ABOVE: *Porch tower roof detail.*
LEFT: *The porch tower provides panoramic vistas.*
RIGHT: *This compact cottage is made up of three separate buildings.*

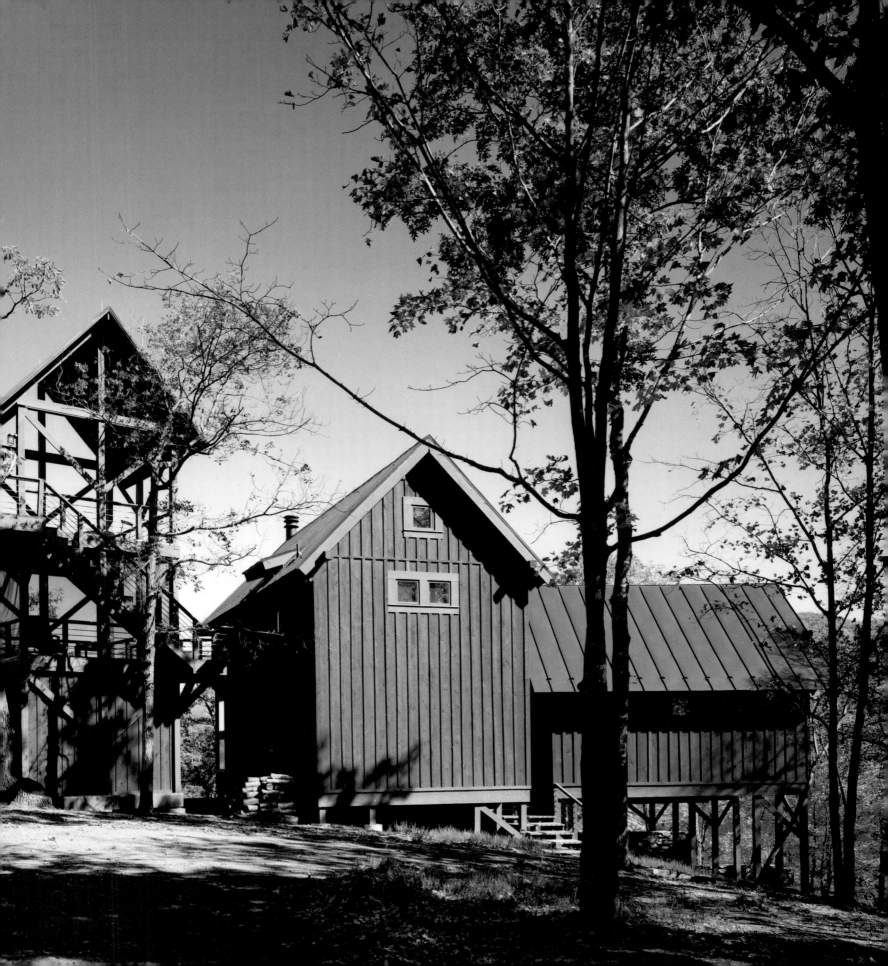

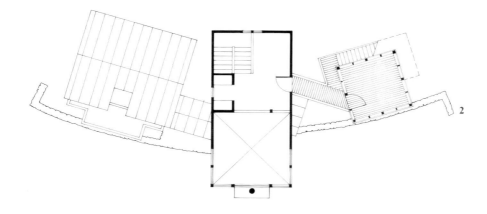

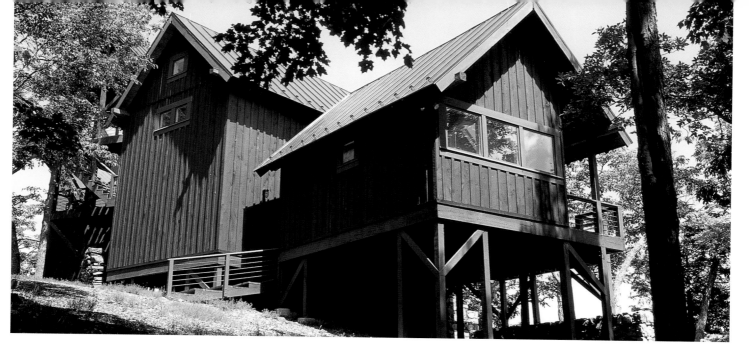

CONCEPTUAL SKETCHES

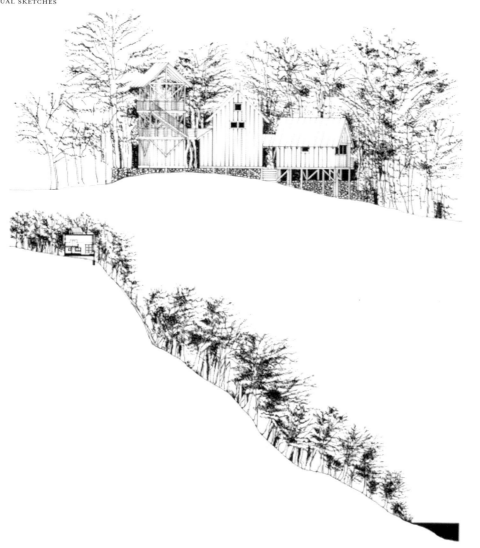

LEFT: *Living area.*
RIGHT: *Stair detail.*

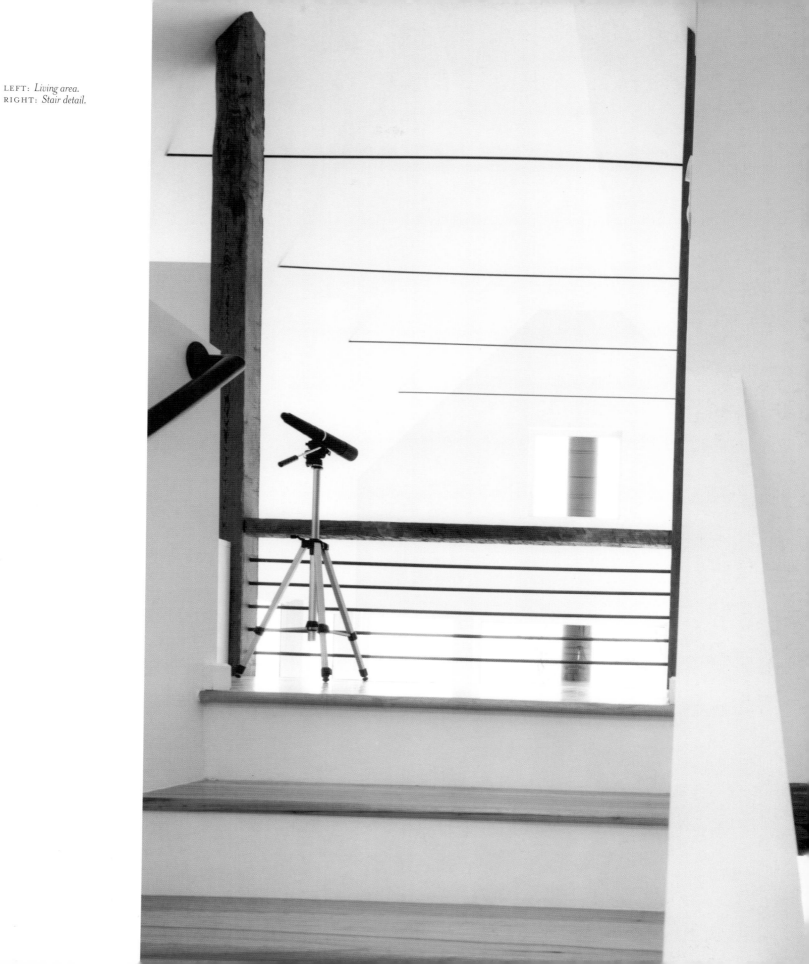

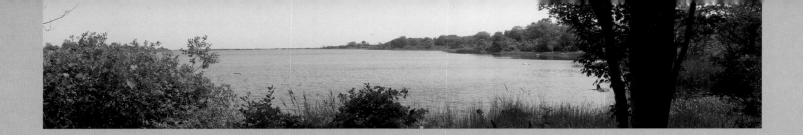

GOOSEWING FARM

NORTHEAST

This modest farm is surrounded by water and accessed along a thin strip of land off of a rural road. Two freshwater ponds lie to the east and west with the Atlantic Ocean forming the southern border. The land gently rises to fifty feet above sea level. Over a period of two decades, the owners undertook extensive renovation of an existing eighteenth century cottage called Sisson and the construction of a new caretaker's compound known as Tunipus.

From the exterior, the renovation and expansion of Sisson is unassuming. It is modestly clad in cedar shingles not unlike many of the region's vernacular buildings. However, two unusual metal-clad monitors rise from the gabled cottage signaling that the simple facade may conceal an unexpected design inside. Here, in what was once a rabbit warren of small rooms, the cottage has evolved into an open, modernist plan punctuated with recycled Douglas fir beams and columns, a fireplace constructed of boulders, and screens made of Douglas fir framing, boards, and lath.

The caretaker's compound is tucked in the woods away from the original cluster of buildings.

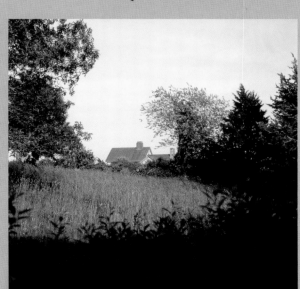

The simple gabled forms of Tunipus are detailed with restraint. The interior reveals the character of its construction. Although it is finished with more modest materials than the main cottage, there is still a rich dialogue and kinship established between the old and new cottages.

ABOVE: *The ocean and ponds surround the farm.*
LEFT: *A view of Tunipus.*
RIGHT: *The main house as seen from the meadow.*

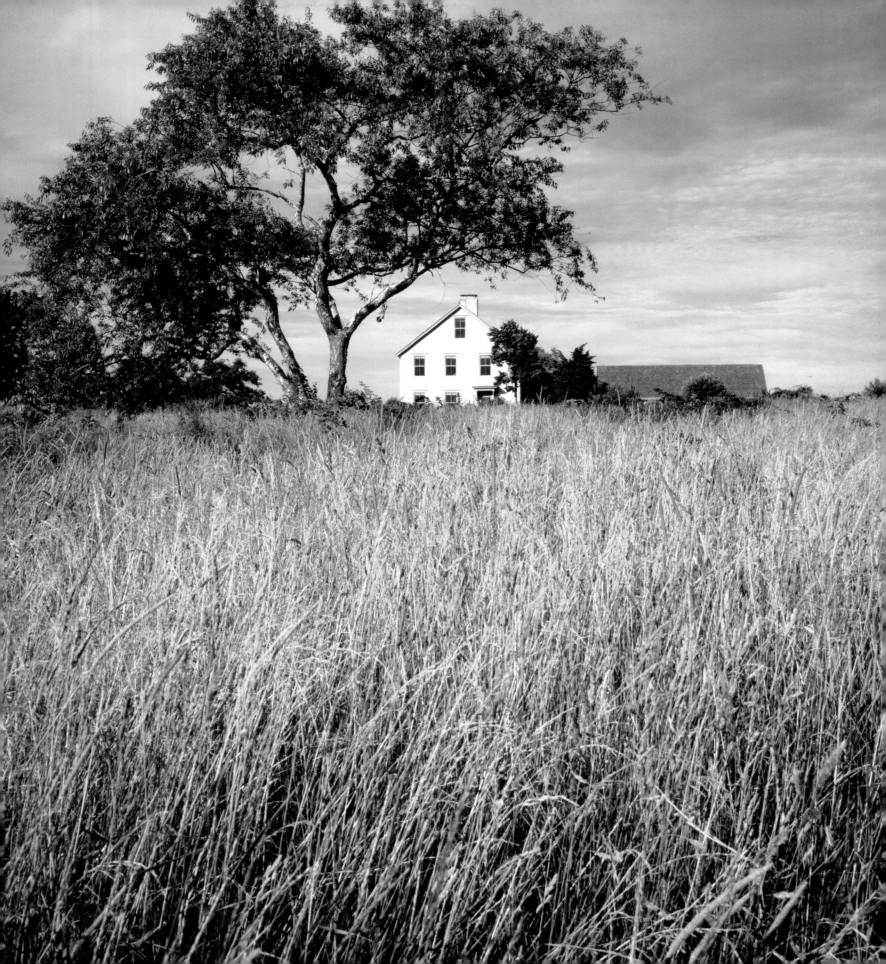

EXPLODED DRAWING OF SISSON

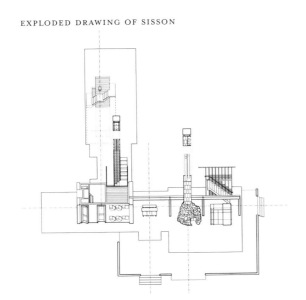

SISSON ATTIC PLAN

SISSON SECOND-FLOOR PLAN

SISSON FIRST-FLOOR PLAN

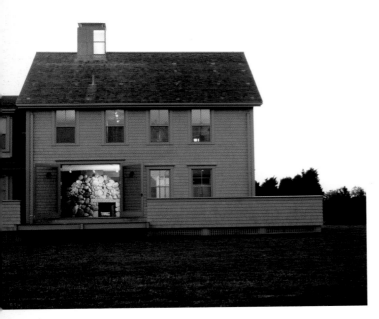

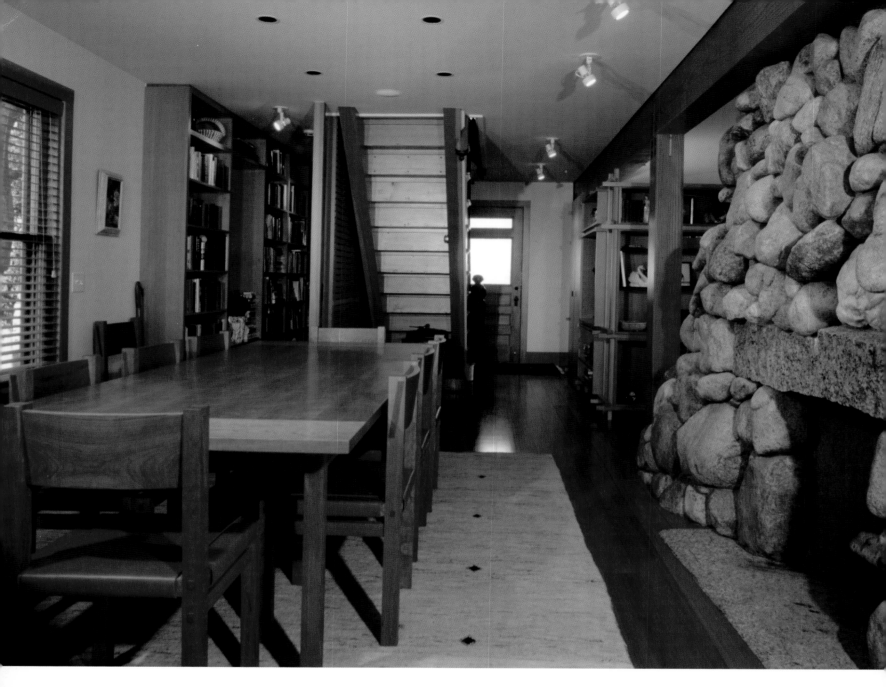

ABOVE: *Sisson dining area.*
RIGHT: *Fireplace detail.*

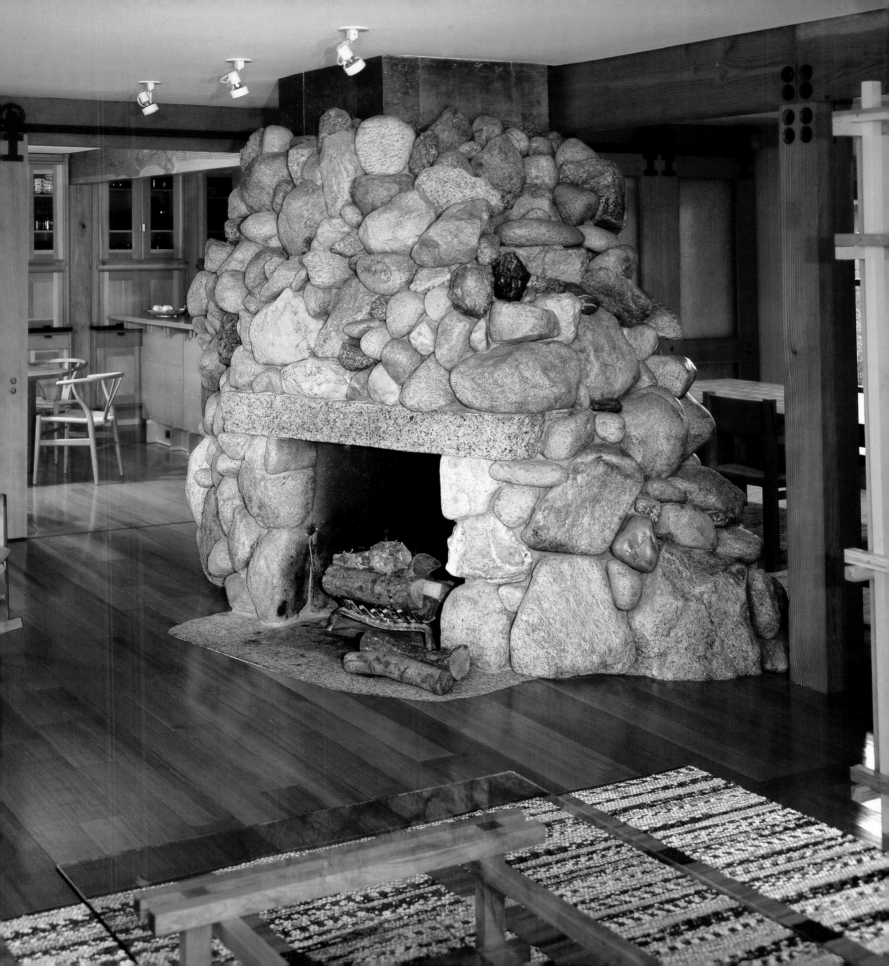

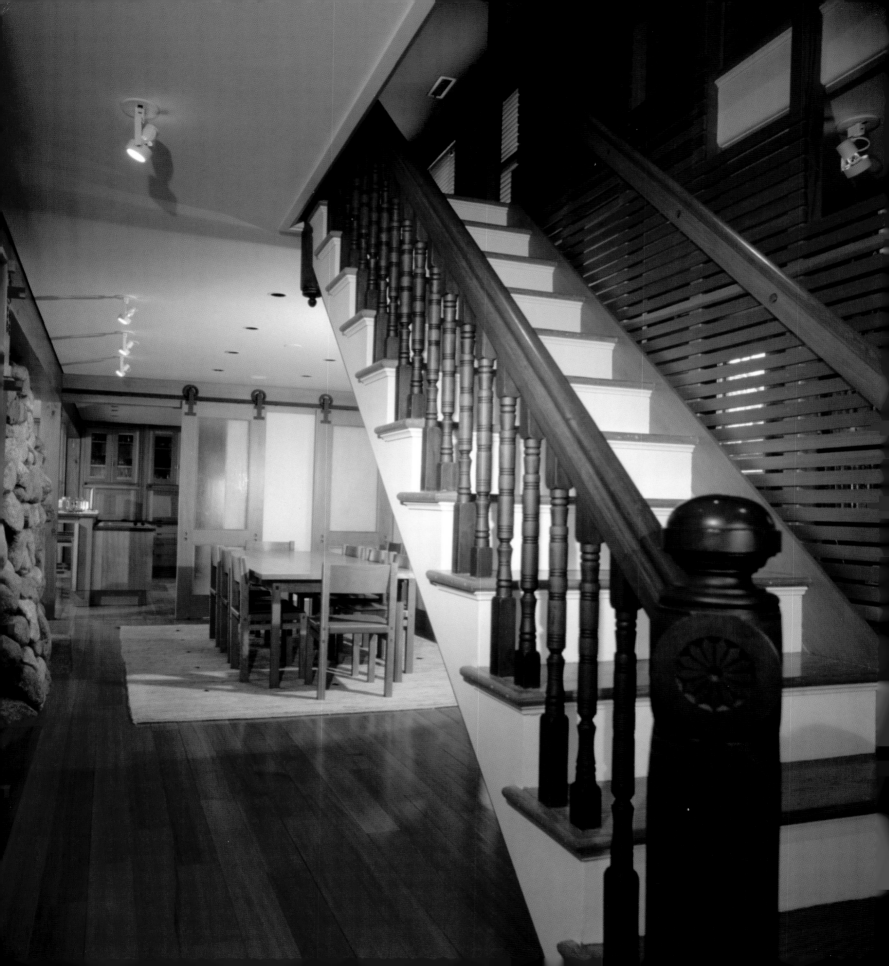

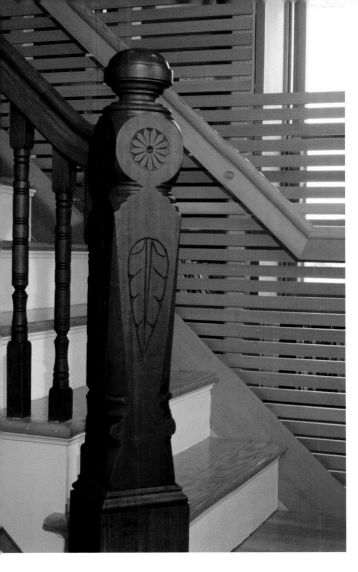

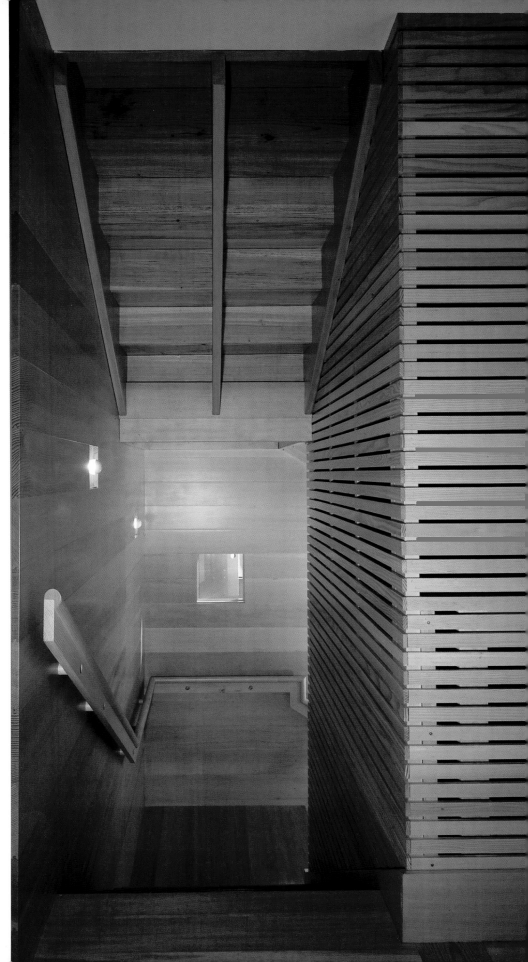

LEFT: *The dining room as seen from the staircase.*
ABOVE AND RIGHT: *Staircase details.*

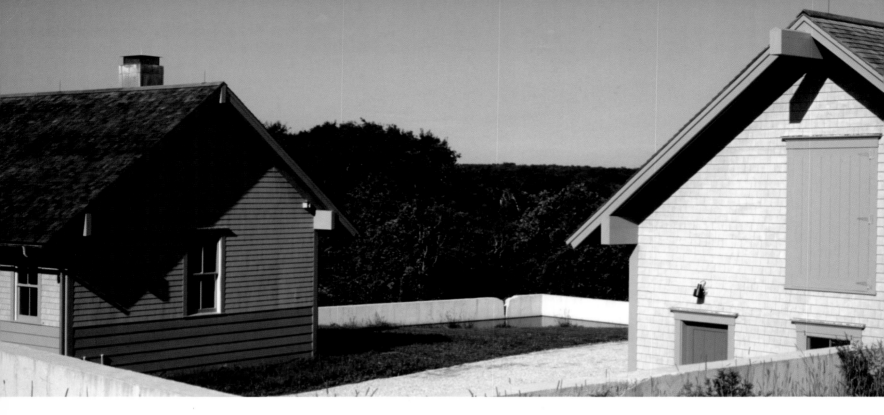

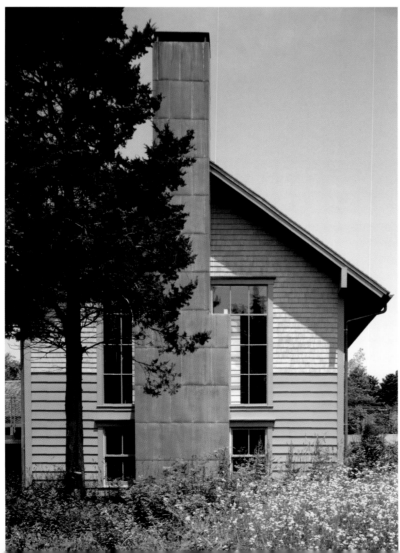

TUNIPUS SITE PLAN

THIS PAGE AND
OPPOSITE: *Tunipus as seen
from various elevations.*

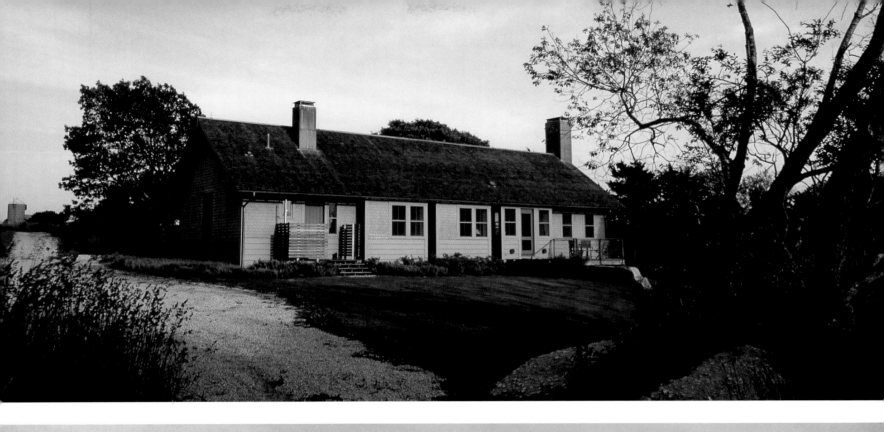
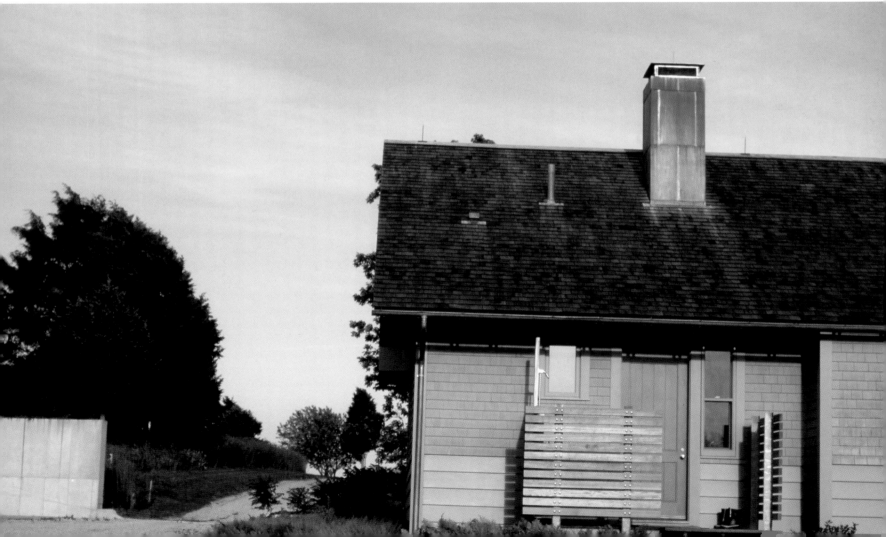

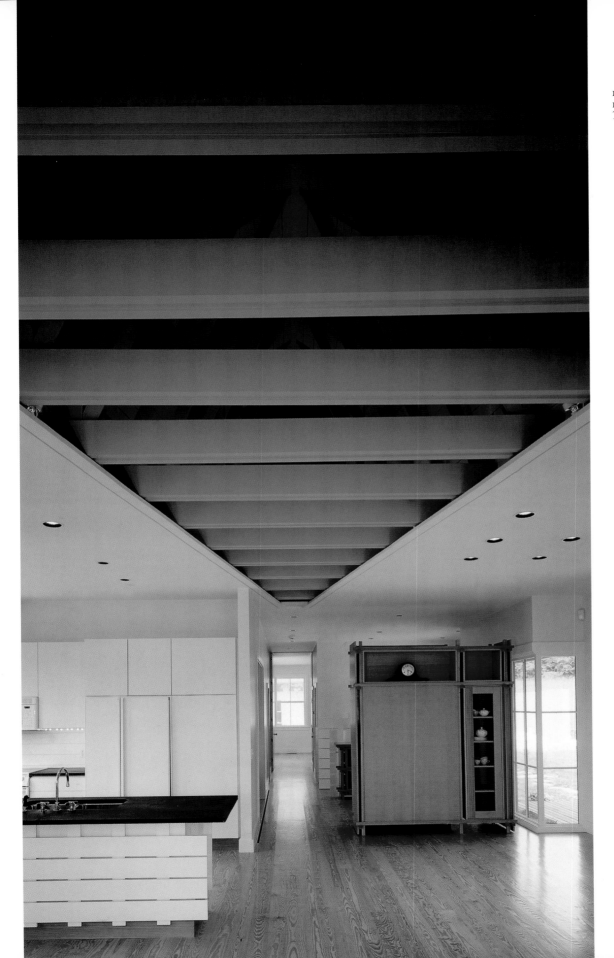

LEFT: *Tunipus kitchen.*
RIGHT: *Living area in Tunipus.*

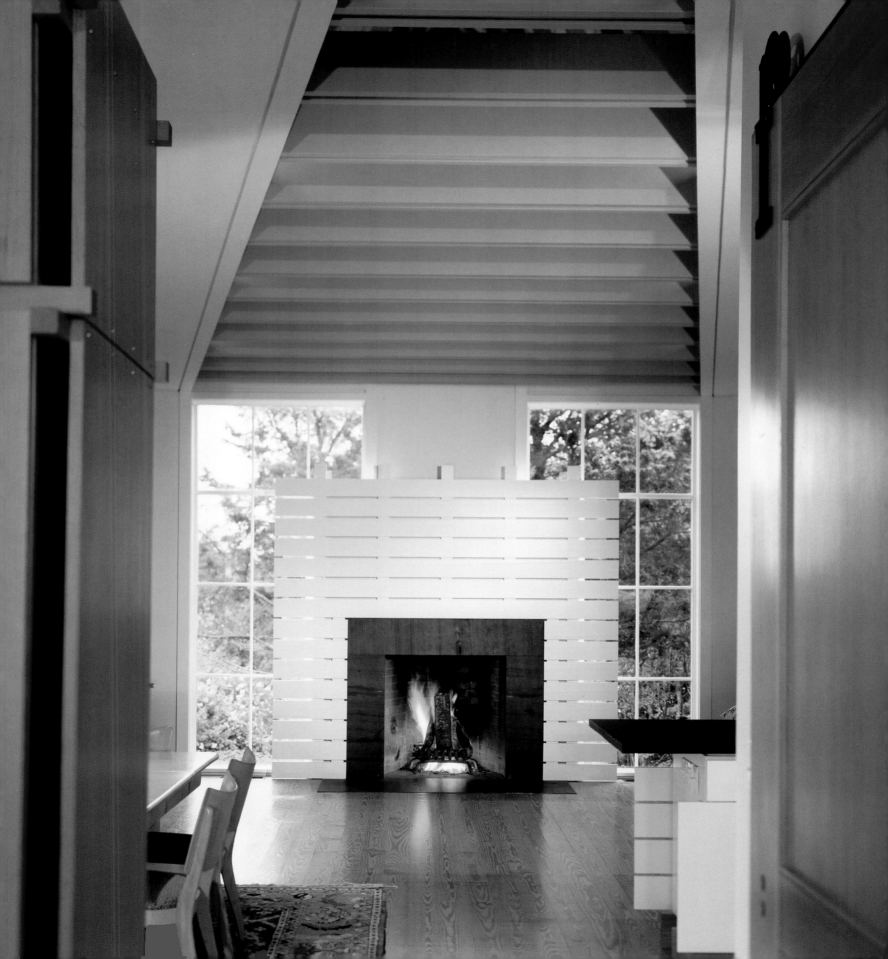

THE BRAIN

SEATTLE, WASHINGTON

This cottage, dubbed "The Brain" by its owner, is unique for two reasons. First, it is set in the backyard of a house in a dense urban neighborhood and second, its primary purpose is to serve as a creative retreat for a filmmaker. The idea of the home garage being the birthplace of ideas and inventions was the basis for the design of this 14,280-cubic-foot structure.

The form is essentially a cast-in-place concrete box intended to be a strong yet neutral background allowing complete flexibility to adapt the space at will. Inserted into the box along the south wall is a steel mezzanine that functions as an office. All interior structures, including the mezzanine, are made using raw, hot-rolled steel sheets.

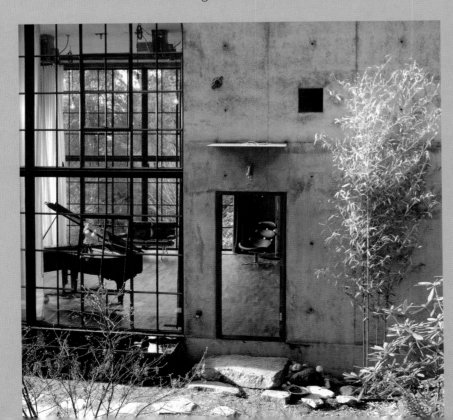

LEFT: *Entry.*
RIGHT: *Ample glazing merges the outside with the interior in this cast-in-place concrete cottage.*

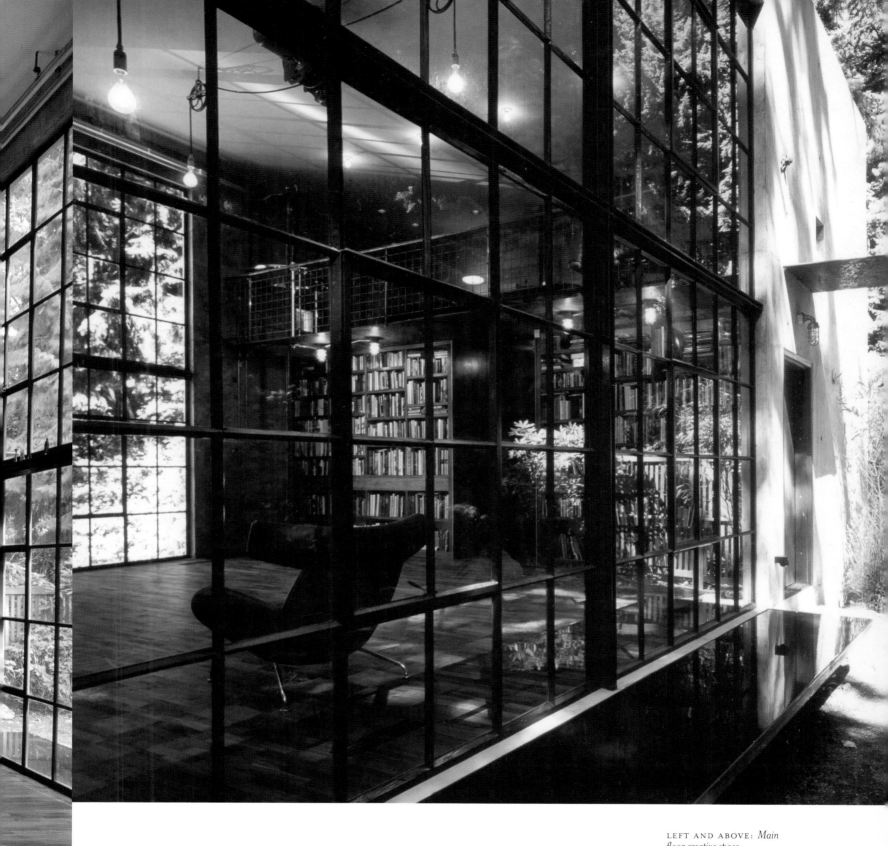

LEFT AND ABOVE: *Main floor creative space.*
FOLLOWING PAGES: *Office space on the mezzanine level.*

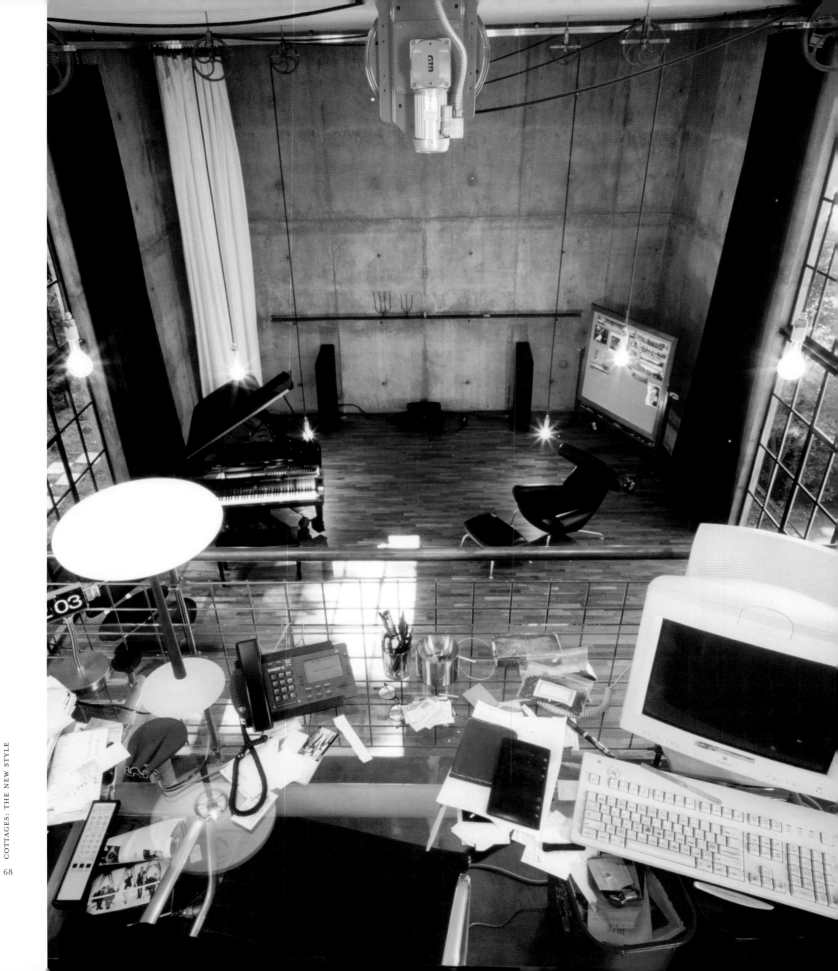

CREEK COTTAGE

MARYLAND

Situated between two 1950s modern houses by architect Charles Goodman, on a sloped wooded site overlooking a park, this small cottage attempts to reconcile a limited budget with a desire for expansive, light-filled spaces. The dwelling was configured to accommodate the mature trees found on the site and, as a result, is broken into three parts. The first is a simply and rationally built sixteen-foot-wide bar containing the library and kitchen on the main level, bedrooms and bathrooms below, and master suite above. A second barrel-vaulted volume contains the living room and dining room, and is more complex in form and construction. The third part of the scheme is a carport.

A line of fourteen reinforced concrete columns, angled relative to the rest of the plan, links all three pieces. This line energizes the geometry of the house and forces the perspective of the hall, ending at a small pool whose jets mask the sounds of nearby traffic.

Materials were chosen for their economy—plywood, metal, concrete—as well as for their expressive possibilities. Post and beam framing, corrugated metal, and white rooms accented by rich colors create light-filled spaces.

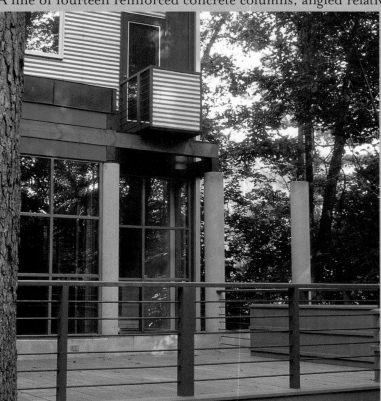

ABOVE: *Rear façade.*
LEFT: *View of deck across rear of house.*
RIGHT: *Entry façade.*

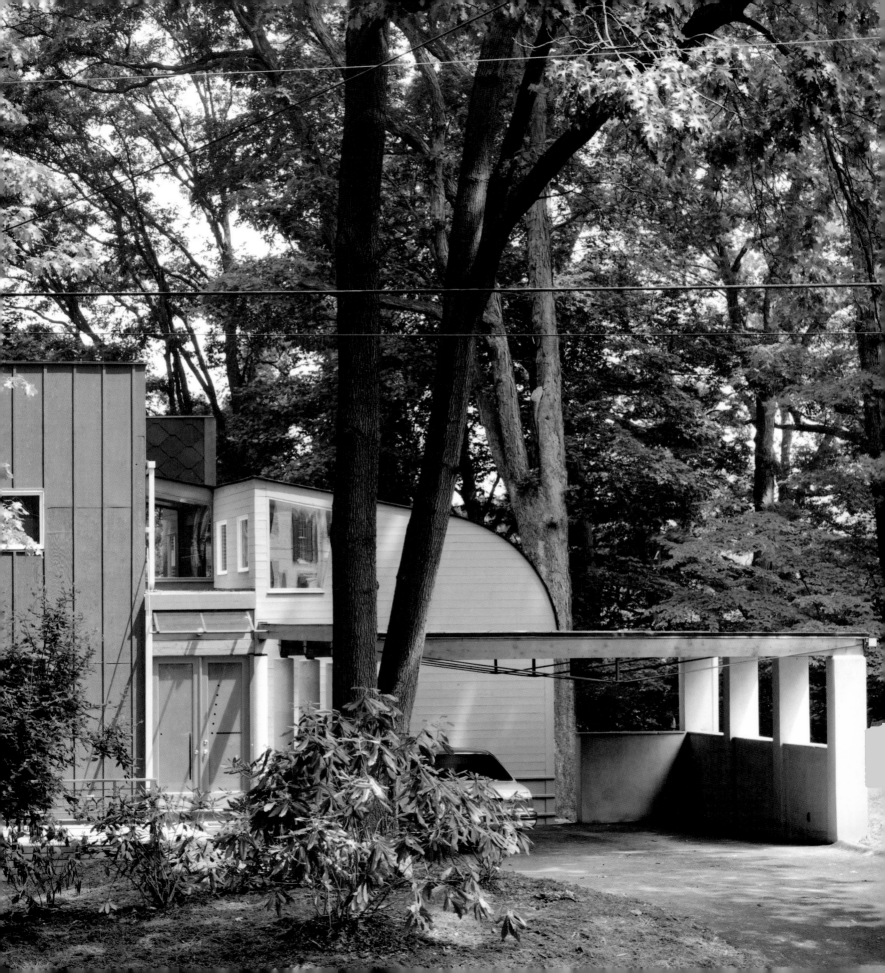

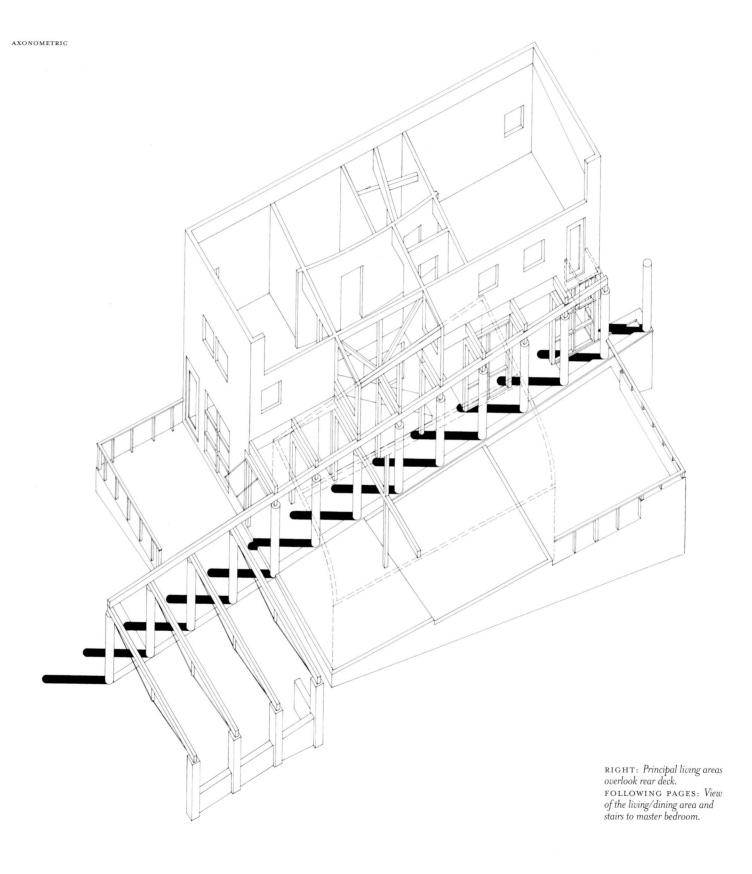

RIGHT: *Principal living areas overlook rear deck.*
FOLLOWING PAGES: *View of the living/dining area and stairs to master bedroom.*

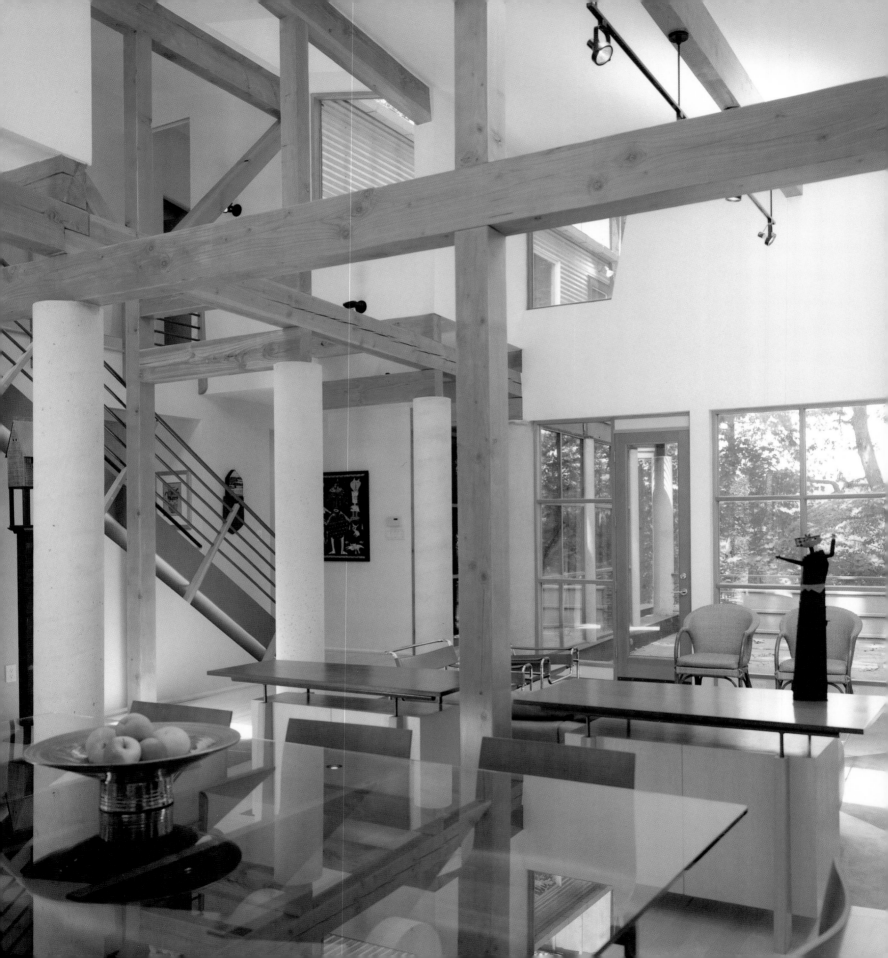

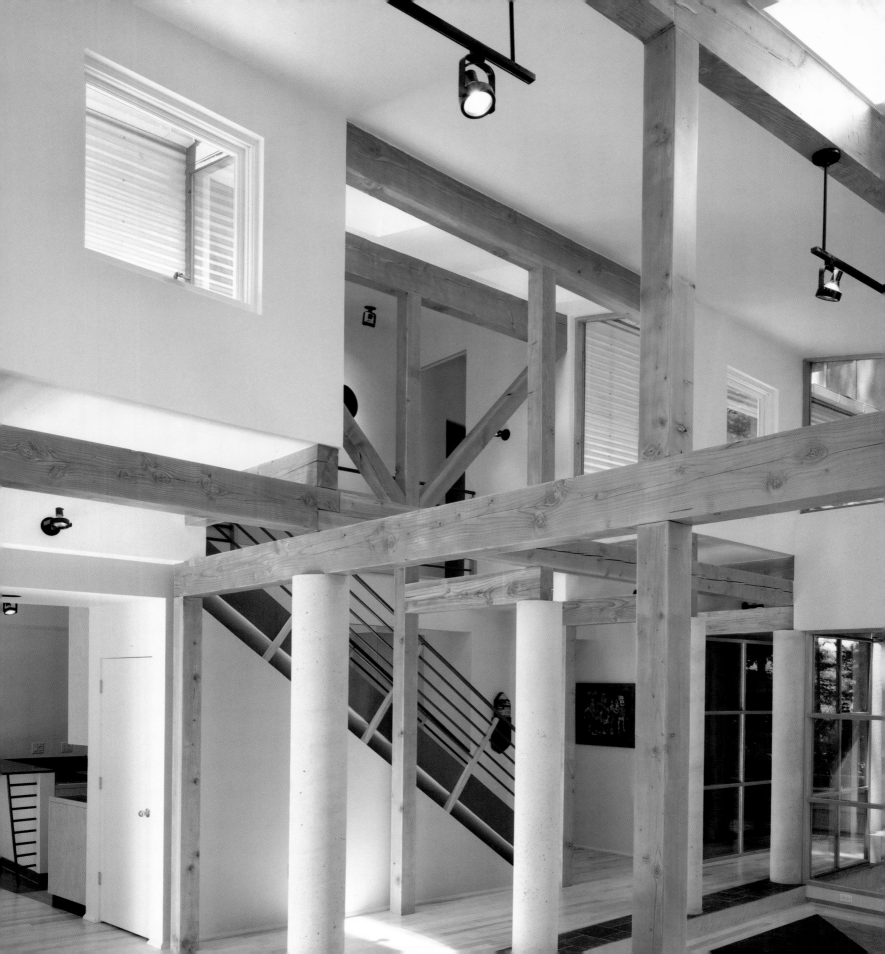

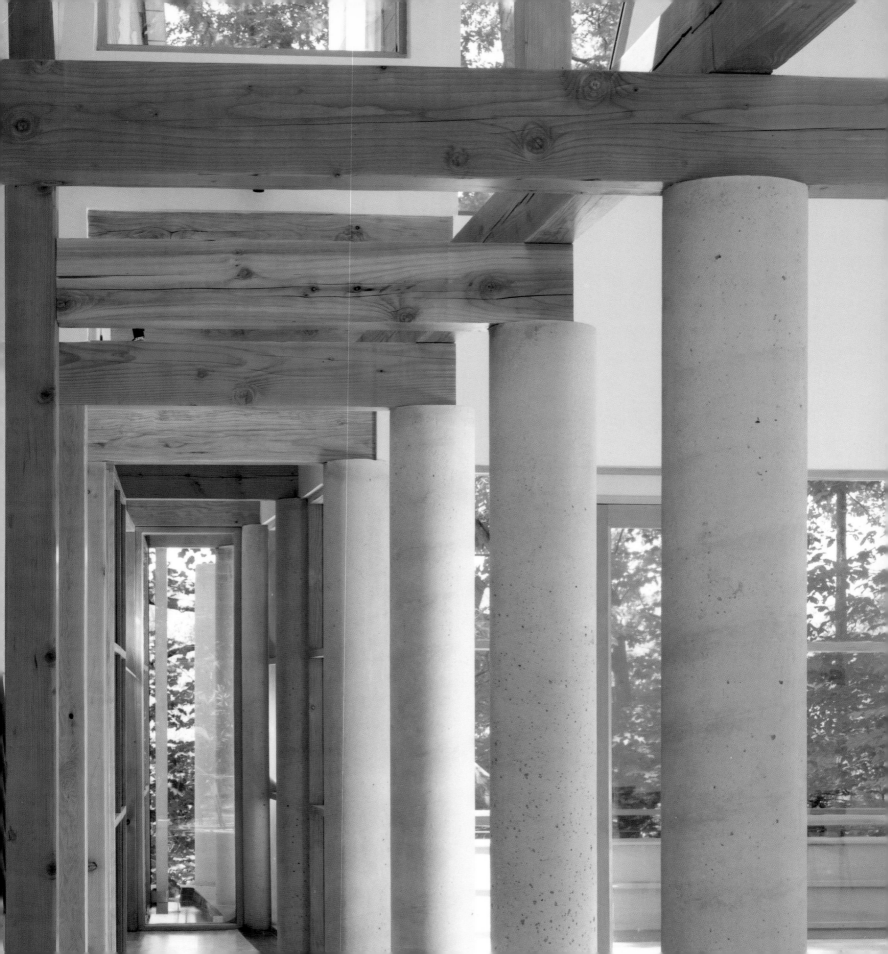

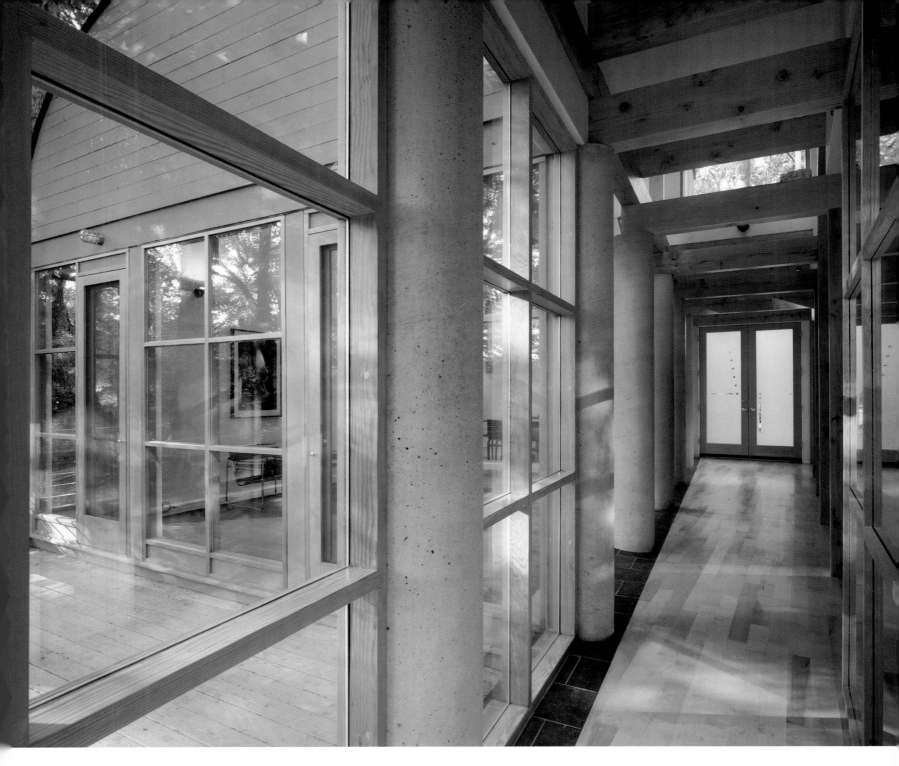

LEFT AND ABOVE: *A row of fourteen concrete columns link the three main zones of the house.*

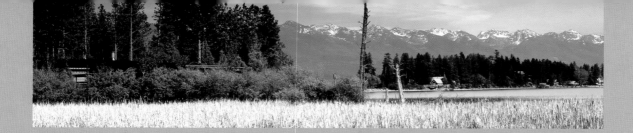

THE POINT

MONTANA

S et on a peninsula that extends into a large western Montana lake, this cottage is part of a year-round family compound and was conceived as the hub of daytime activities as well as a quiet retreat.

Because the site consists primarily of an untouched forest and wetlands that flank the peninsula, a delicate intervention was called for, one that maintained the unspoiled natural beauty of the land while allowing access and enjoyment in the rugged climate with extreme seasons.

Tucked between cedars and pines on the secluded point, the house extends from the rock spring to the edge of the dense wetlands. A long linear wall of Cor-ten steel slices through the site and frames the various building elements. On the northern face two boxes clad in heavy cedar planks contain bathrooms and utilities. The living spaces face south to the lake and open onto a wood deck running the length of the house. The edge separating the inside from the outside is intentionally blurred with tall glass windows and large sliding glass panels.

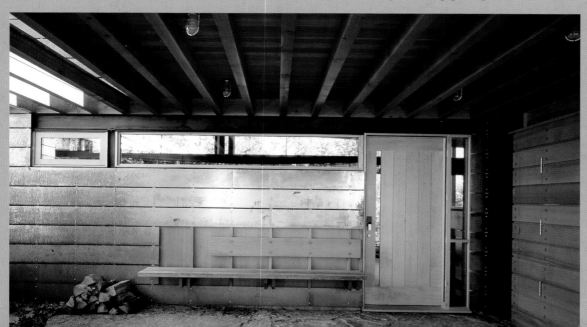

ABOVE: *The peninsula.*
LEFT: *The long deck extends across the living spaces.*
RIGHT: *East façade.*

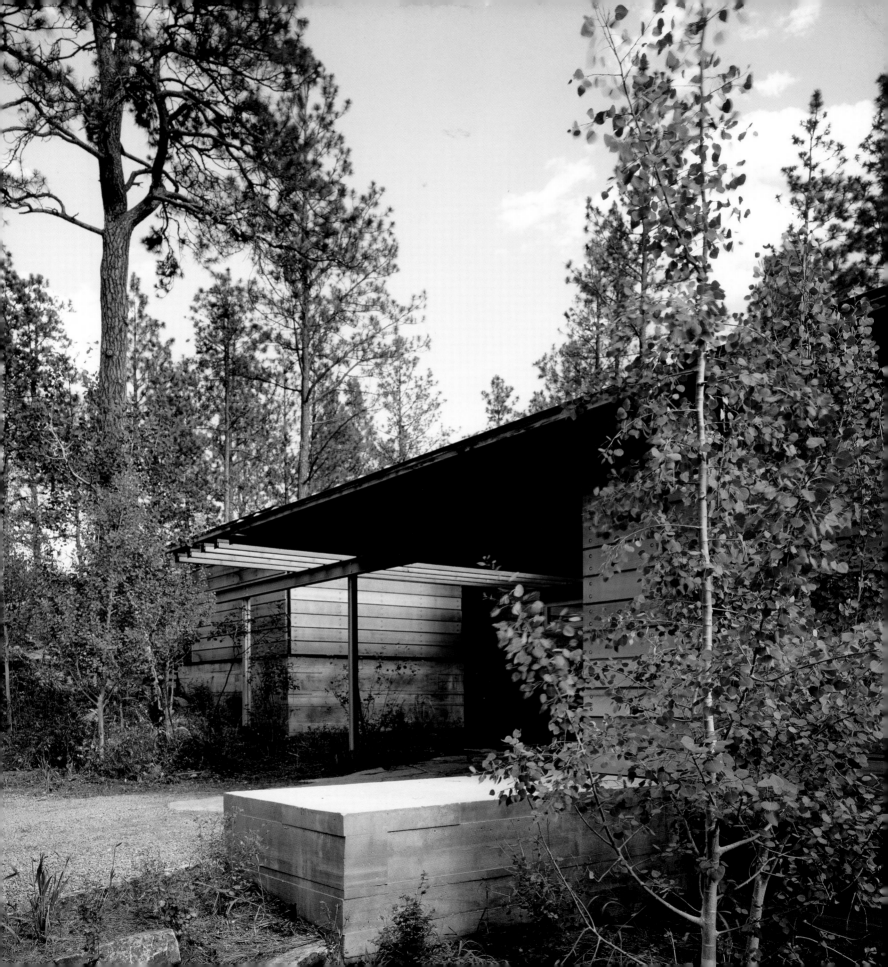

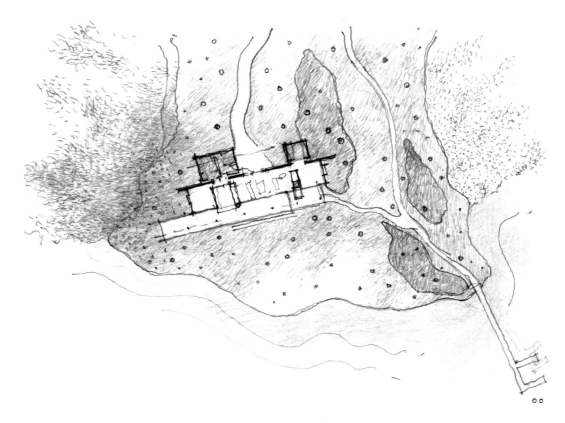

AXONOMETRIC

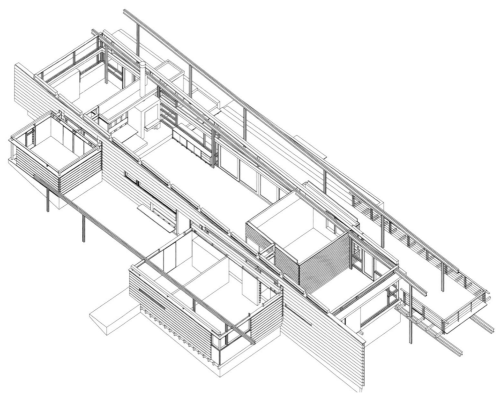

ROOF PLAN

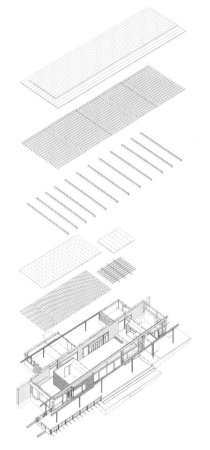

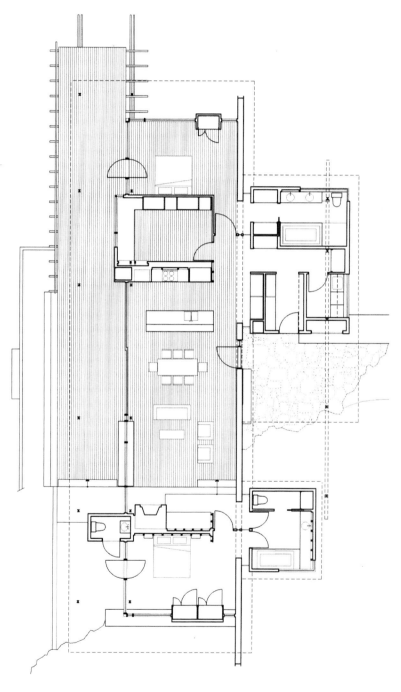

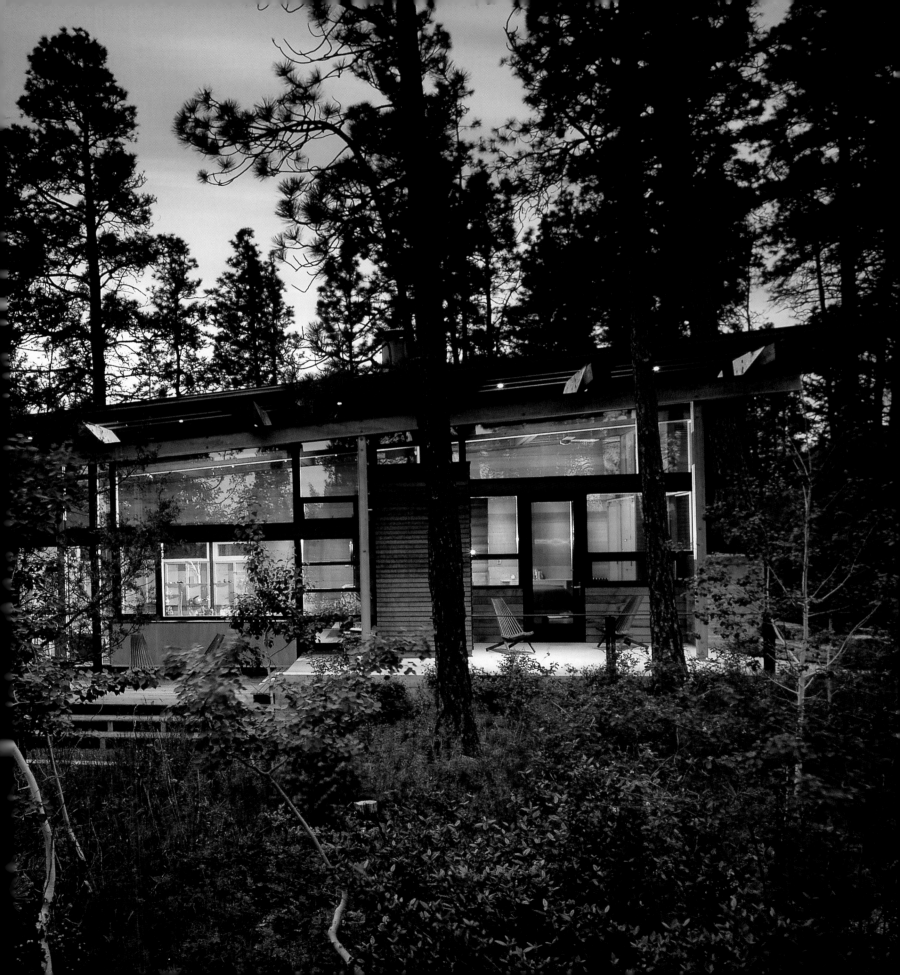

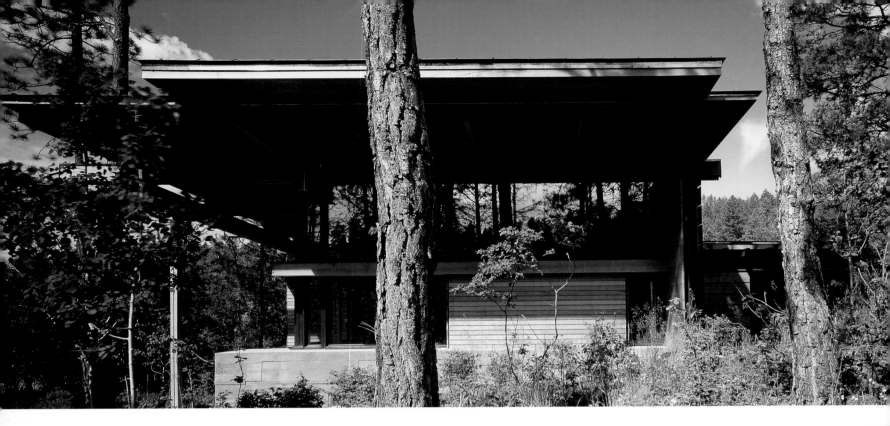

PREVIOUS PAGES: *South façade.*
ABOVE: *East elevation.*
RIGHT: *West elevation.*
FAR RIGHT: *The porch at dusk.*

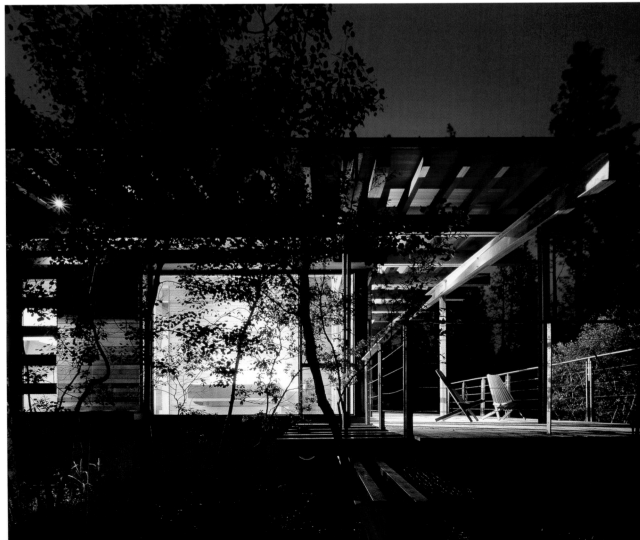

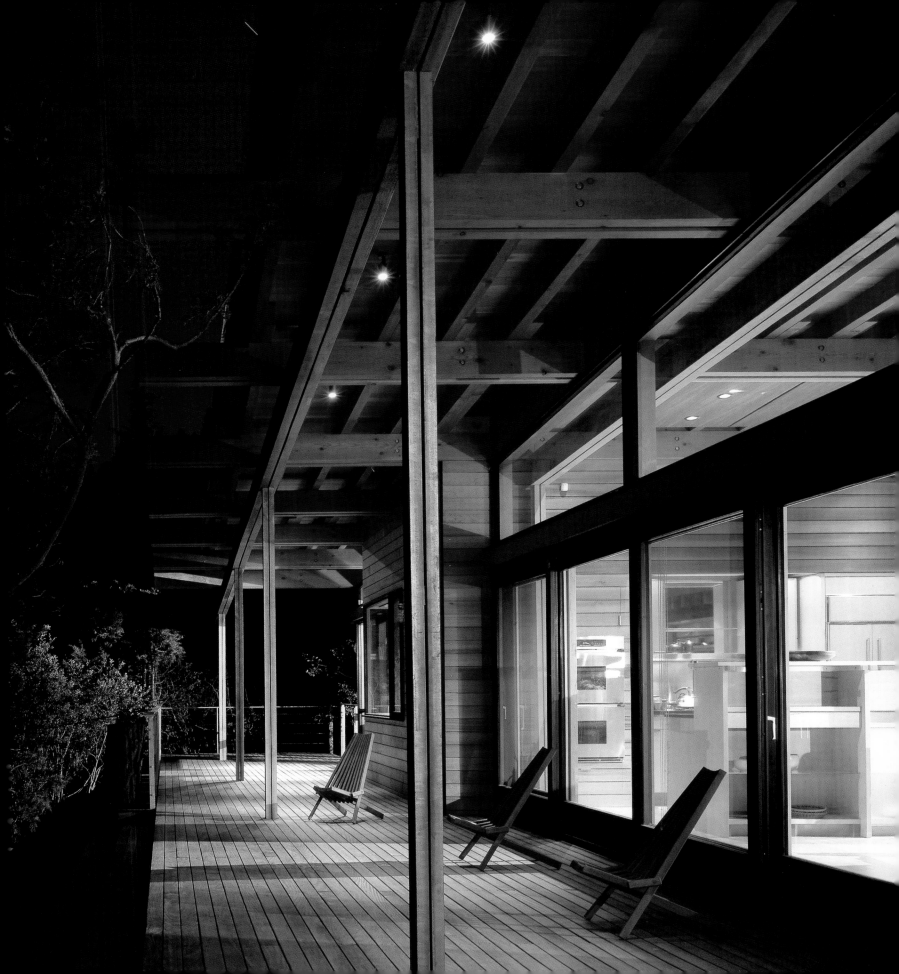

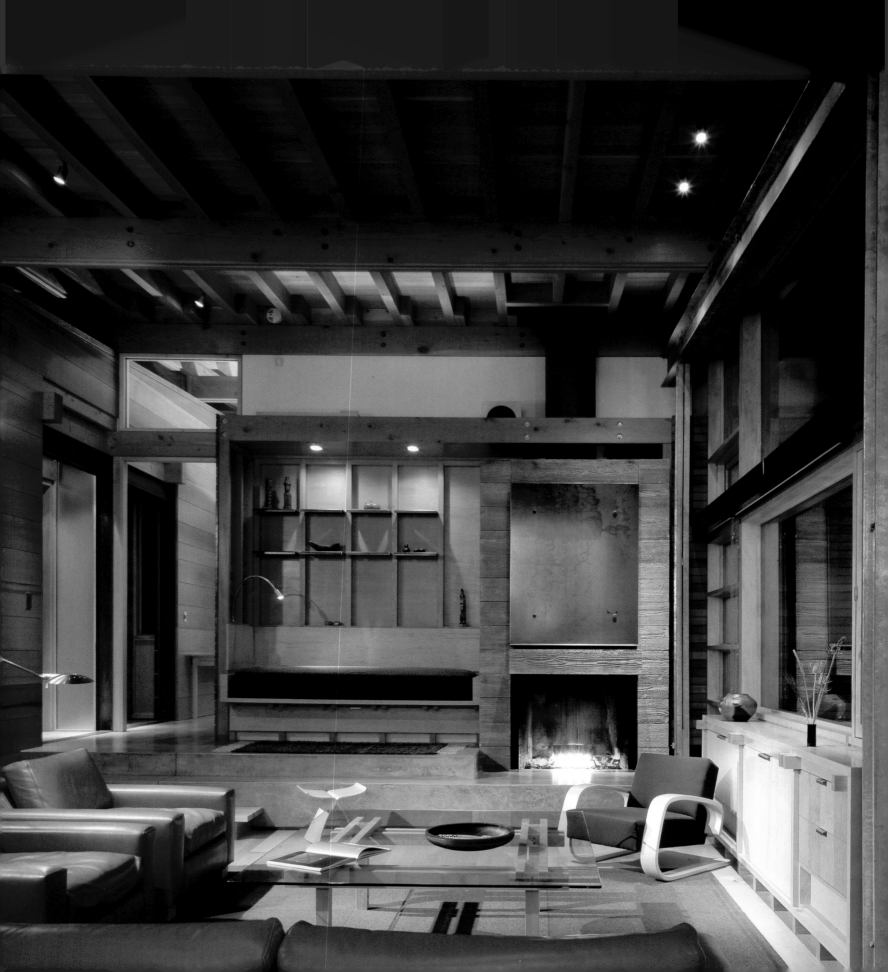

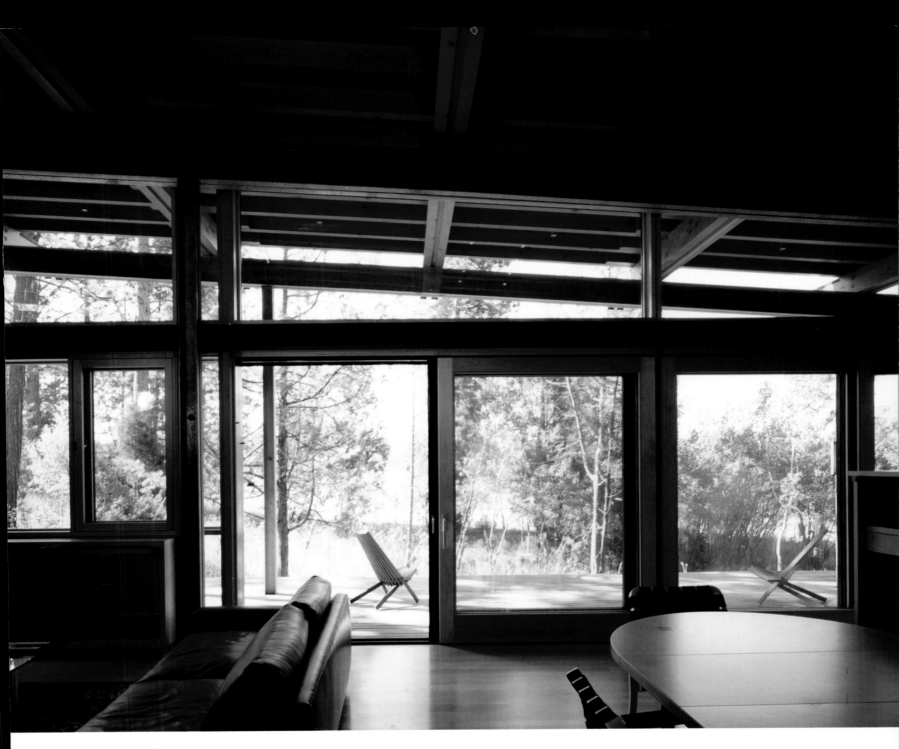

LEFT: *A view of the kitchen from the living room.*
ABOVE: *A view of the porch from the living room.*

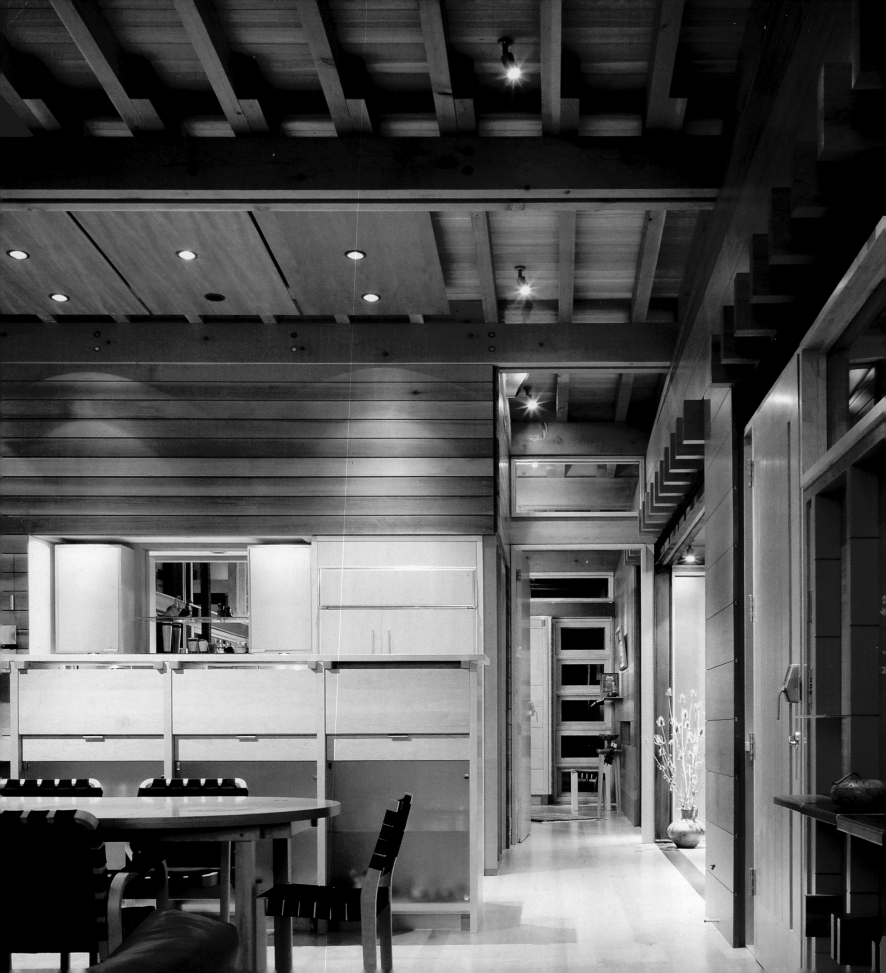

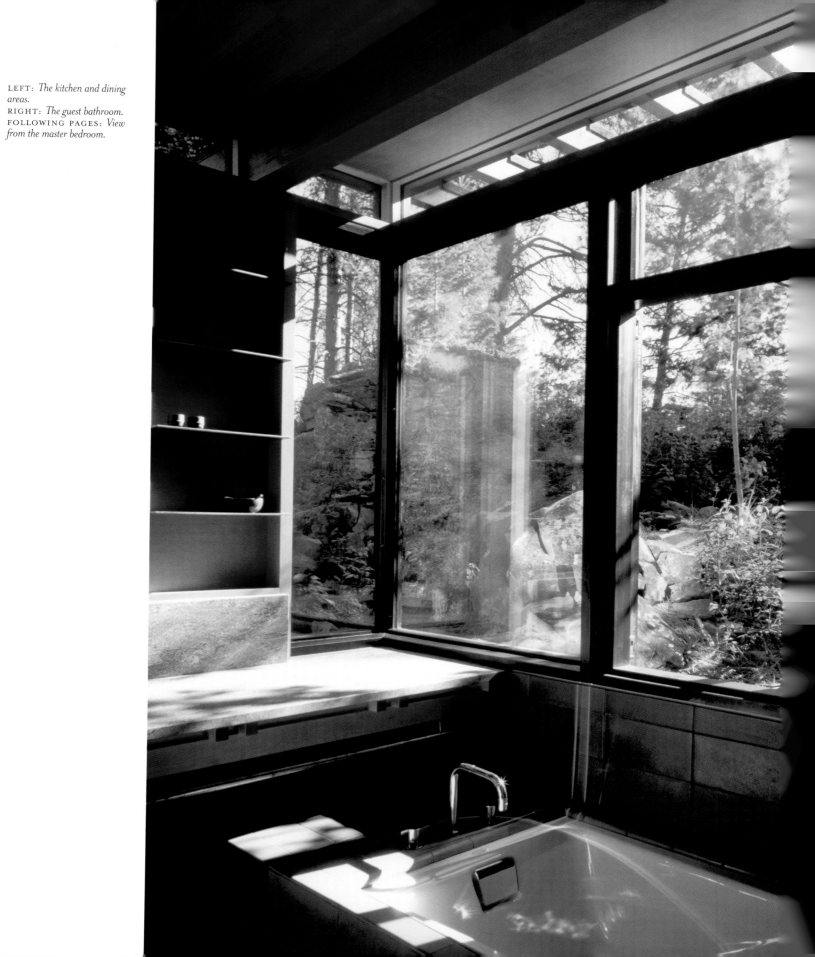

LEFT: *The kitchen and dining areas.*
RIGHT: *The guest bathroom.*
FOLLOWING PAGES: *View from the master bedroom.*

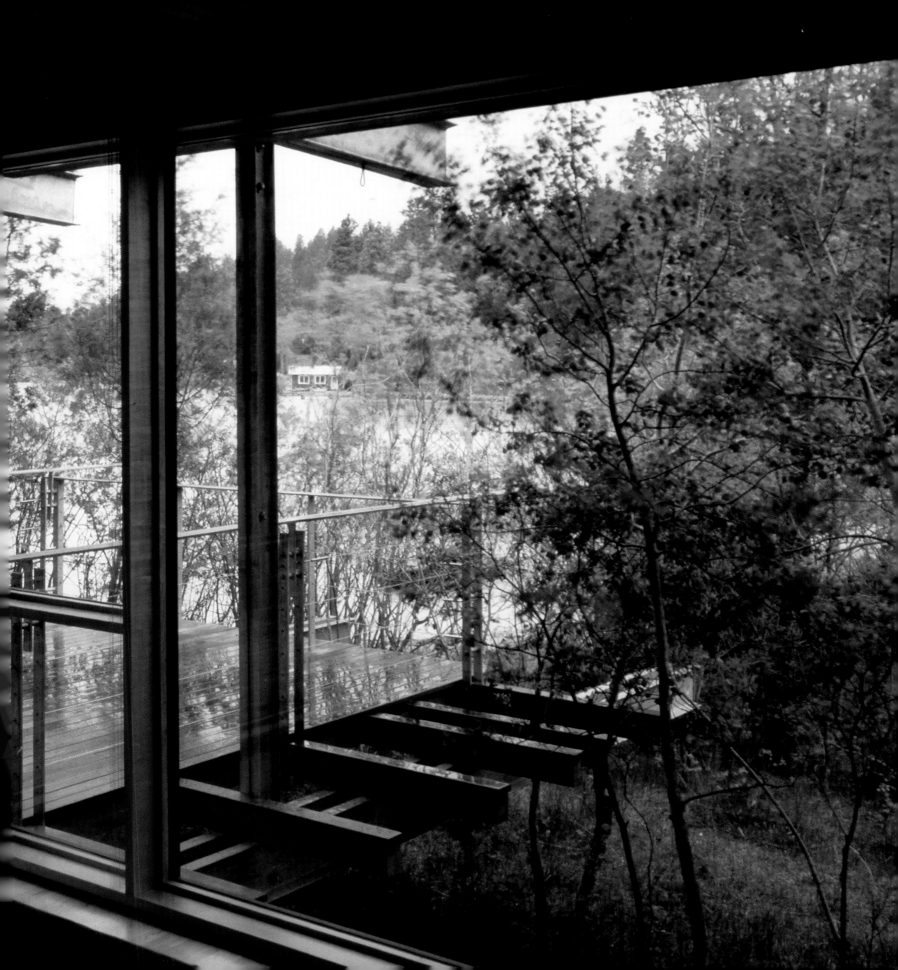

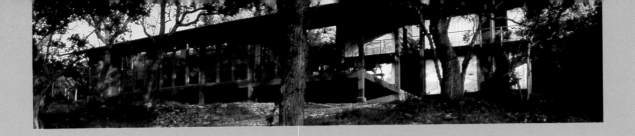

LUCKY BOY RANCH

CENTRAL TEXAS

The program for this modest weekend retreat for a family of four was explicit: maximize the square footage for public spaces by allocating less for private spaces consisting of four bedrooms and two bathrooms. The family also wanted the house to maintain a strong link with the environment and to rely on natural cooling and heating techniques.

The resulting design revolves around a massive two-story entry porch that provides a link between the pubic and private spaces and operates as the family's central entertaining and "camp-fire" site. A two-story, metal-siding bunkhouse is bisected with "dog run" openings that frame hillside views and channel cross-ventilation breezes. Balconies from the bedrooms overlook the entry porch.

A sandstone wall anchors timber framing for the great room. Timber-framed bays hold clad double-hung windows that capture east-to-west river views and provide cross ventilation assisted by clerestory windows.

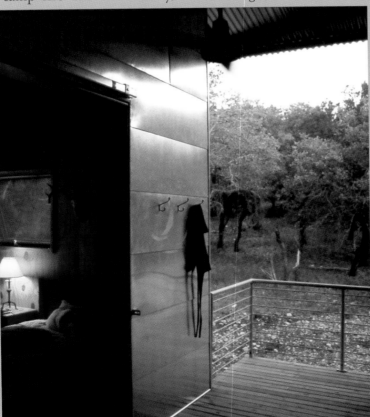

ABOVE: *The dwelling blends harmoniously with its natural surroundings.*
LEFT: *A view through the "dog run" in the bunkhouse.*
RIGHT: *The entry porch.*

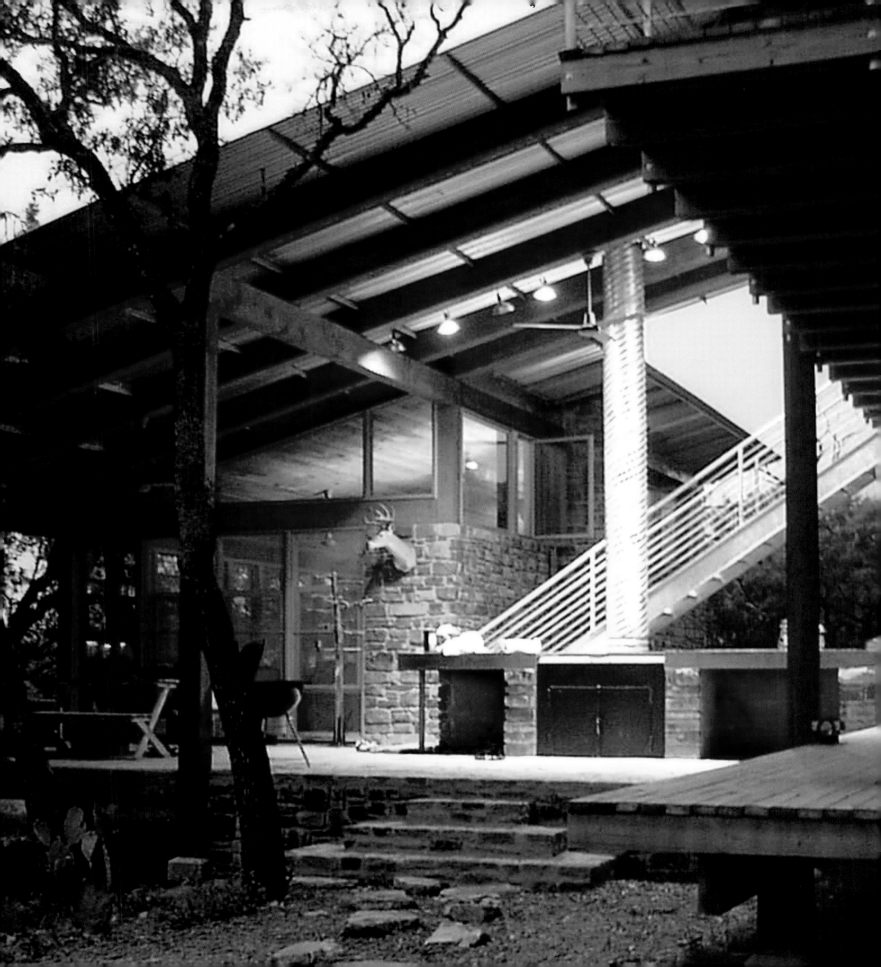

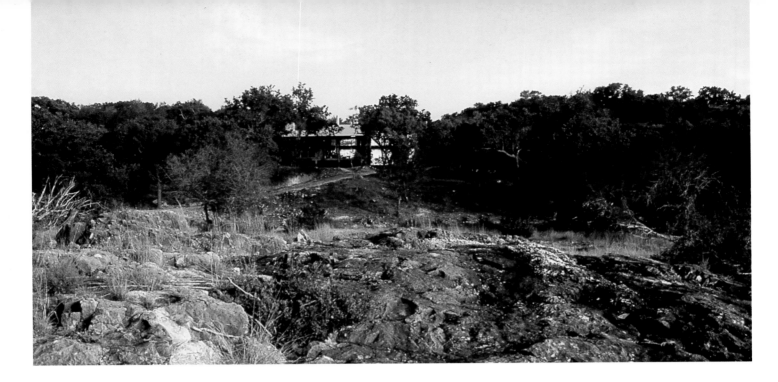

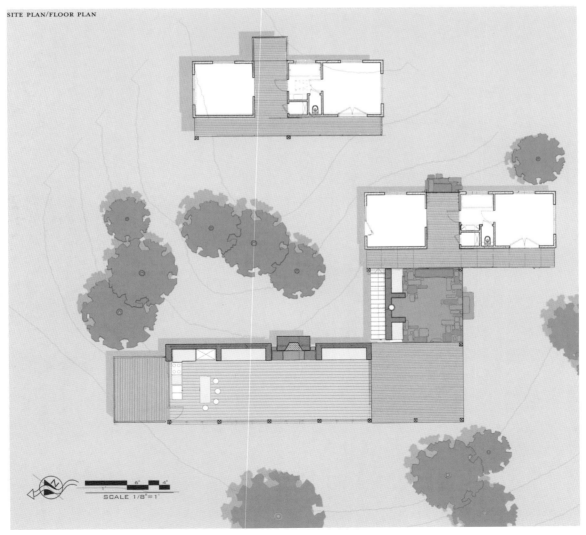

ABOVE: Entry to the property.
RIGHT: A view of the entry porch with the adjacent metal–clad bunkhouse.

SCALE 1/8"=1'

RIGHT: The "dog runs" have balconies at either end.
FAR RIGHT: The "dog runs" allow for cross ventilation.

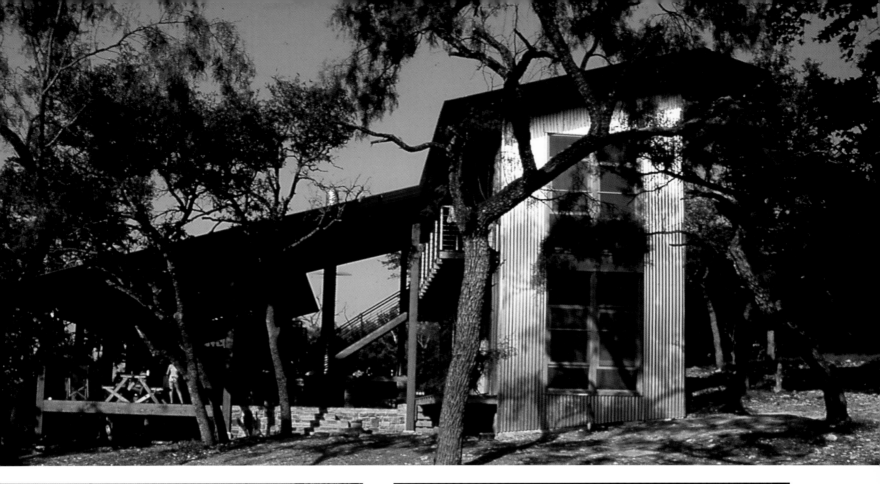

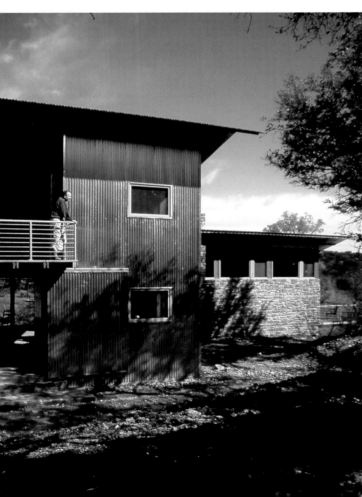

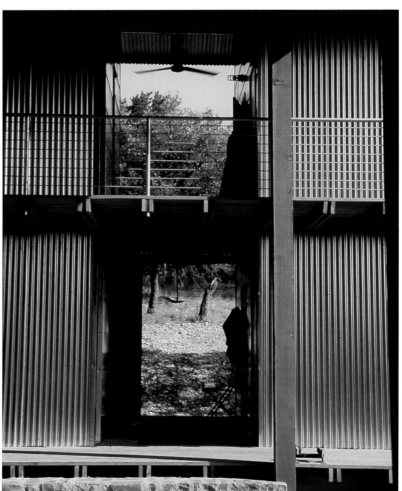

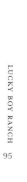

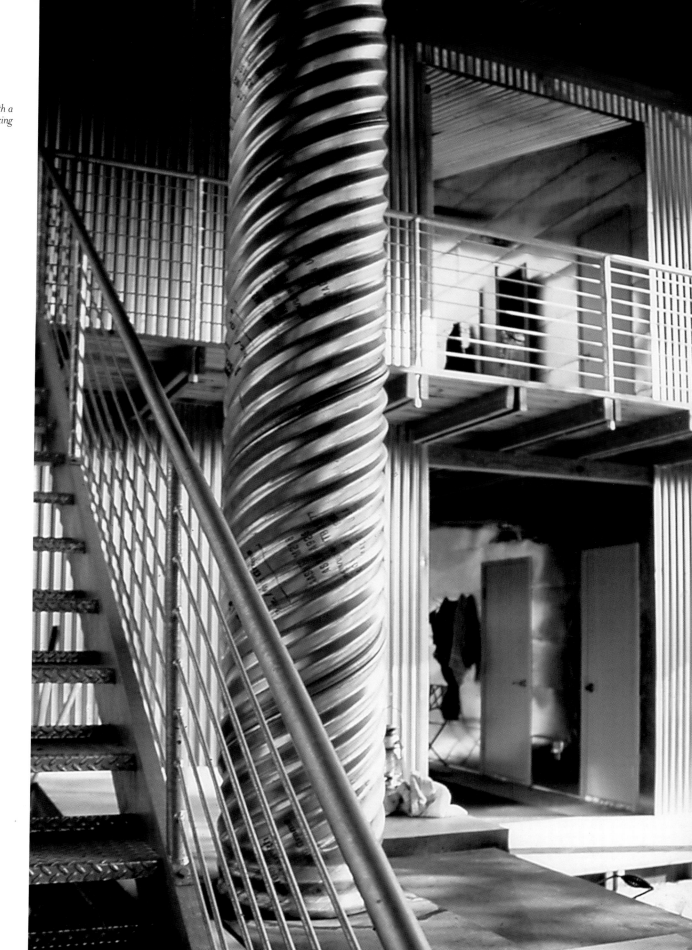

LEFT: *Entry porch.*
RIGHT: *The bunkhouse as seen from the entry porch with a smoke stack for outdoor cooking in the foreground.*

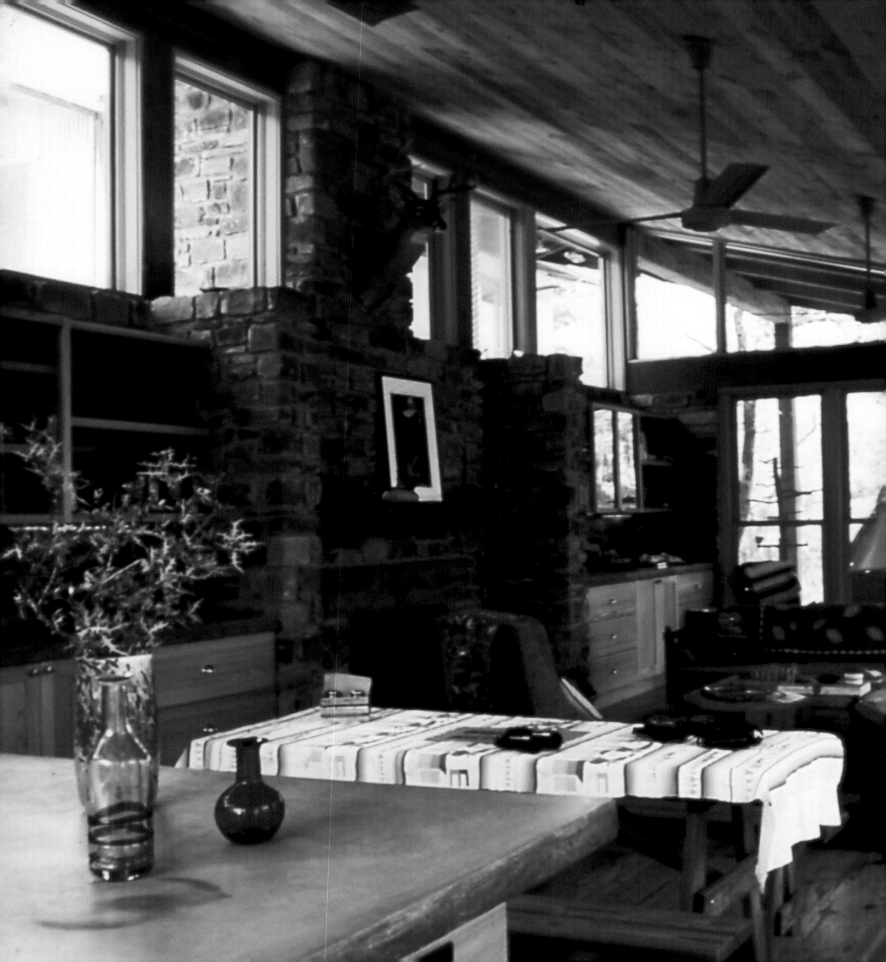

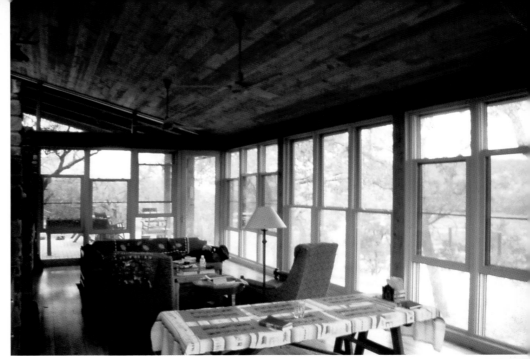

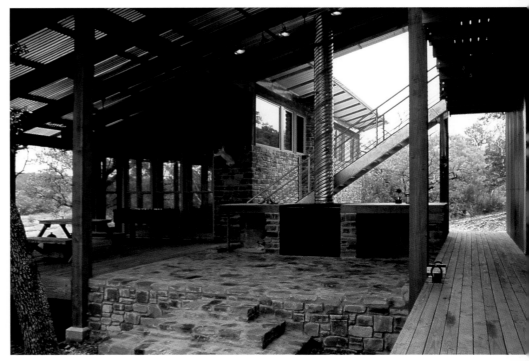

LEFT AND TOP: *Interior of the great room.*
ABOVE: *The great room as seen from the entry porch.*

COTTAGES: THE NEW STYLE

100

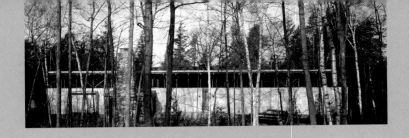

GEORGIAN BAY RETREAT

ONTARIO, CANADA

This retreat north of Toronto on Georgian Bay called for a modernist structure that celebrates its natural surroundings. The site slopes down through a forest of mature birch trees. A dense band of evergreens borders the rocky shore of the bay.

A series of layers heightens the experience of moving through the site and house. The driveway winds through the forest to the house. Visitors are greeted by a white-stained cedar plank wall that reflects the whiteness of the birch trees. The log and stone fireplace alcove and entry door are the only interruptions to this wall. Passing through the entry, an evergreen forest and the bay are revealed through large expanses of glass that make the sloping landscape an extension of the open plan. Interior walls exist only to define more private spaces and appear as independent volumes within the post-and-beam structure.

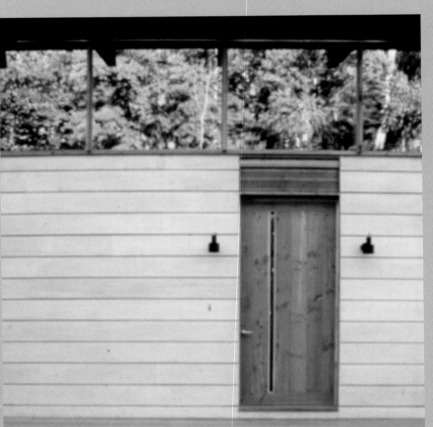

ABOVE: *A continuous white wall greets the visitor.*
LEFT: *The entry passes through the white wall.*
RIGHT: *West elevation.*

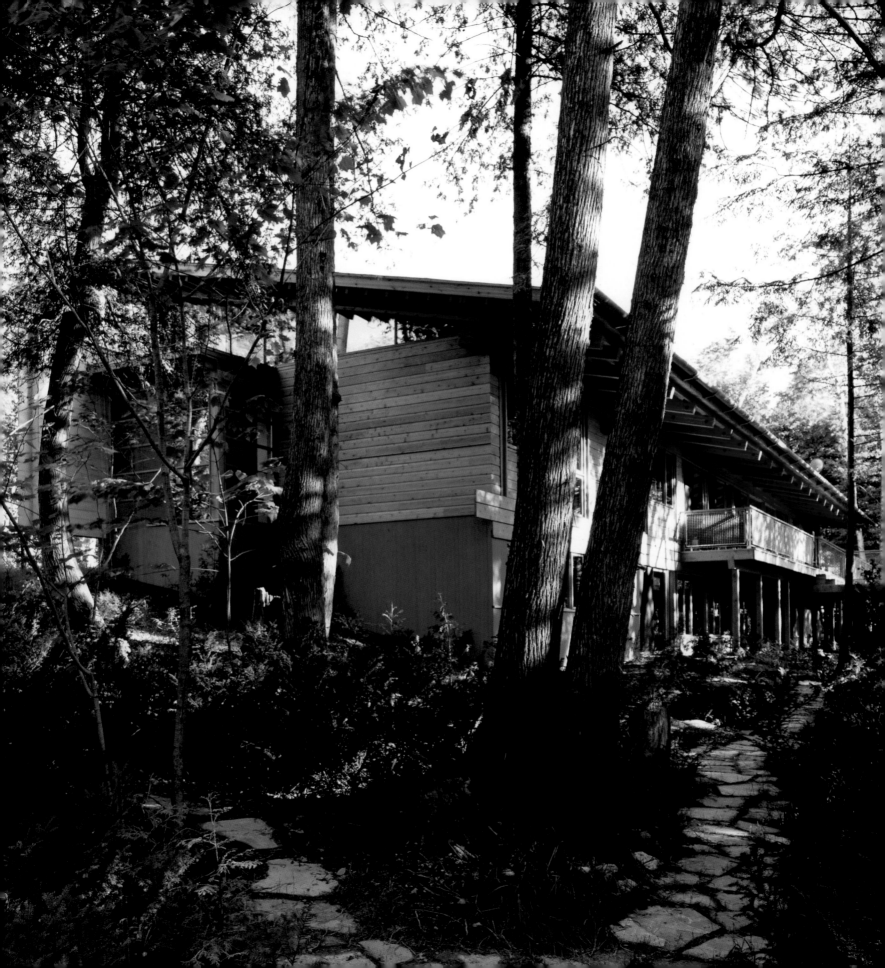

'99

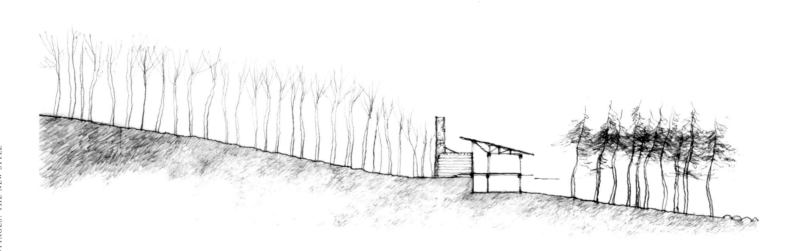

NORTH ELEVATION

FIRST FLOOR

SOUTH ELEVATION

GROUND FLOOR

WEST ELEVATION

EAST ELEVATION

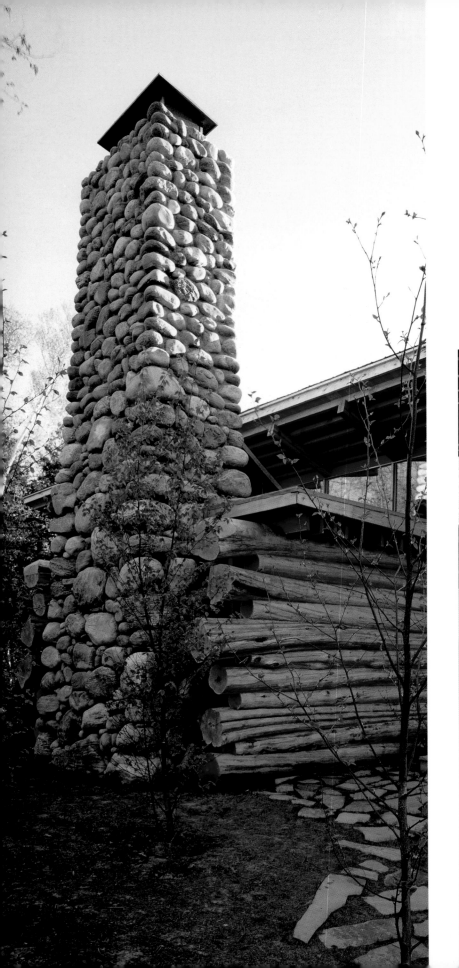

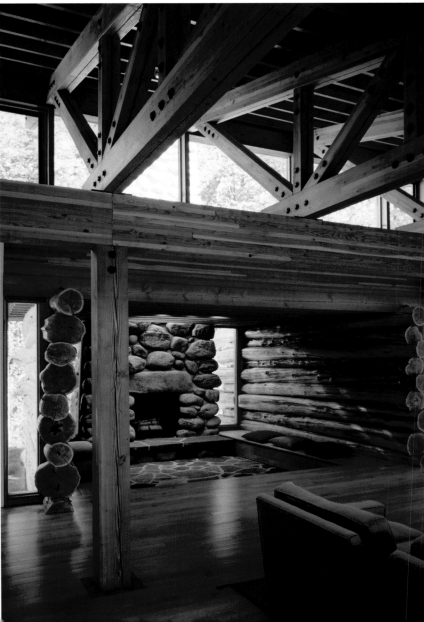

LEFT AND BELOW: *Interior and exterior views of the stone and log fireplace.*
RIGHT: *Corridor with fireplace alcove on the right.*

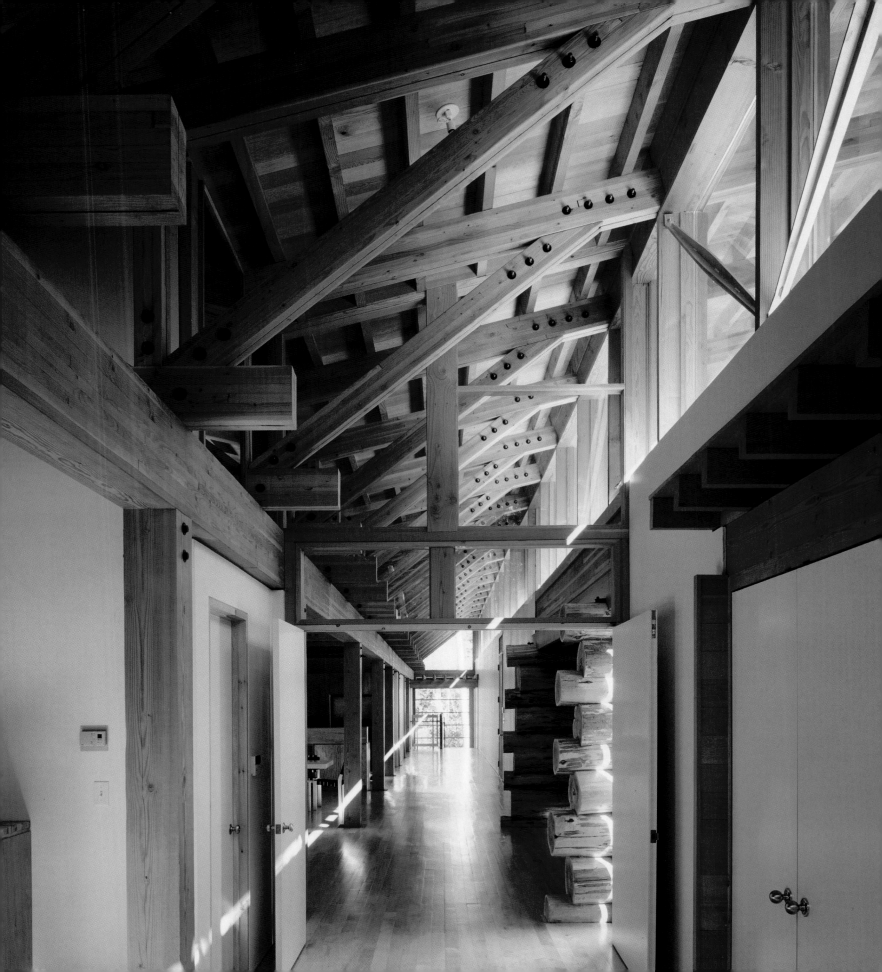

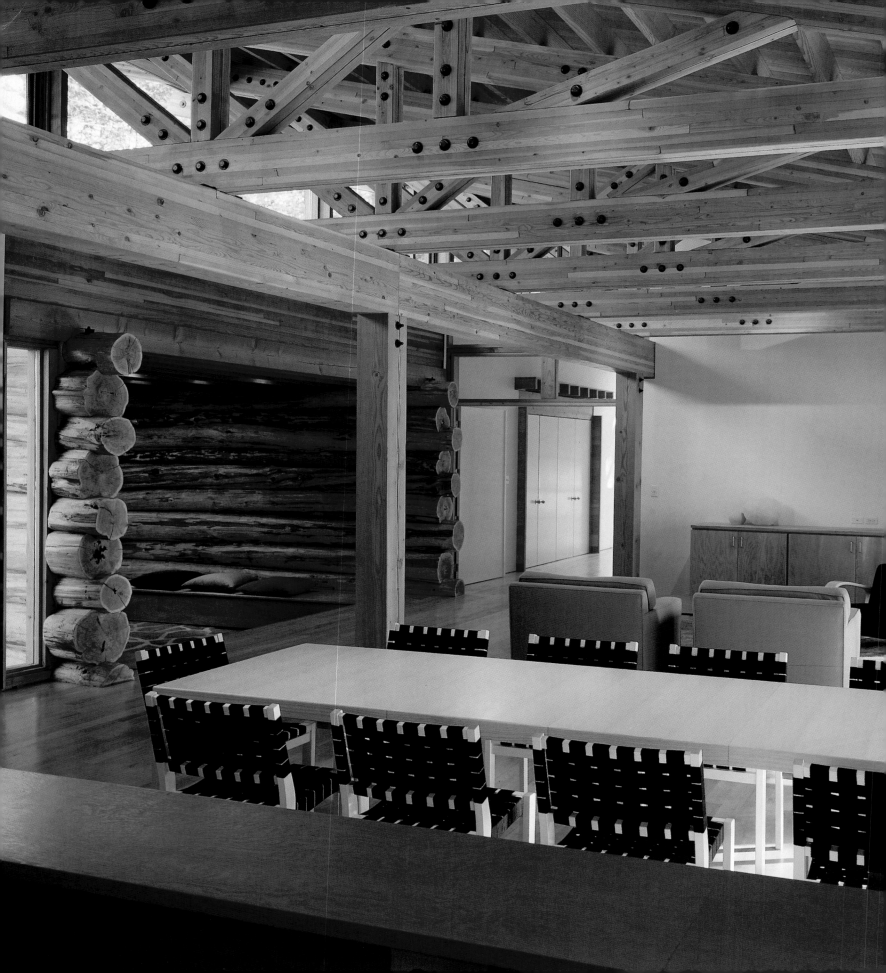

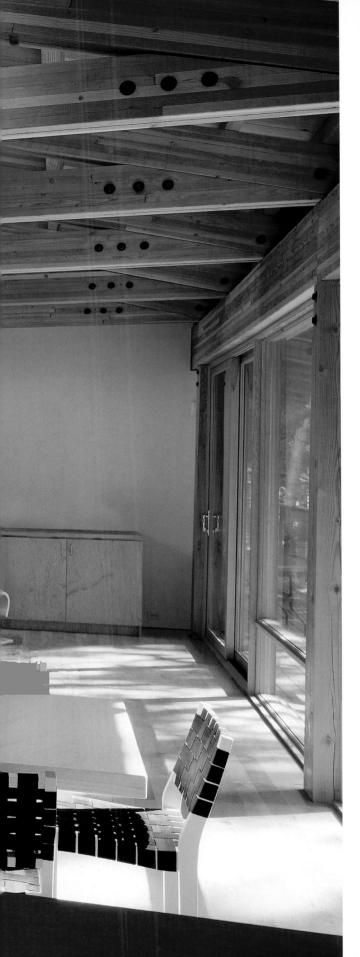

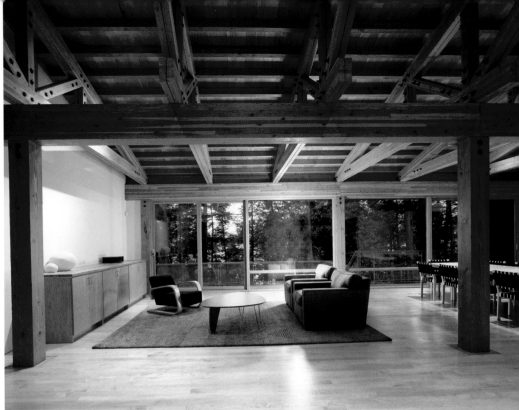

LEFT: *Living and dining area.*
ABOVE: *Living area with view of bay.*

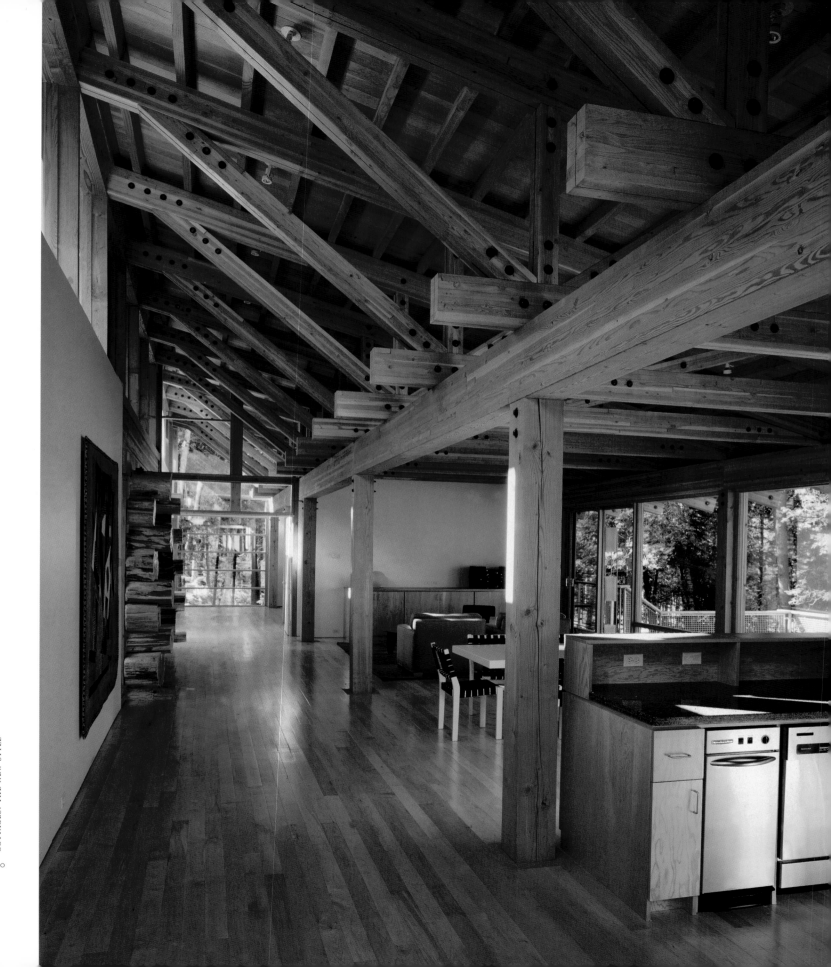

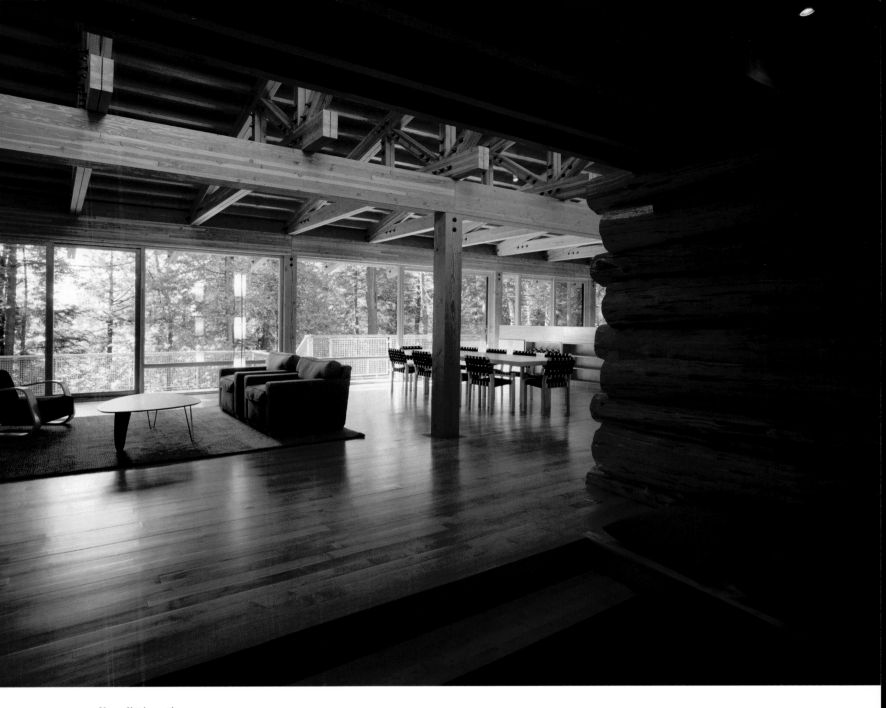

LEFT: *View of kitchen with living and dining area beyond.*
ABOVE: *Living and dining area.*
FOLLOWING PAGES: *South elevation at dusk.*

WITHERS COTTAGE

ACCOKEEK, MARYLAND

Art was the driving force behind the design for this contemporary cottage on a wooded ten-acre site in rural southern Maryland. The client, a professor of art history who grew up in a house designed by the noted Modernist landscape architect Dan Kiley, had two requirements—a simple cabin in the woods in the spirit of the Kiley house, and the proper setting for a commissioned artwork, a "sun drawing" by artist Janet Saad Cook.

The cabin consists of two asphalt-shingled, tightly functional wings for the bedrooms and bathrooms. These wings are joined by a metal-and-glass room with a second-story bridge that connects them. This two-story room contains the living, dining, and kitchen areas and is designed specifically for Saad Cook's art work, a "sun drawing" that projects reflected images, which change with the movement of the sun and clouds, onto the billboard-like wall. Bands of windows at the top and bottom of this wall brings south light into the two-story space.

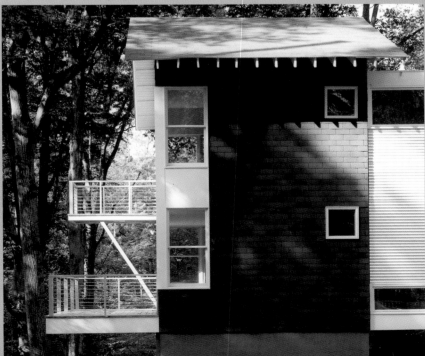

ABOVE: *The "sun drawing" by Janet Saad Cook.*
LEFT: *The exterior surface consists of black asphalt tile and metal siding.*
RIGHT: *The house cantilevers over its sloped wooded site.*

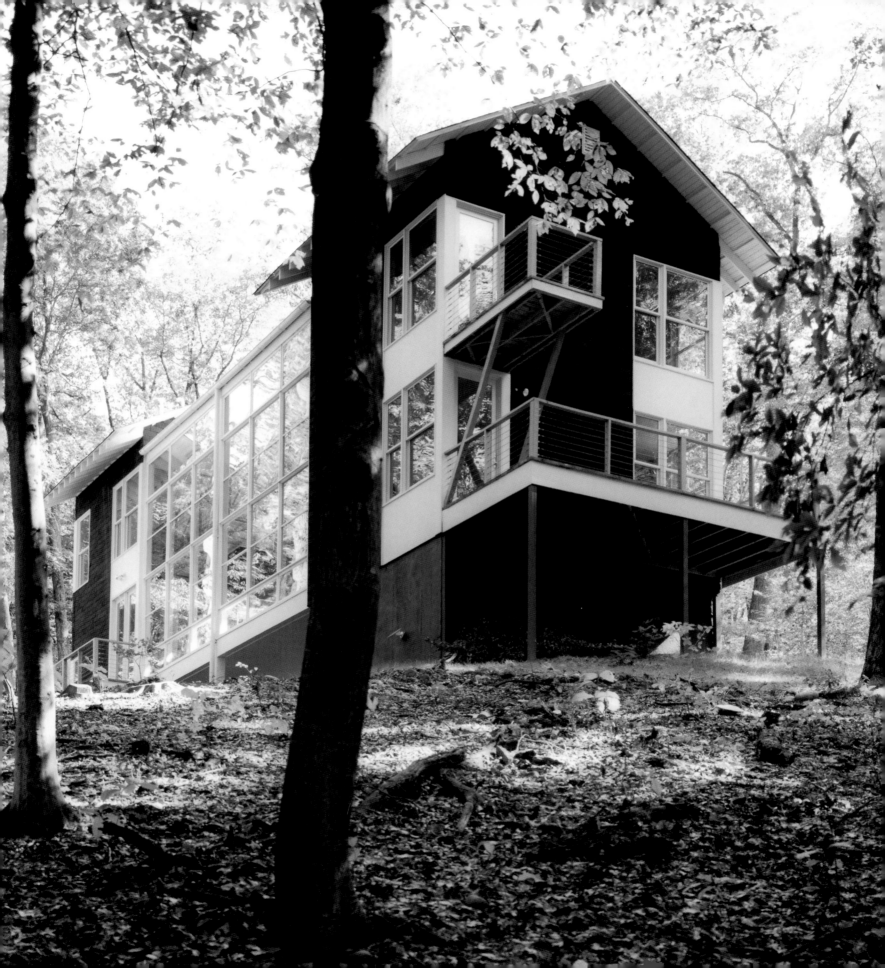

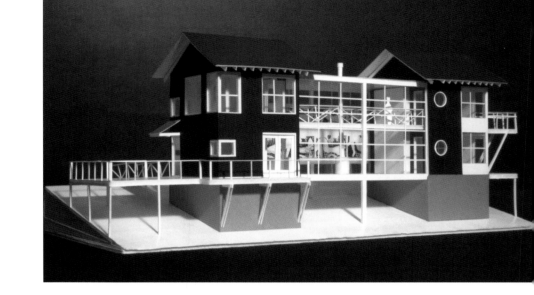

STUDY DRAWING

MODEL

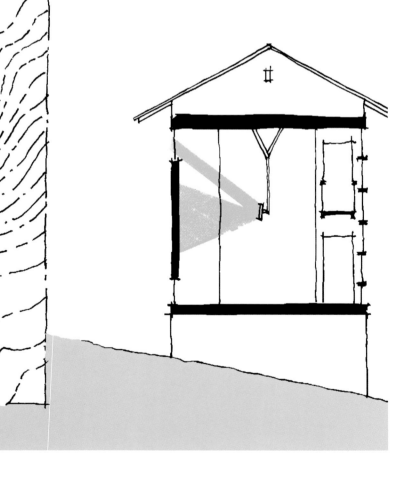

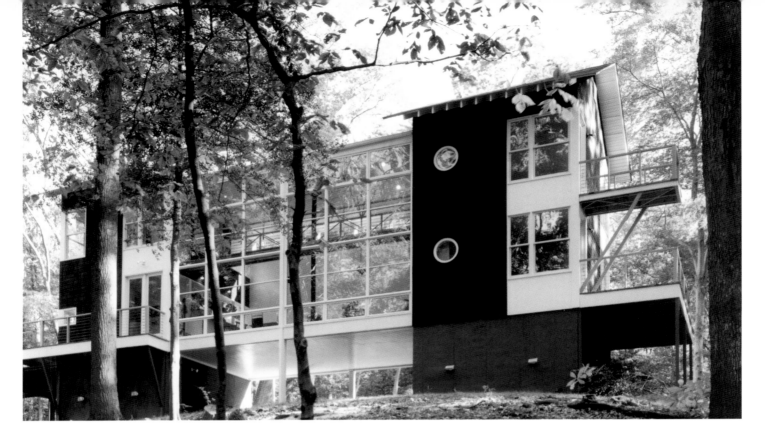

ABOVE: *North elevation.*
FOLLOWING PAGES: *South elevation.*

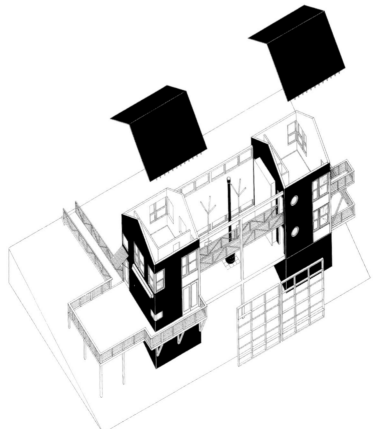

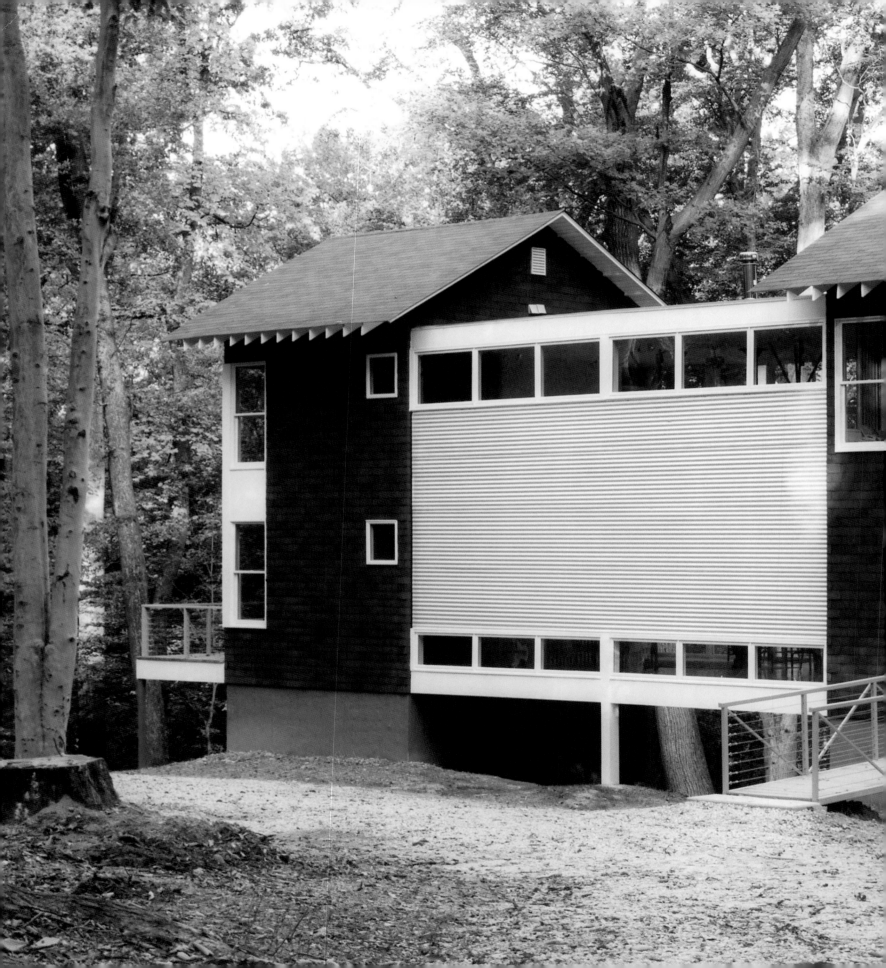

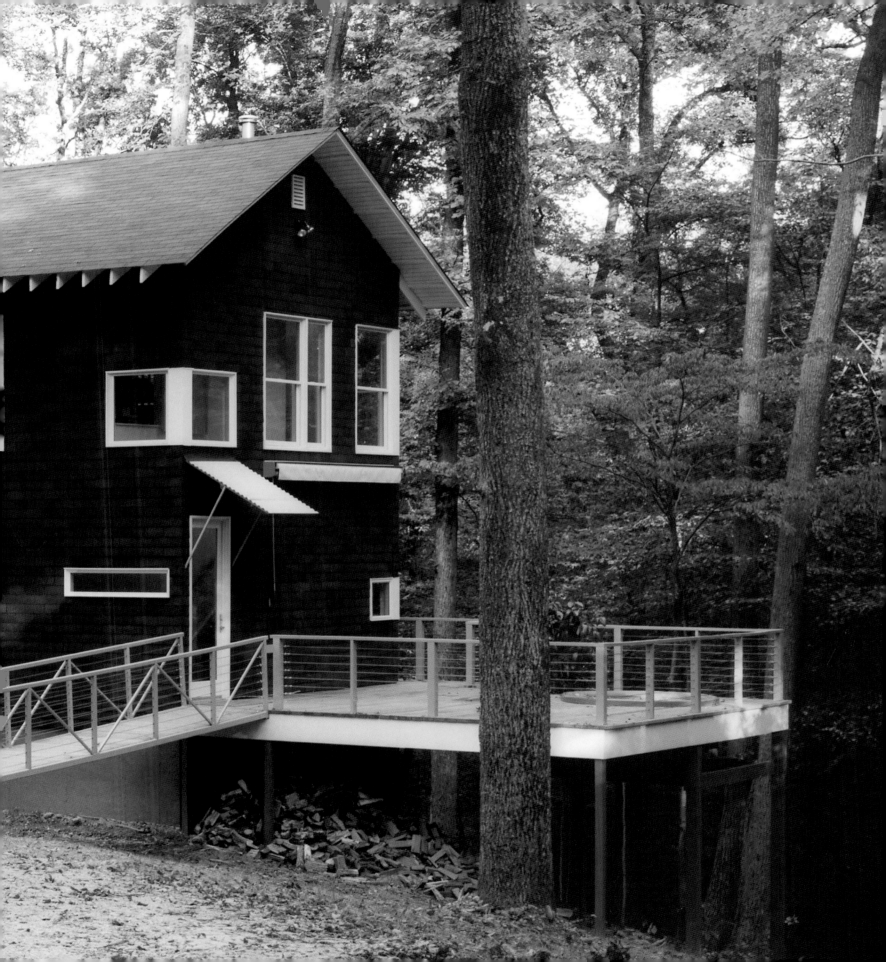

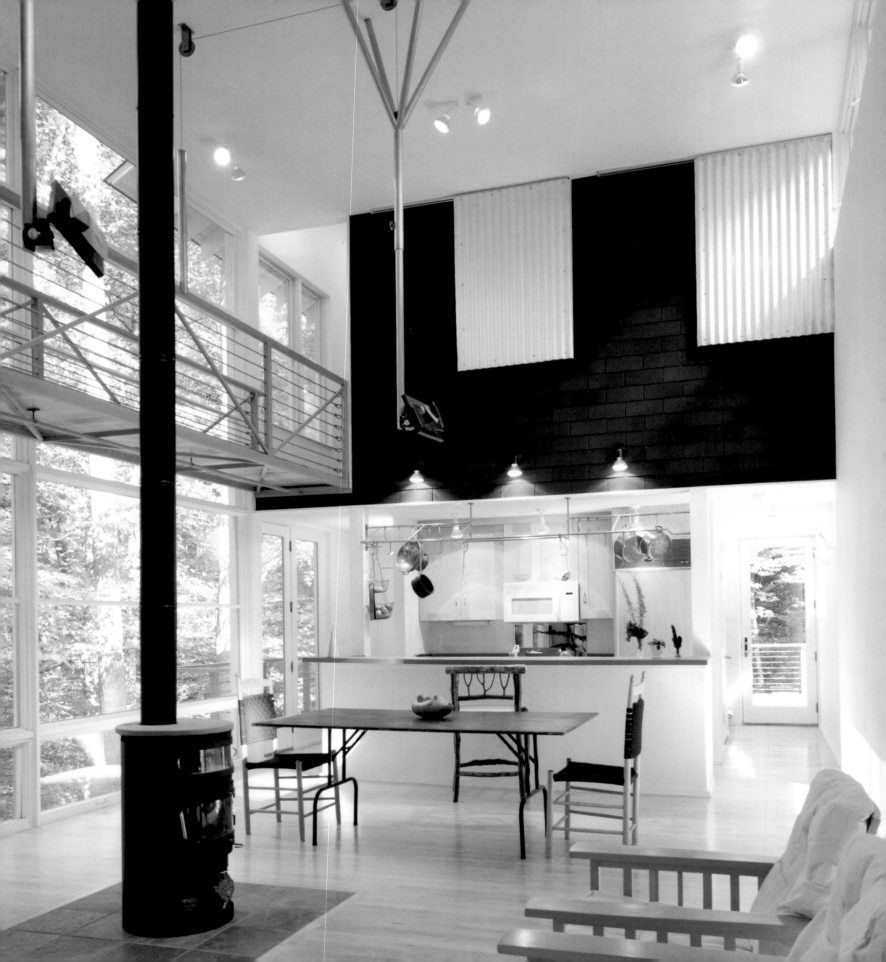

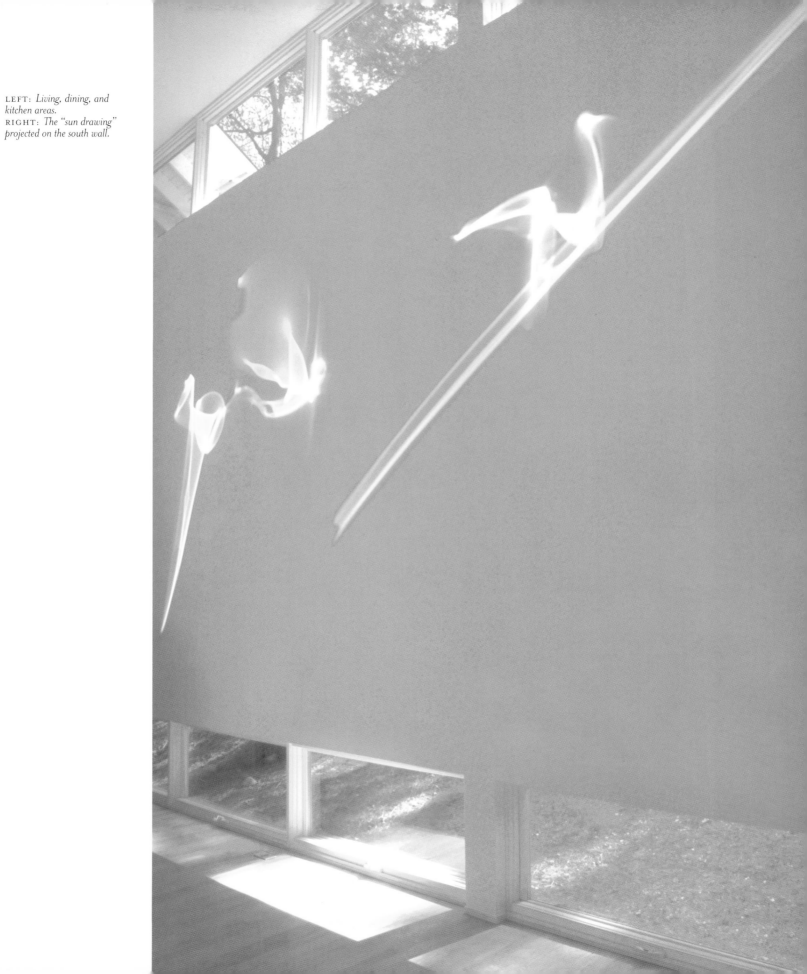

LAKESIDE CABIN

IDAHO

The nineteen-foot-tall steel entry door provides the first clue that this is no ordinary vacation cottage even though the modest building materials—concrete block and plywood—would suggest otherwise. Entering through this dramatic portal and into the twenty-two-foot-high living room, one feels instantly transported outside again for directly ahead is a massive pivoting steel-and-glass window that provides an unobstructed panoramic view of the lake and hills in the distance. It measures twenty-by-thirty feet and, like a garage door, is flipped open by a mechanical device that the architect calls "the Gizmo." Outside the window is a concrete terrace complete with a built-in hot tub.

A large plywood balcony that connects to the master bedroom suite is suspended over the kitchen. It is accessed via a stair at the entry. The island in the long, stainless steel kitchen is extended to create a generous dining table. On the main level there are also a guest room and a bunk room for the children. In all, the cabin, which is only 2,600 square feet, can comfortably sleep ten people.

In keeping with the industrial, raw quality of the cottage, the floors are polished concrete, and a four-feet-in-diameter steel pipe that has been fashioned into a fireplace also serves as a structural component.

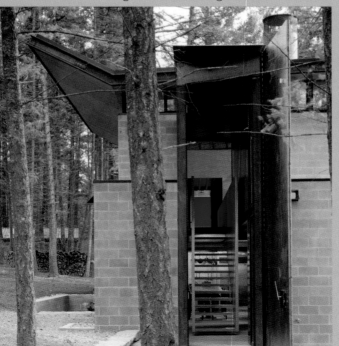

TOP: *The site affords commanding views of the lake and hills beyond.*
LEFT: *The entry with steps to the master bedroom.*
RIGHT: *The cottage as viewed from the lake at dusk.*

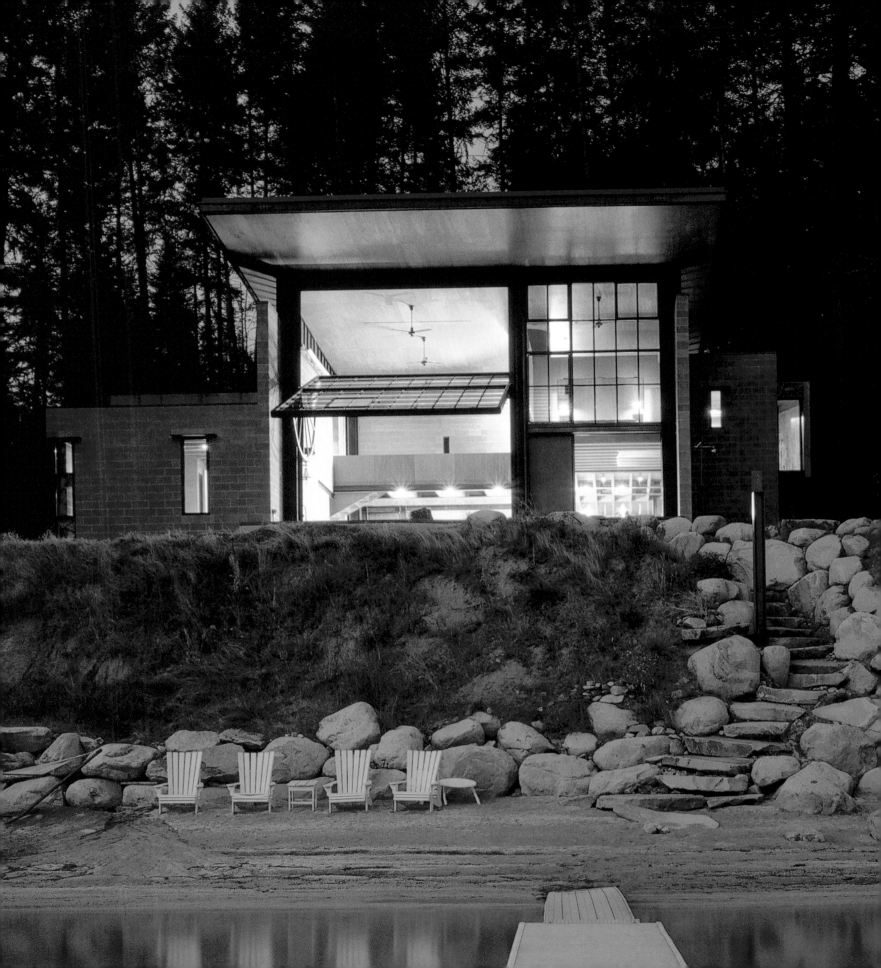

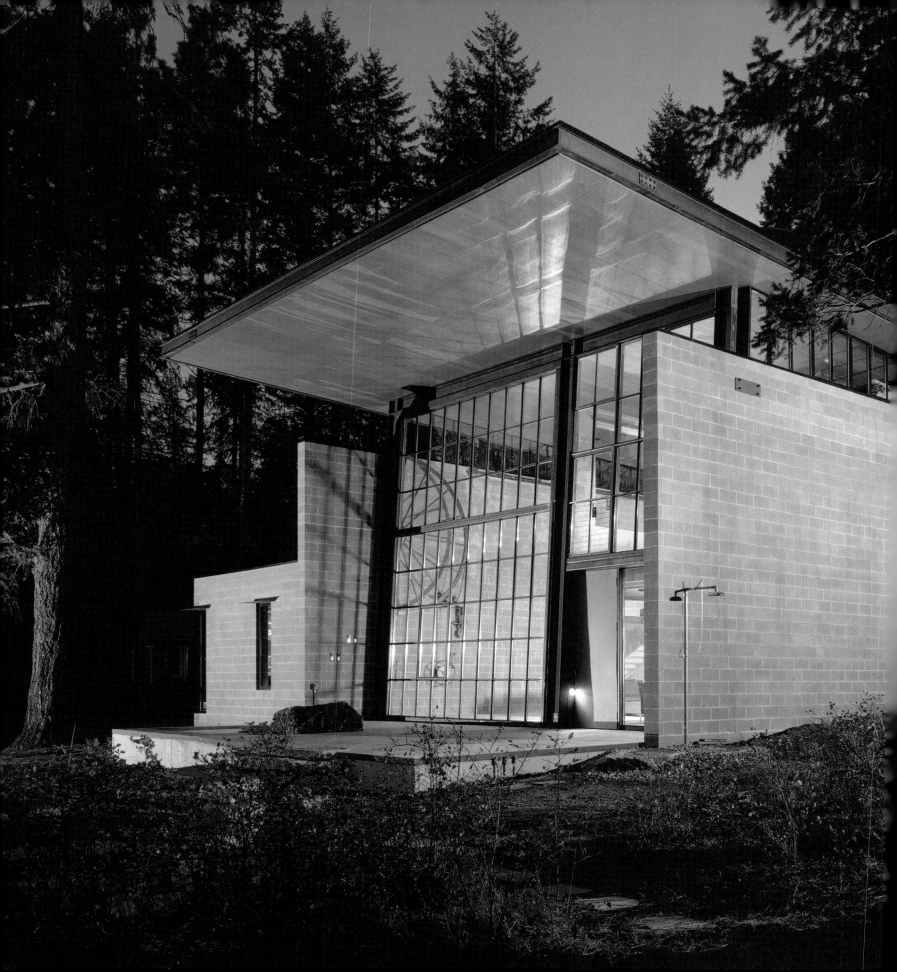

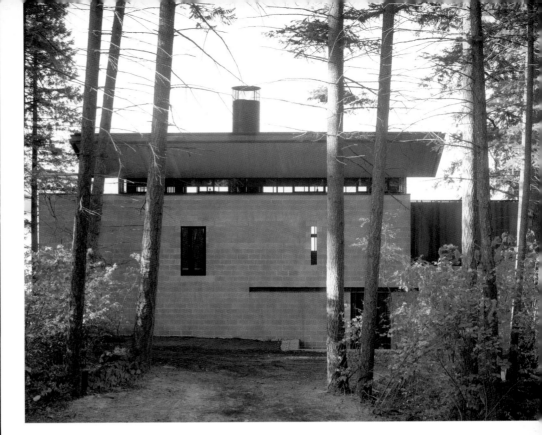

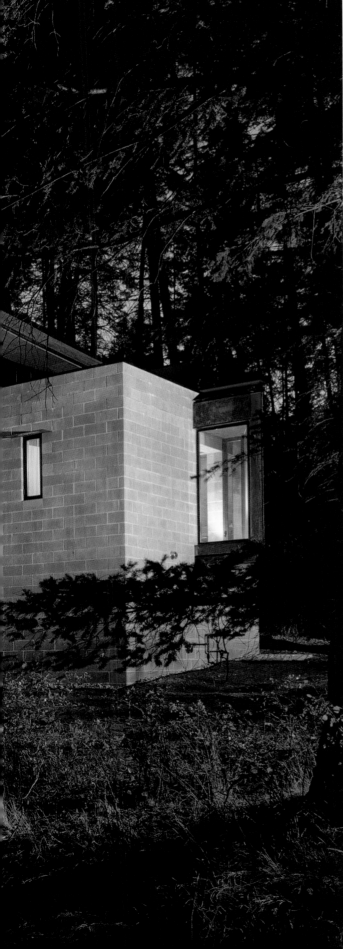

ABOVE: *North façade.*
LEFT: *South façade.*

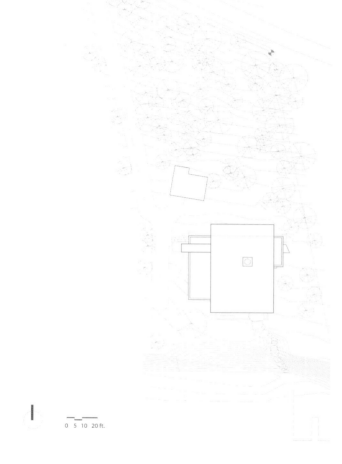

0 5 10 20 ft.

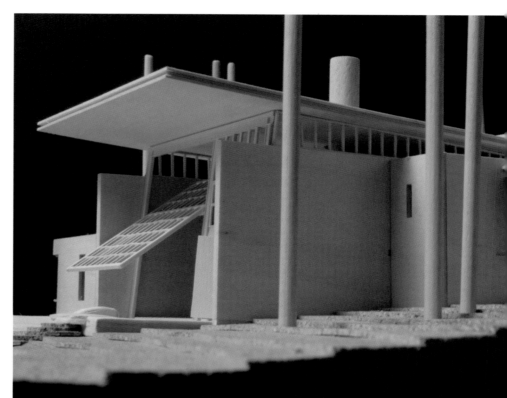

ABOVE AND RIGHT: *Model views.*

AXONOMETRIC

LOFT

loft

wood loft

steel bong

concrete block

big steel door

big window

gizmo

bridge sitting office

bath

bedroom

FIRST FLOOR

mechanical

laundry/pantry

kitchen

entry

guestroom

living

bath

library/t.v.

bunk room

IDEA SKETCH

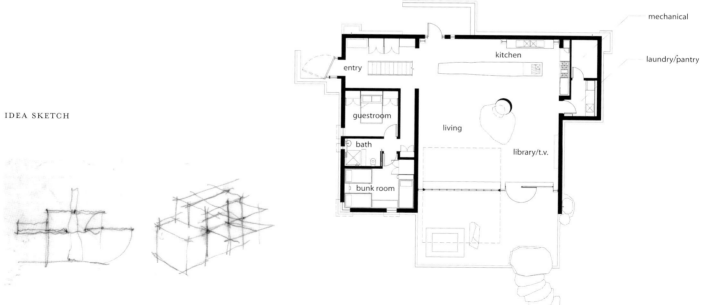

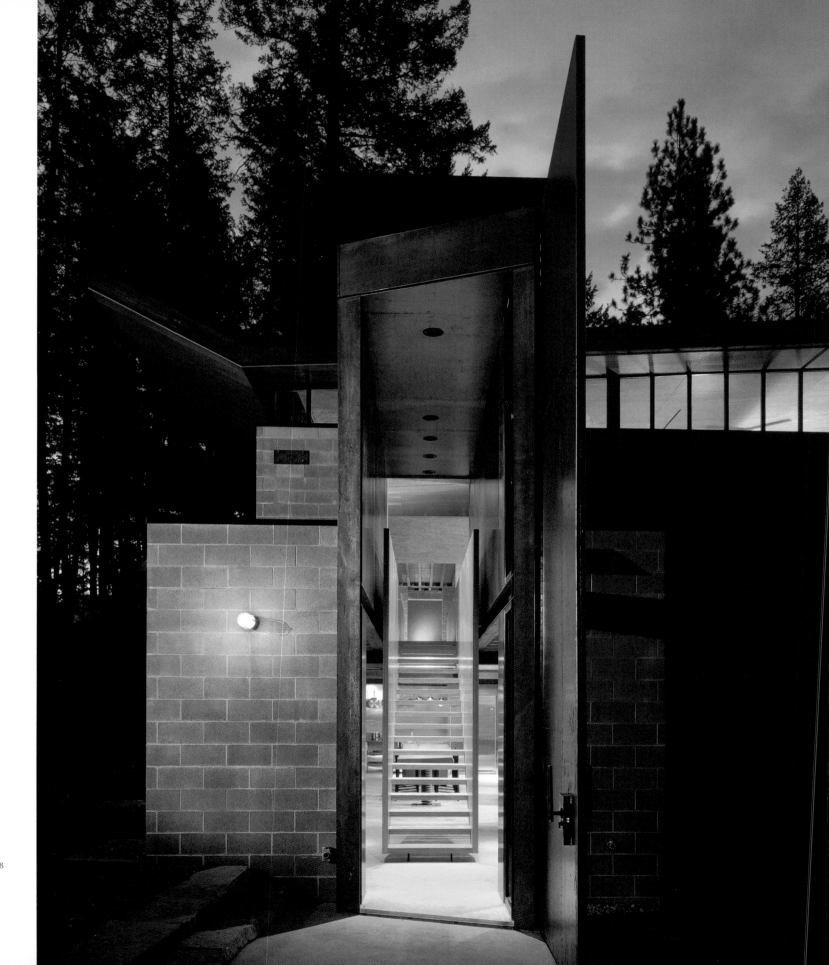

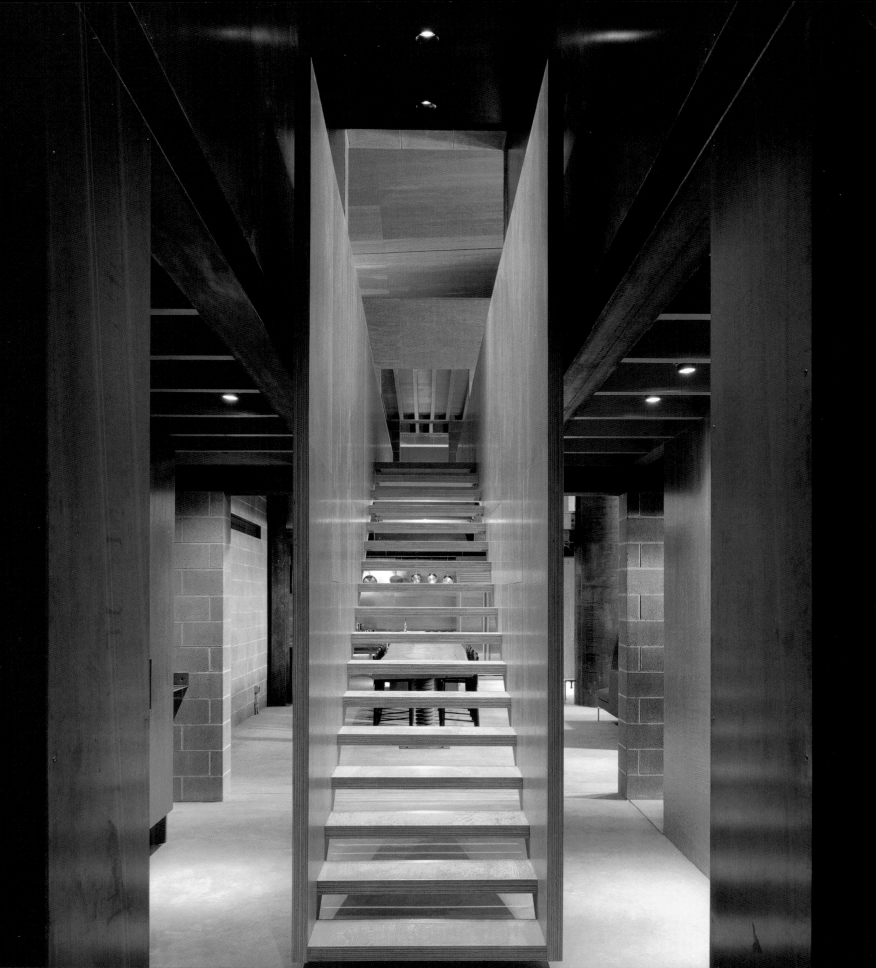

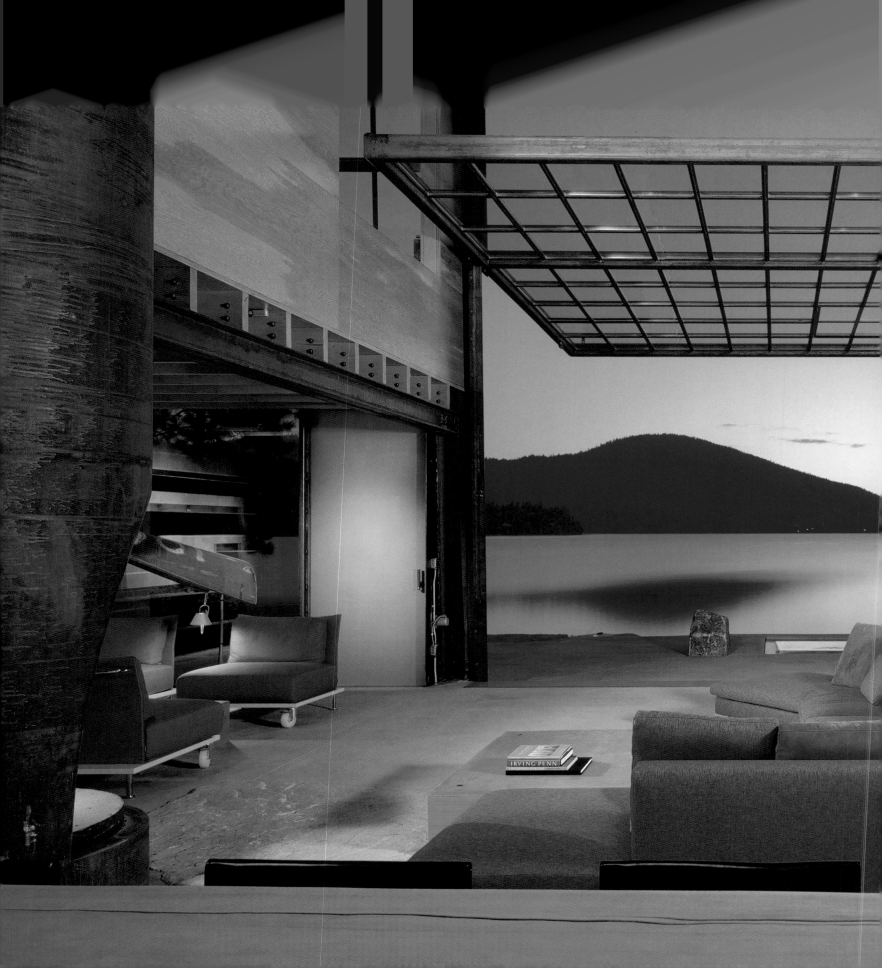

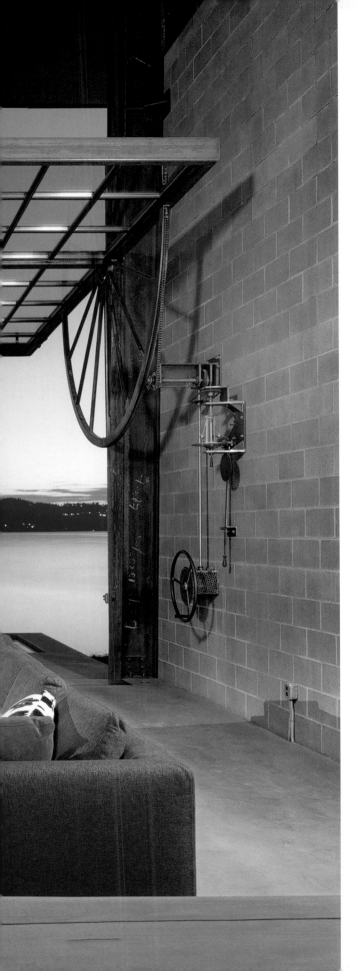

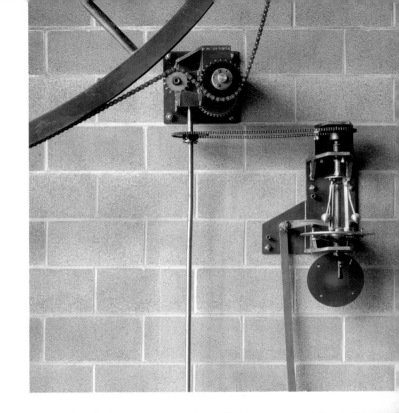

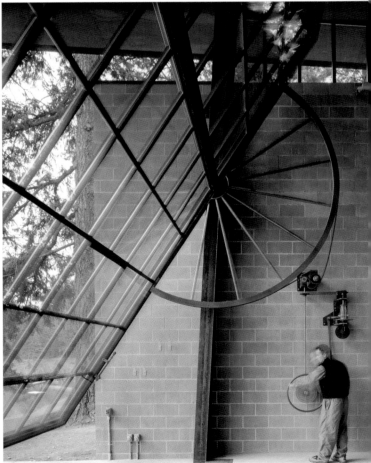

PREVIOUS PAGES: *View of the entry and stair leading to the master bedroom sleeping loft.*
LEFT: *View of the living room with the twenty-by-thirty-foot window that pivots up to allow unobstructed views.*
ABOVE LEFT AND LEFT: *Detail of "the Gizmo," the mechanical device that opens and closes the window.*

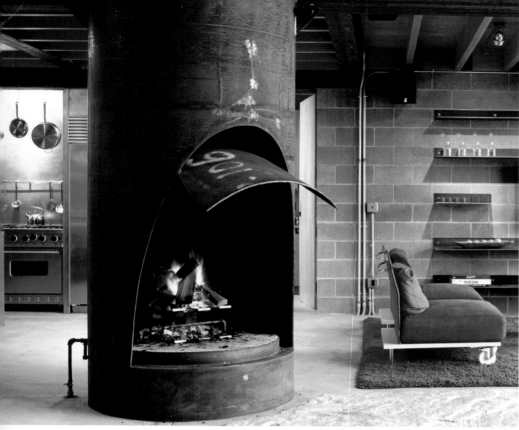

ABOVE: *The fireplace is constructed of a four-foot-in-diameter steel pipe that also serves as a structural component.*

RIGHT: *The deck, with its sunken concrete hot tub sits just outside the living room. The media room can be seen at right, tucked under the master bedroom sleeping loft.*

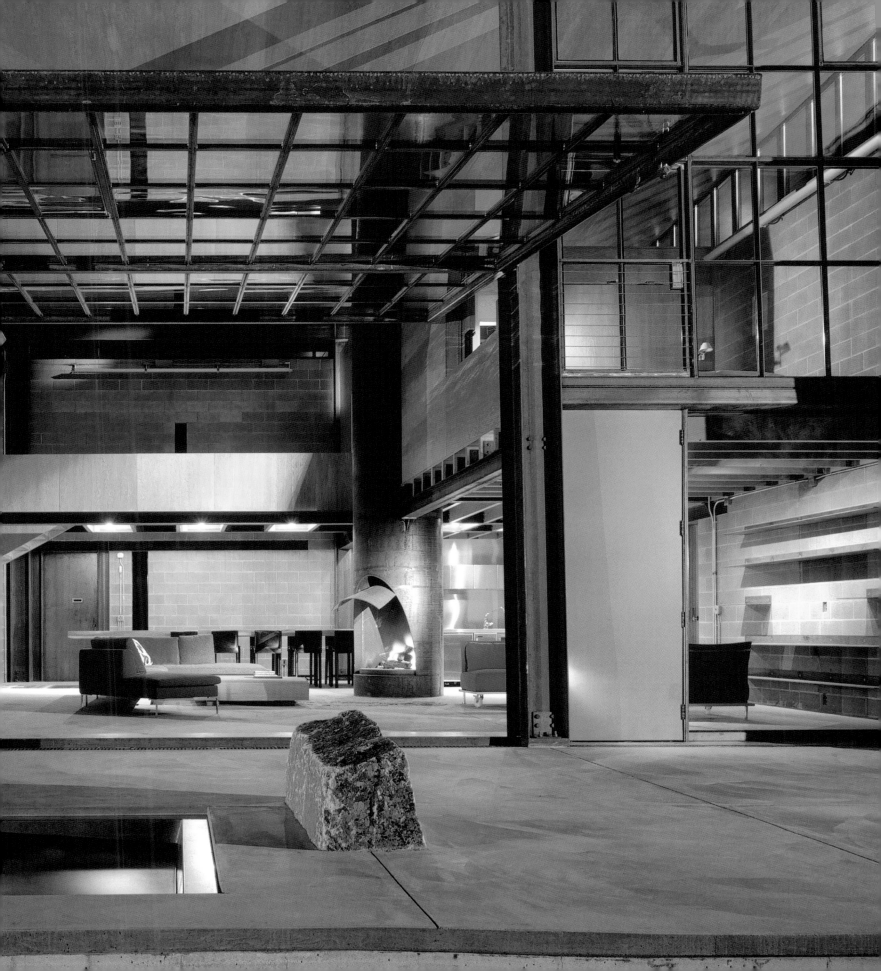

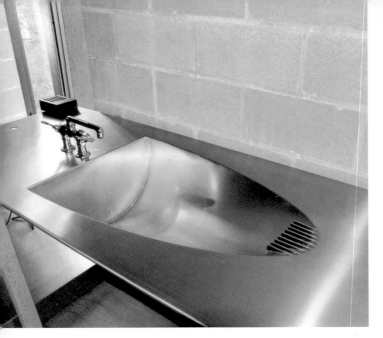

ABOVE: *Master bath sink detail.*
RIGHT: *The all stainless-steel kitchen with the island extended to become the dining table.*
FOLLOWING PAGES: *Master bedroom and view of lake at dawn.*

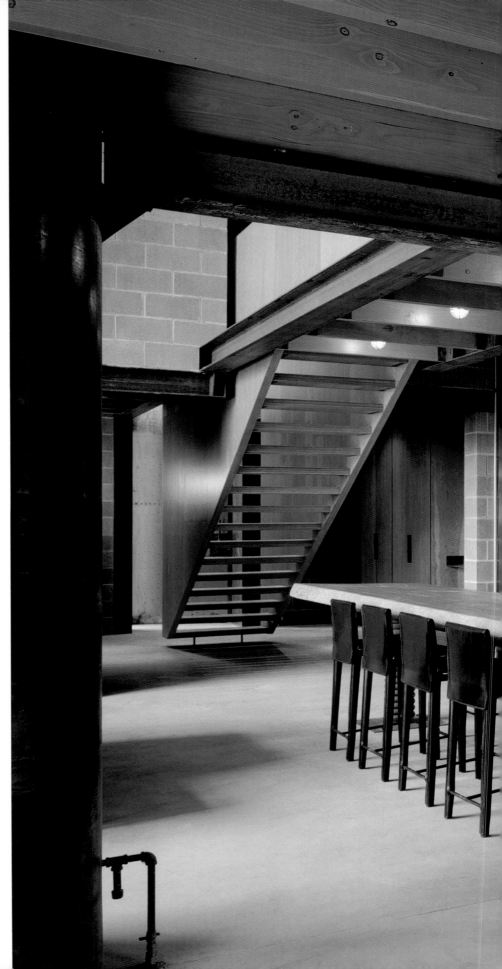

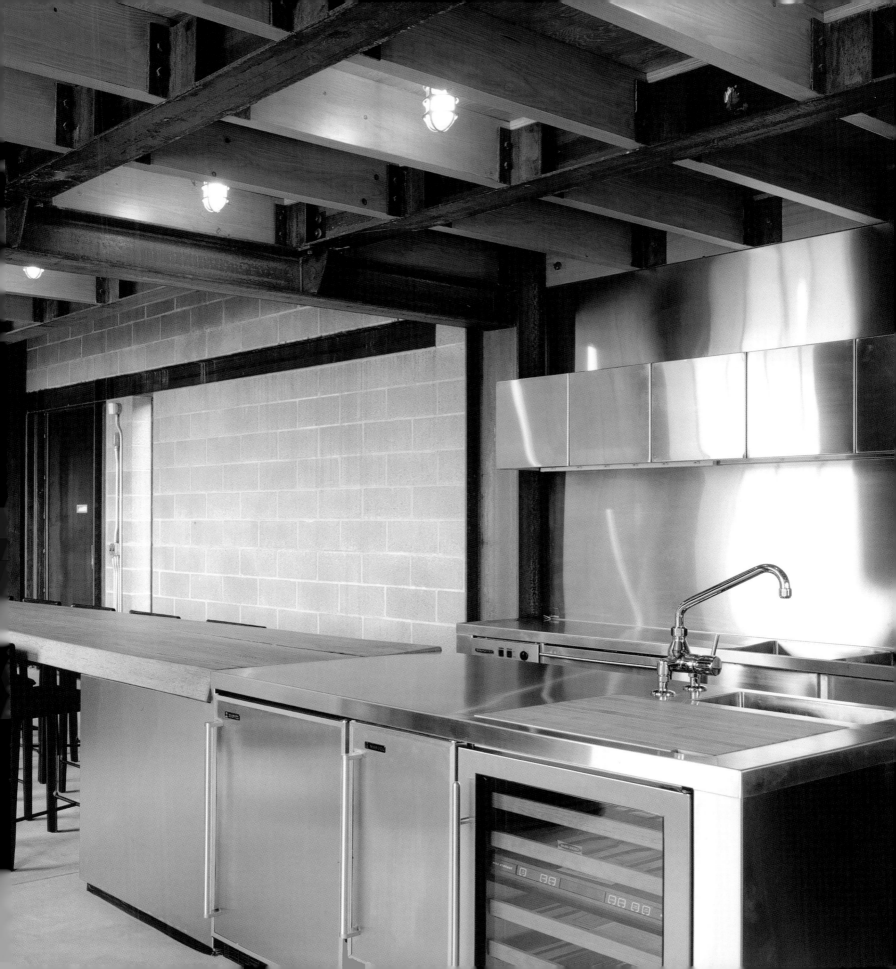

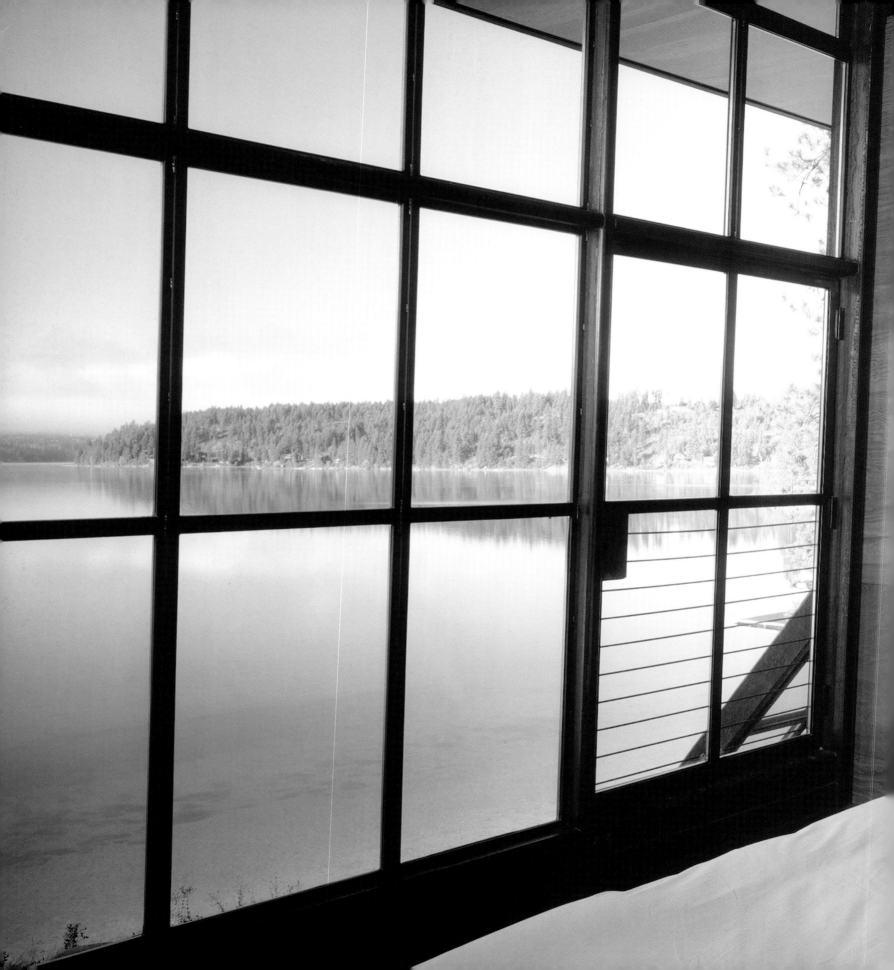

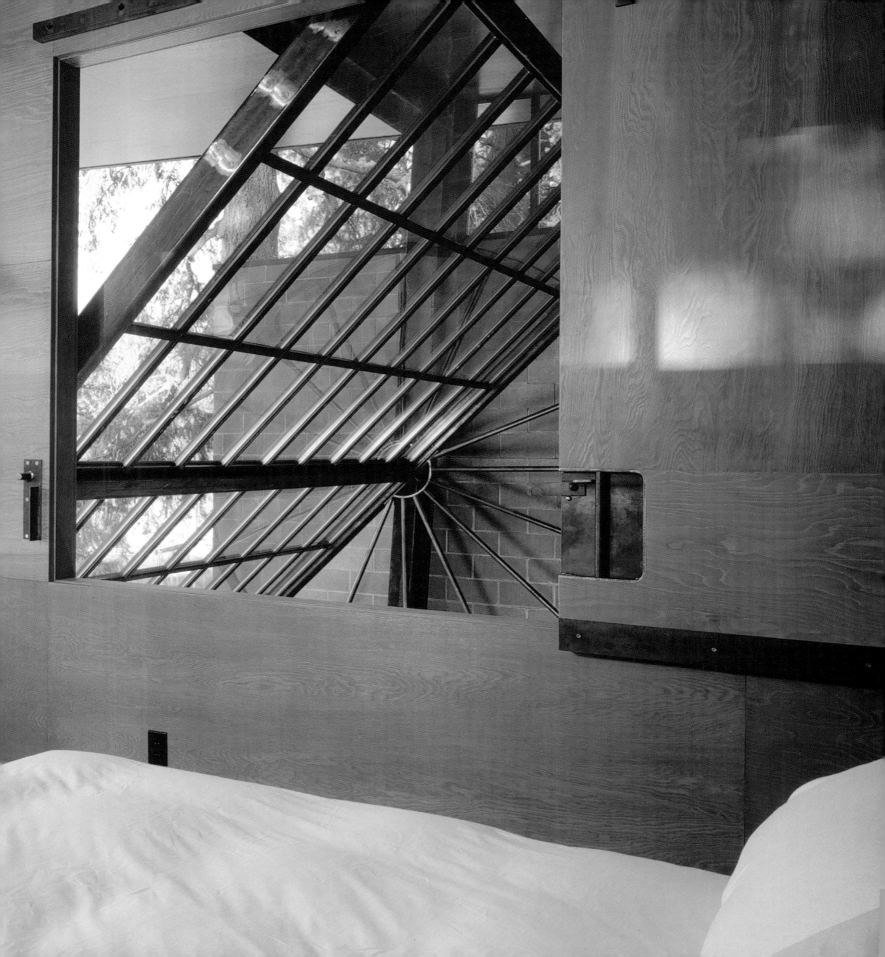

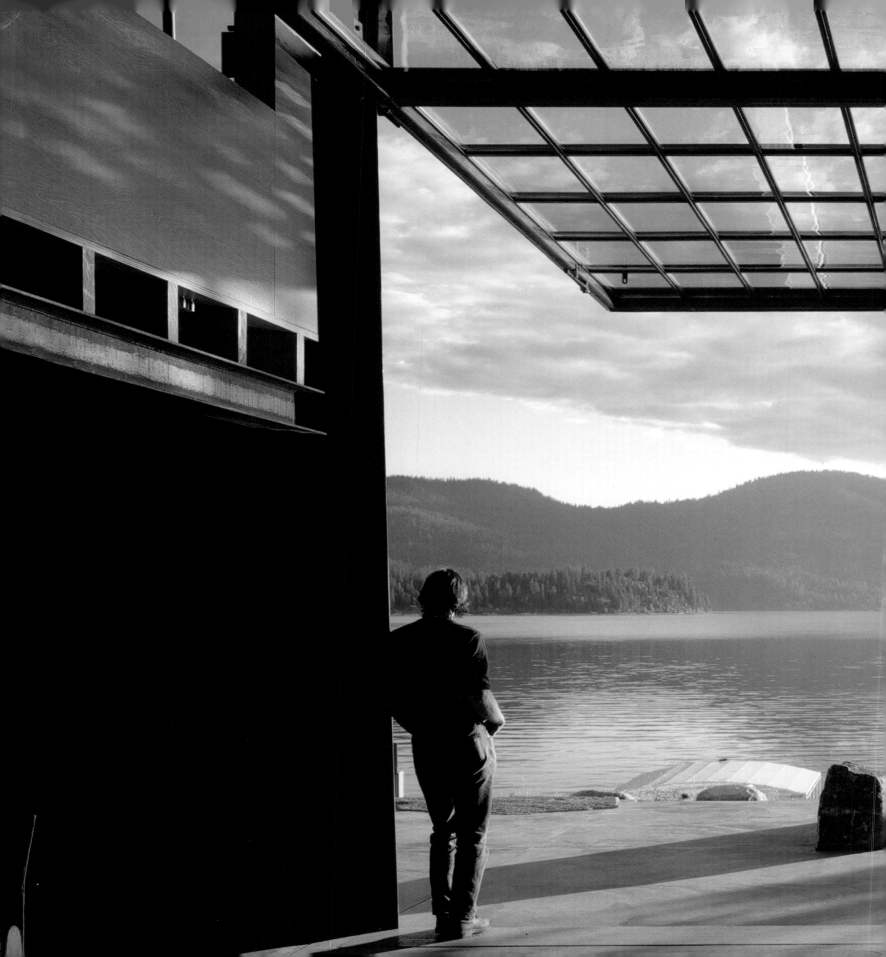

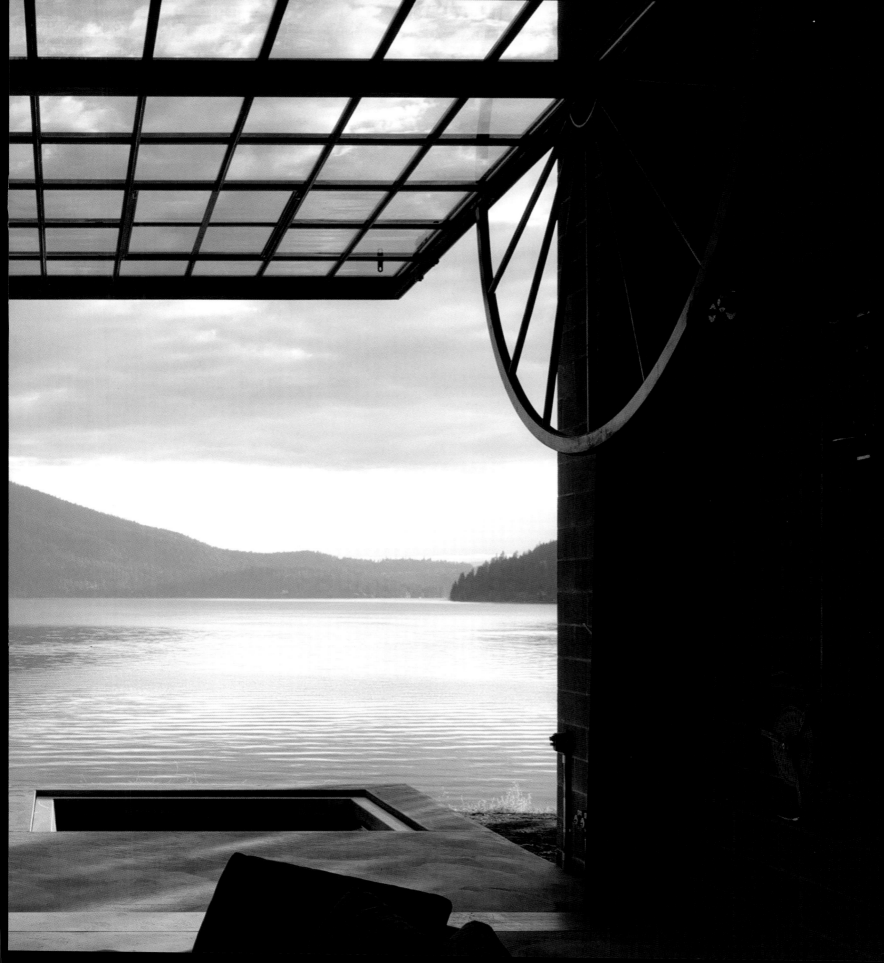

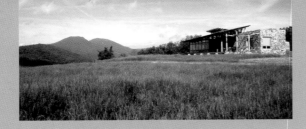

SHRACK RESIDENCE

VIRGINIA

R esting on a plateau of native grasses and surrounded by a mature hardwood forest, this retirement cottage in historic Rockbridge County, Virginia is oriented towards dramatic views of House Mountain to the west and the Blue Ridge mountains to the south.

The kitchen serves as the heart of the house and is carved from the center of the heavy stone walls that embrace the private areas of the cottage. A sleeping loft floats in the space above the kitchen. The timber and glass living and dining pavilion leans against a south-facing stone wall that runs the length of the building. To the north, the garage pavilion rests on top of a stone box that, in warmer months, is used as an indoor/outdoor living space.

Rugged building materials recall local farm buildings. Drystacked stone walls are capped by poured-in-place concrete. The framing is recycled Douglas fir. Structural insulated roof panels are exposed to interior spaces. Thin galvanized corrugated steel roofing float over exposed rafter tails and outriggers and natural cypress wood siding.

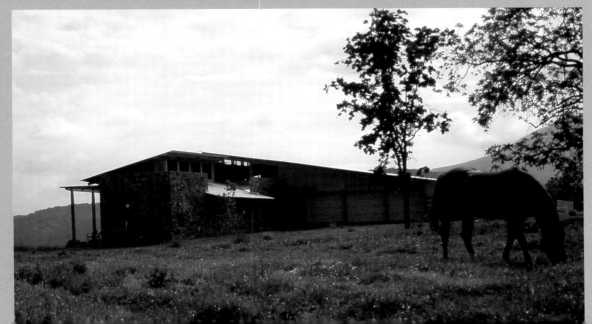

ABOVE: *The house is oriented to take advantage of views to the south and west.*
LEFT: *Entry and garage.*
RIGHT: *South façade.*

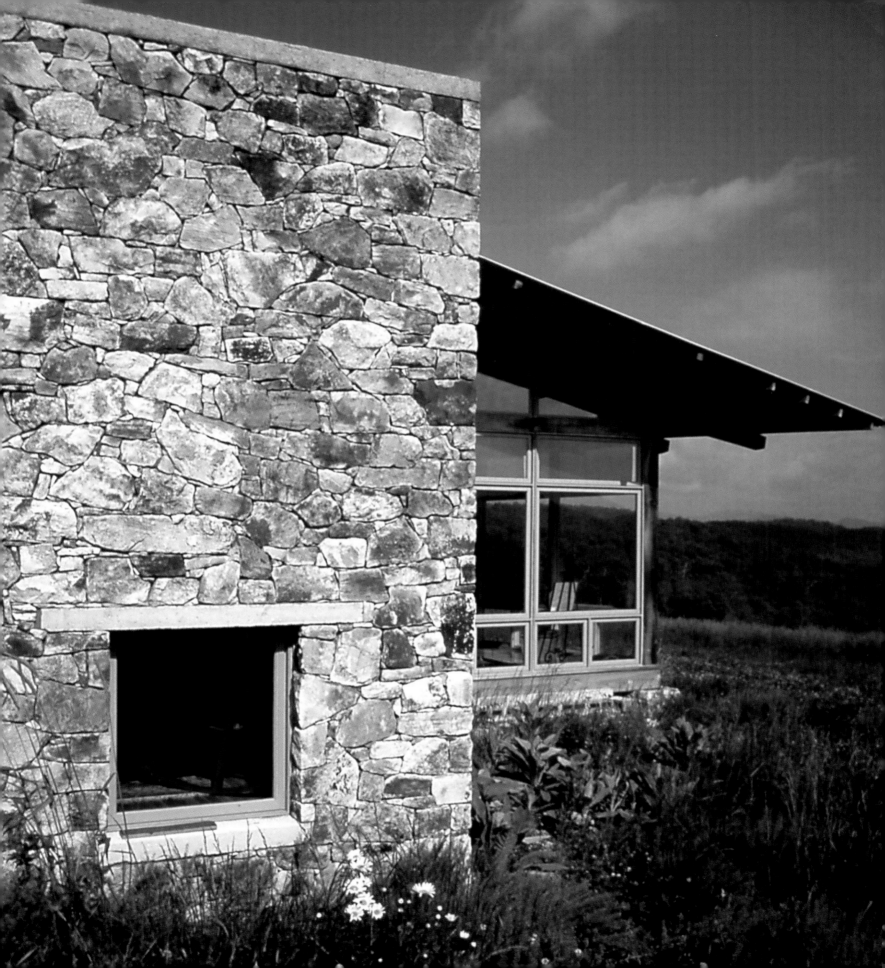

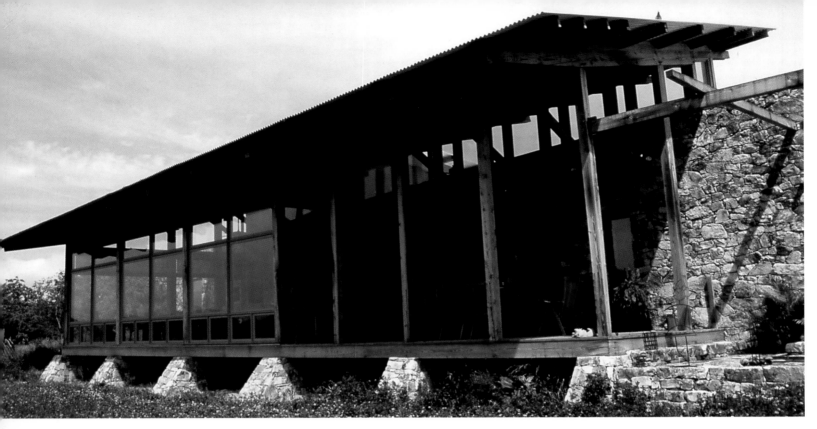

SITE PLAN/FLOOR PLAN

ABOVE: *The rugged building materials recall local farm buildings.*
RIGHT: *Floating roof details.*

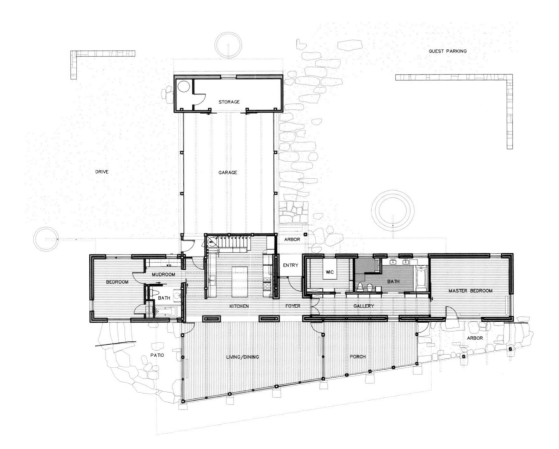

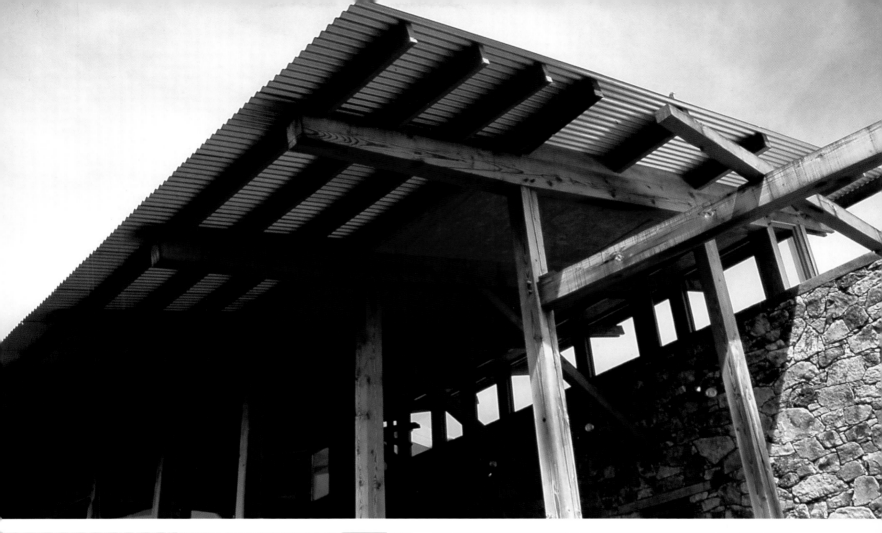

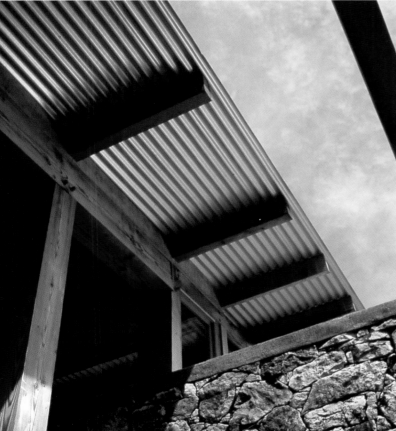

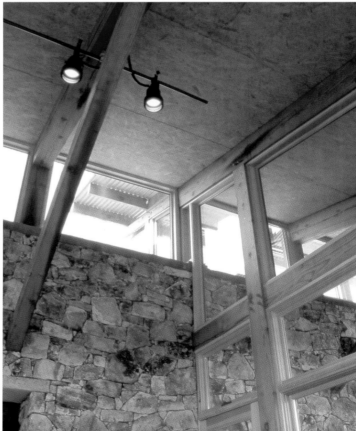

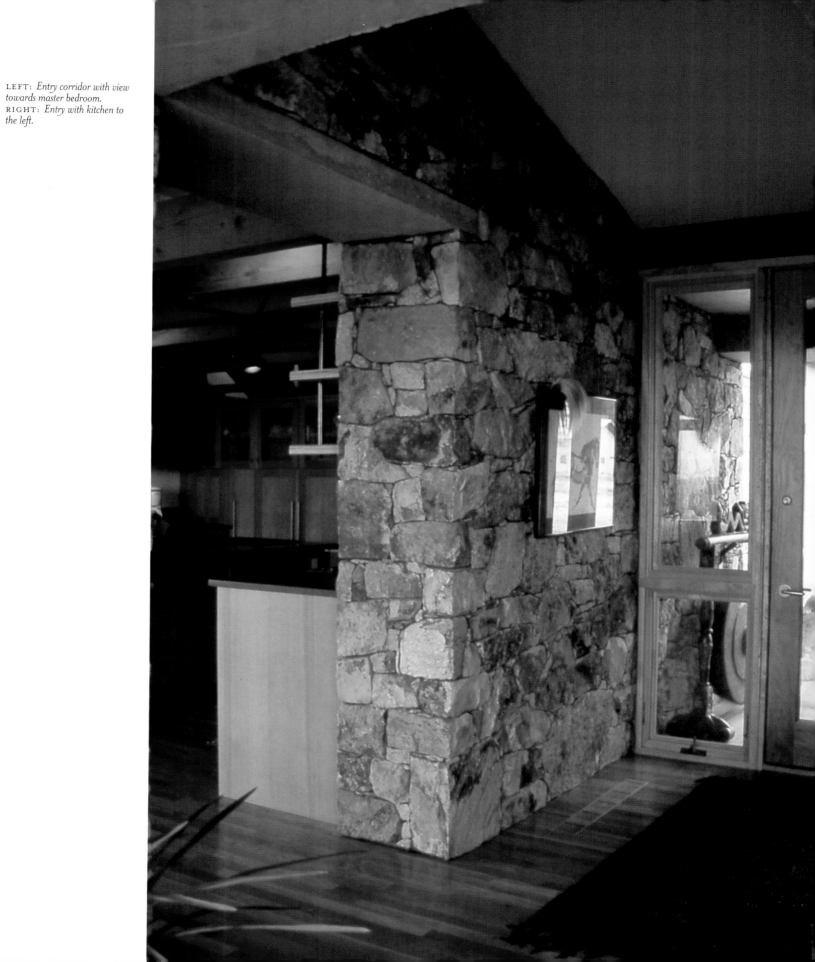

LEFT: *Entry corridor with view towards master bedroom.*
RIGHT: *Entry with kitchen to the left.*

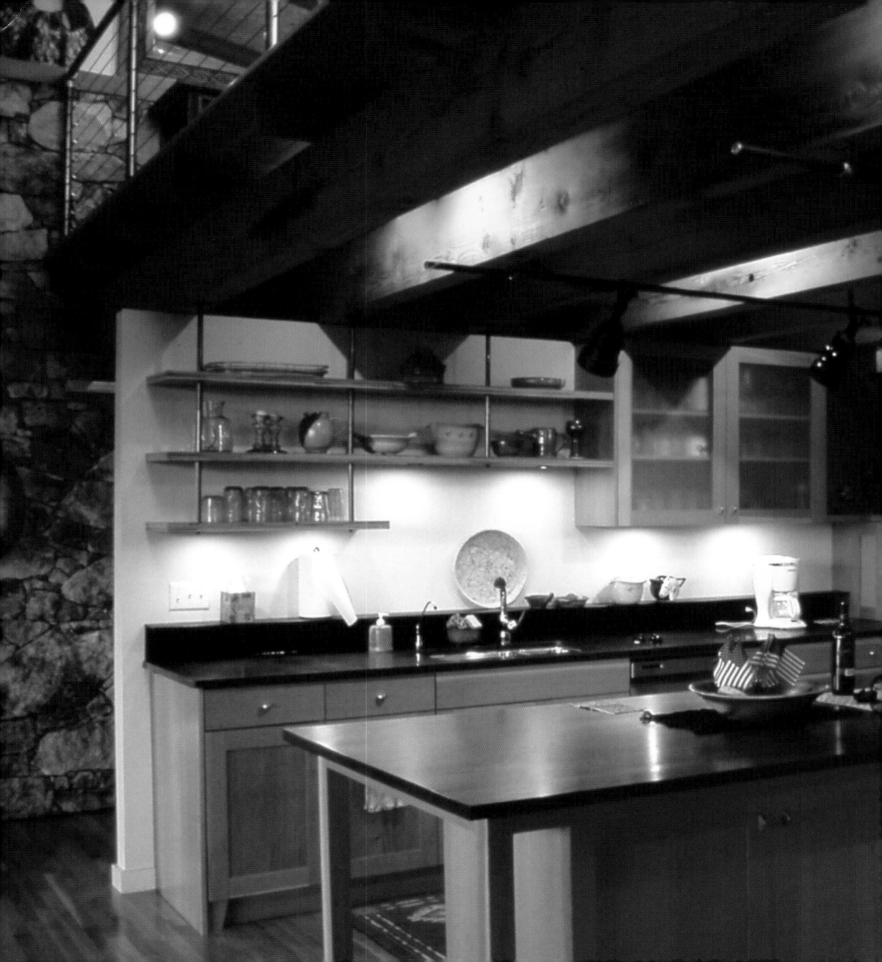

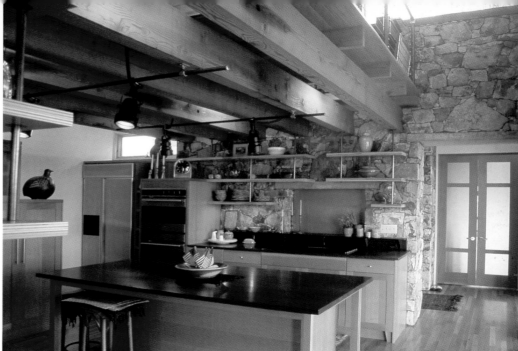

LEFT, ABOVE, AND
RIGHT: *The kitchen is the
principal gathering place in the
house.*

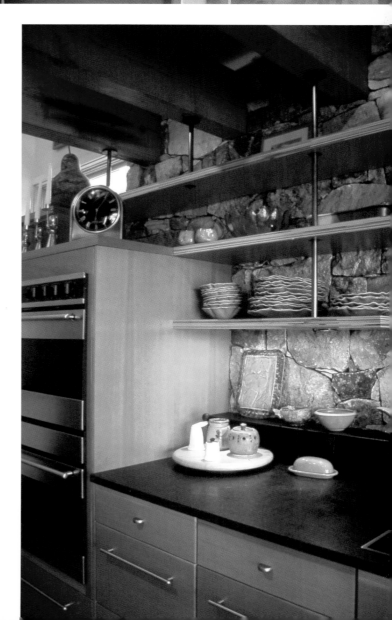

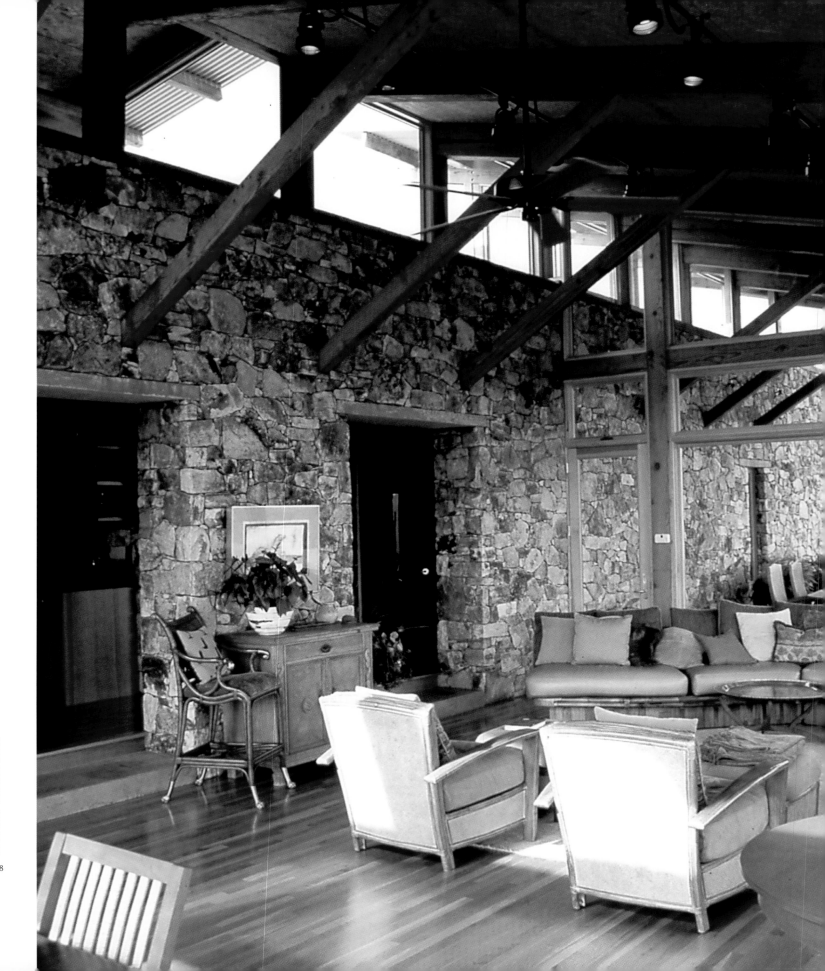

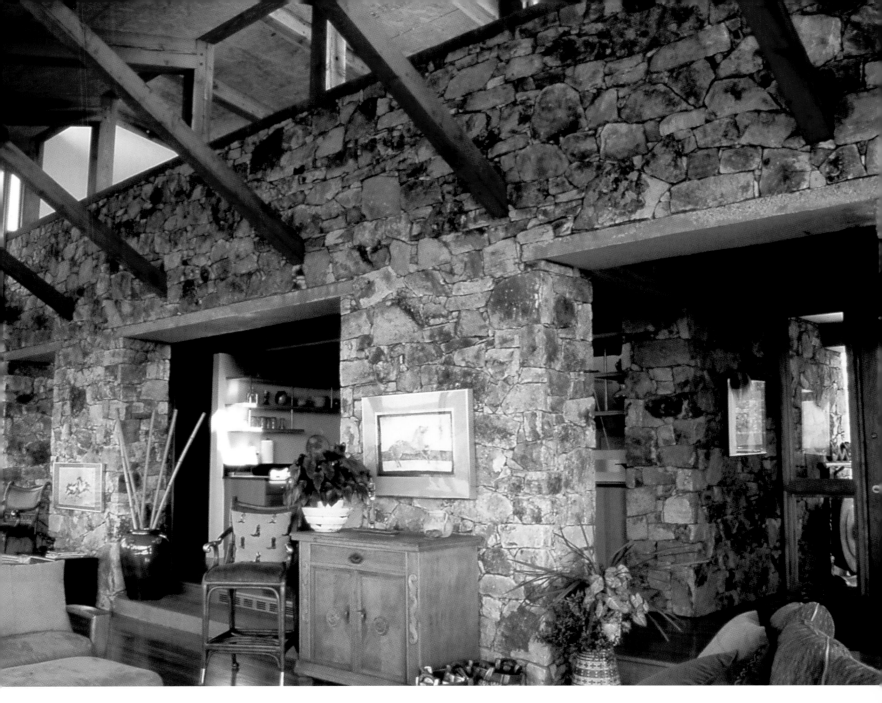

LEFT AND ABOVE: *Living and dining pavilion with view of kitchen past stone wall.*

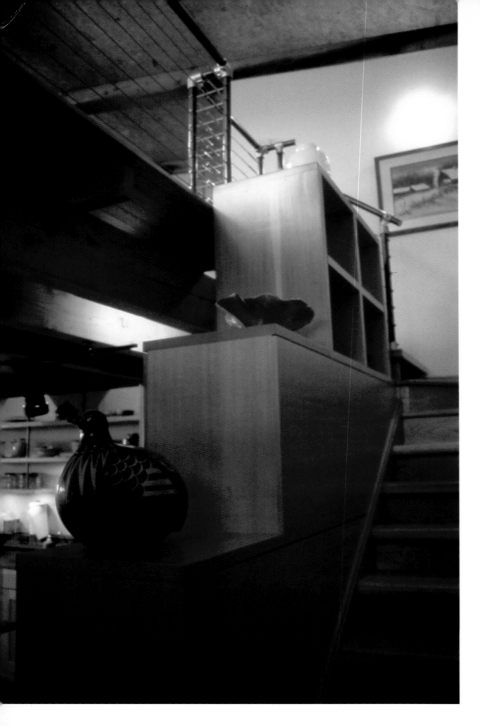

ABOVE LEFT AND ABOVE:
Stairs to the sleeping loft.
RIGHT: *Master bathroom.*
FOLLOWING PAGES: *The living and dining pavilion has stunning views of the distant mountain ranges.*

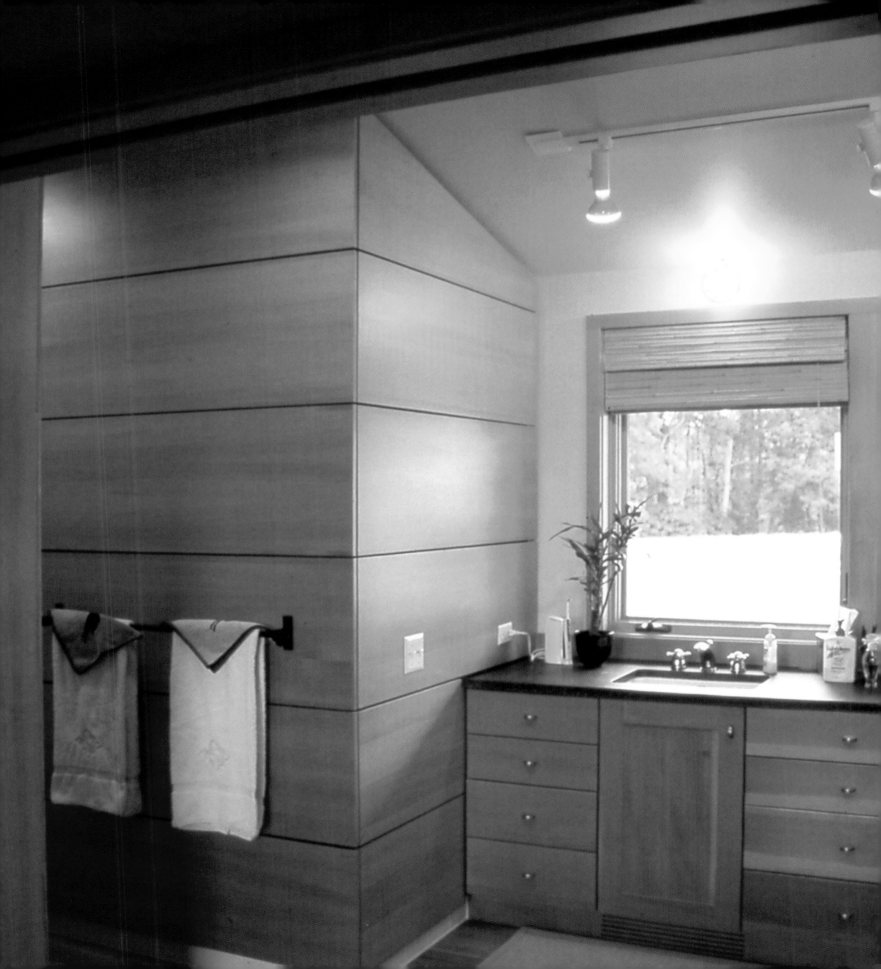

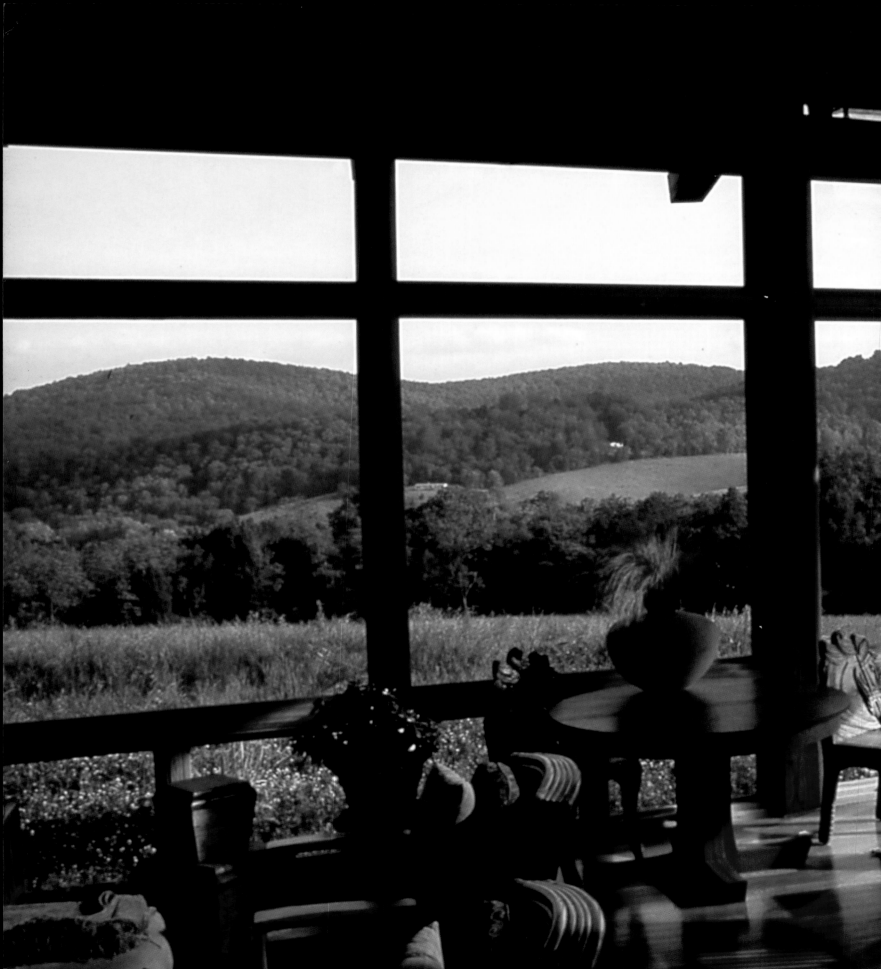

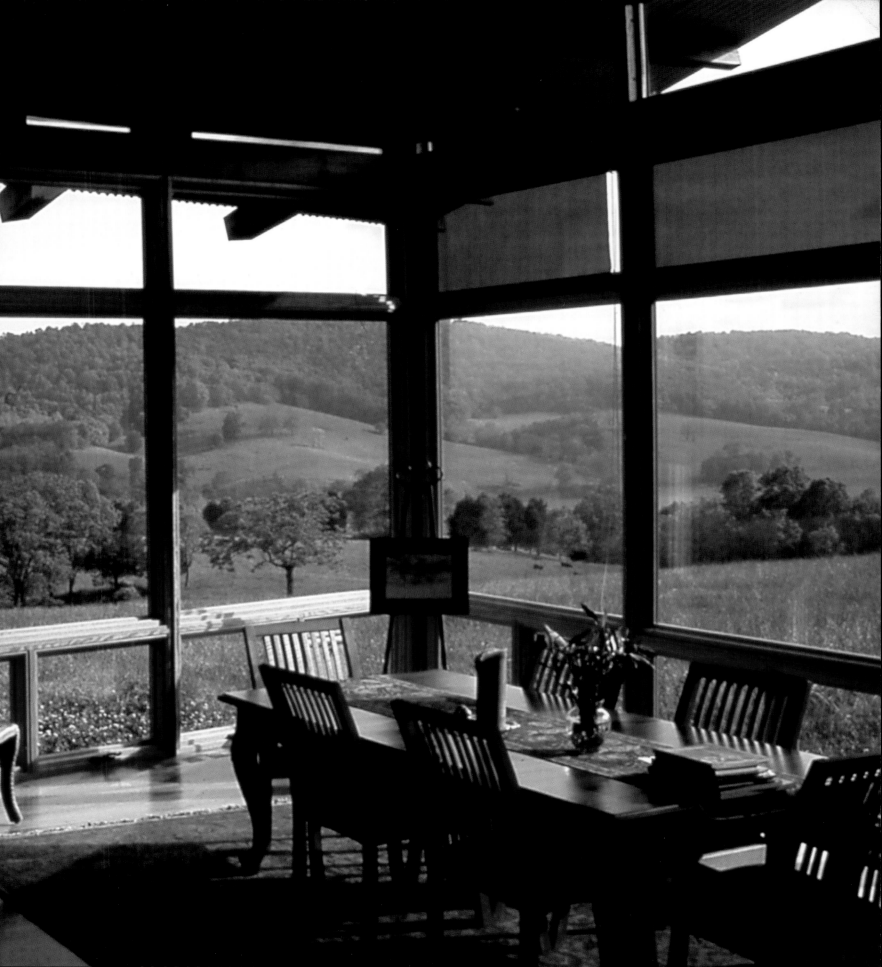

WAVERLY

PENNSYLVANIA

The architect's modest family compound in rural Pennsylvania is composed of two adjacent cottages along with several related structures. By employing common materials with subtle modernist details, the existing houses were transformed. The entry courtyard is formed by the edges of the houses, a stone-paving tongue extending between the houses bordered by a trellis, and by a dry-laid Pennsylvania stone wall that acts as a buffer between the house and the road.

The stone tongue is a dam-like edge for a new pond that extends from the courtyard though a wooded area to a large open field behind the houses. A cantilevered slab of wood projects from the new rear face of the small renovated guest cottage over the pond extending the view to the forest in the distance. In the main house, a new porch-like room looks into a grove of tightly spaced birch trees. Familiar details such as a quintessential stair, a hall of closet doors, the diagonal light in the grided bay windows, and walls of books serve to create a comfortable and inviting space.

ABOVE: *View of the pond in the field behind the houses.*
LEFT: *The renovation employs subtle modernist details such as the living room fireplace.*
RIGHT: *The dry-laid Pennsylvania stone wall separates the house from the road.*

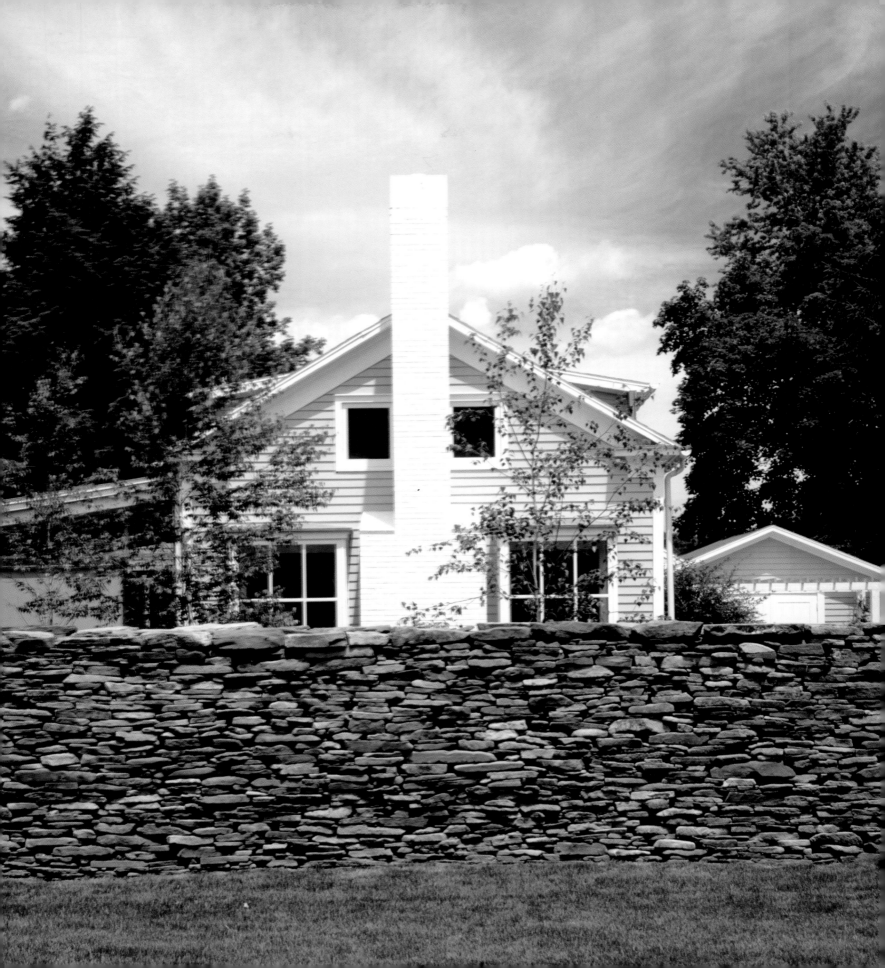

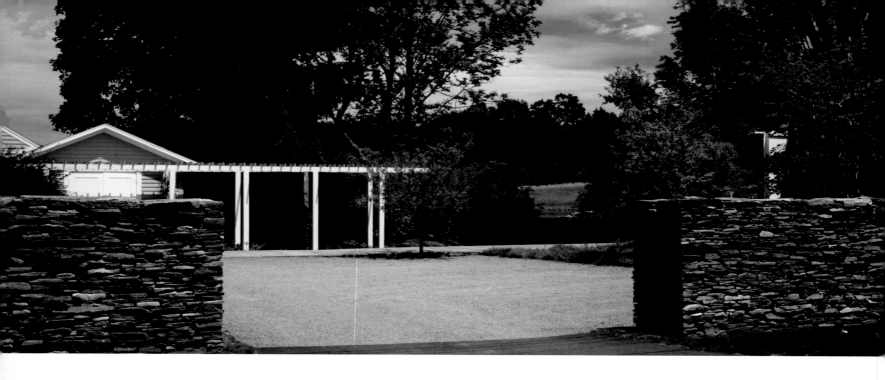

SITE PLAN

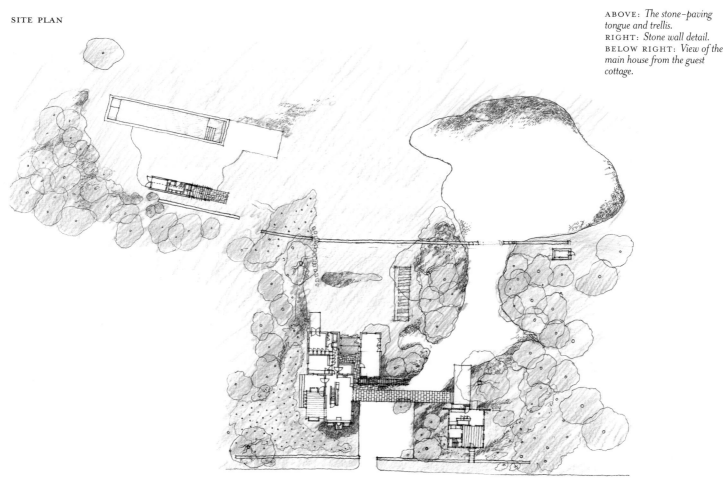

ABOVE: *The stone-paving
tongue and trellis.*
RIGHT: *Stone wall detail.*
BELOW RIGHT: *View of the
main house from the guest
cottage.*

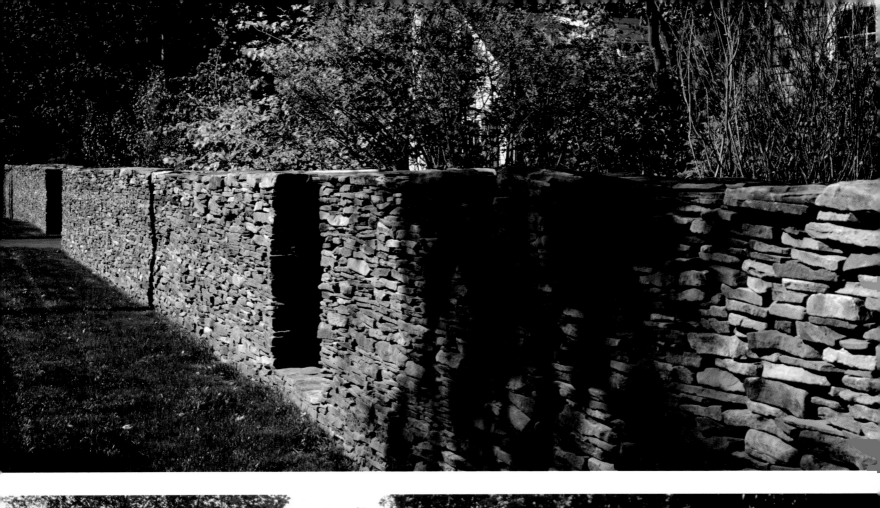

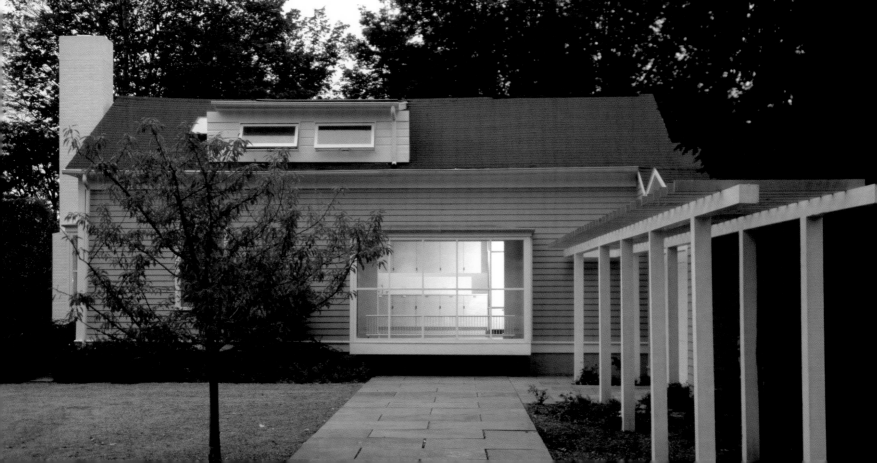

LEFT AND ABOVE: *In the main house, a cabinet appears to float within the glass wall of the dining room.*

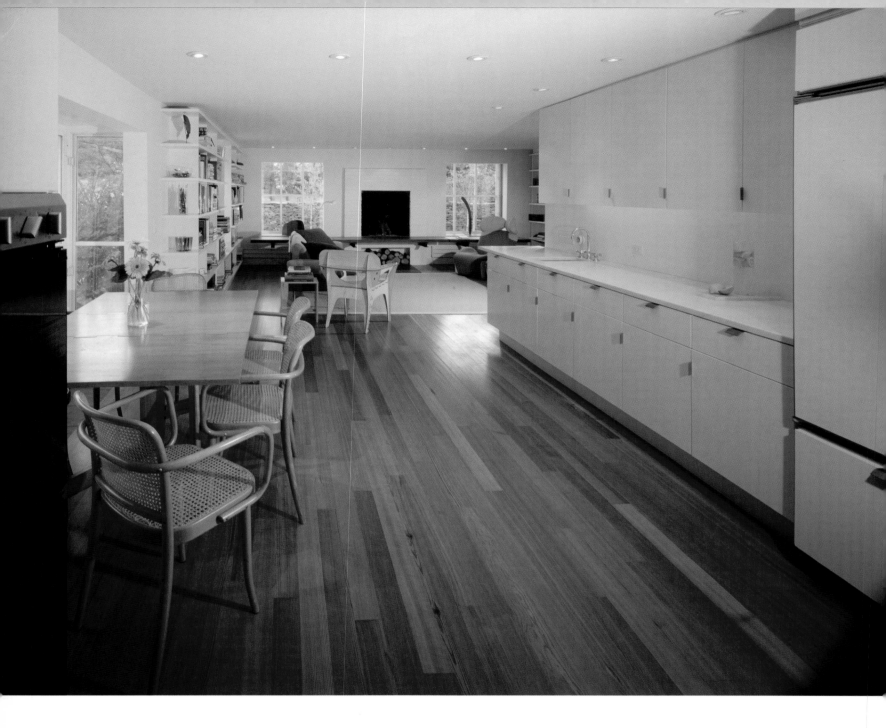

LEFT: *View of the living area from the kitchen in the main house.*

ABOVE: *Guest house kitchen.*

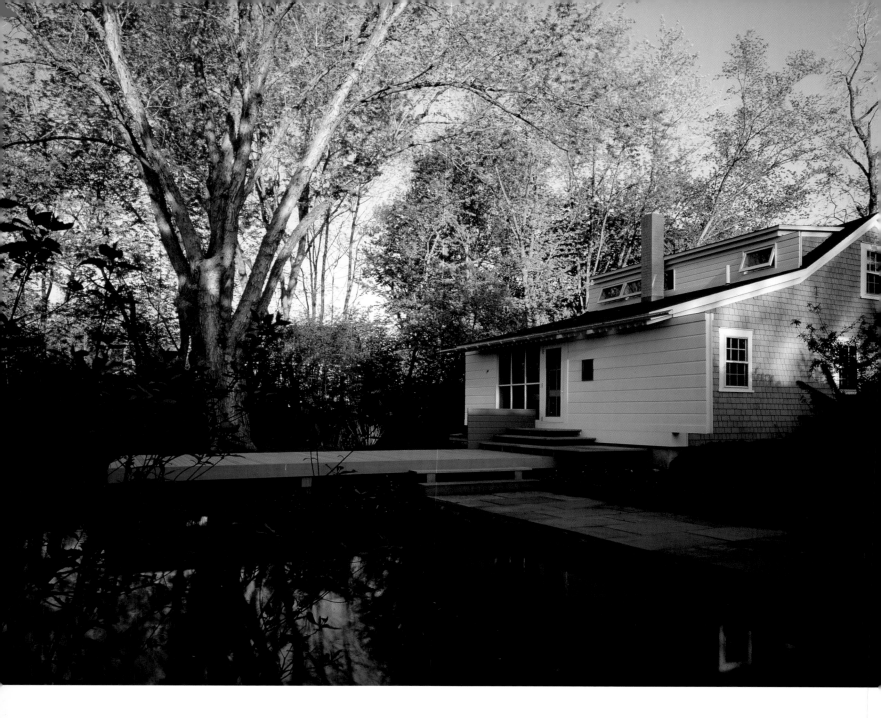

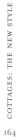
ABOVE: *View of guest house from across the pond.*
RIGHT: *The guest house as seen from the main house.*
FOLLOWING PAGES: *A view of the main house from the guest house.*

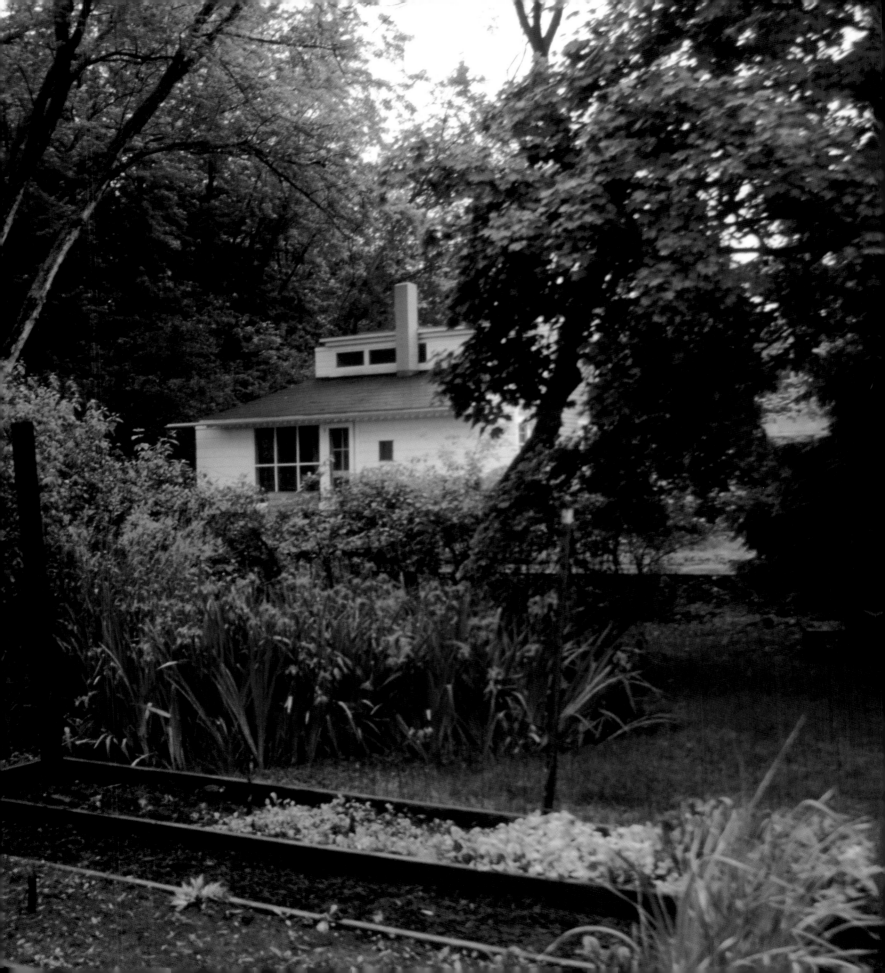

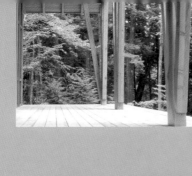

CONDON COTTAGE

MICHIGAN

L ocated along the western shore of Old Mission Peninsula on Lake Michigan's Grand Traverse Bay, this modest house is a re-interpretation of old cabins in an area that the owners were fond of visiting during their summer vacations. The design reflects a simpler and more relaxed life of long, warm summer days and of quiet cool evenings with a fire. In both activity and in structure, the house revolves around centrally positioned fireplaces and a wood-burning stove. The chimney mass—the heart of the house—is constructed of concrete "planks" left unfinished to reveal the grain of the wood forms that created it.

Winding through the forest, the approach to the cottage is from the east, revealing its welcoming, flesh-colored "face." Windows form the eyes and mouth while an exhaust vent is the nose. The entry is marked by a round column of slender wood posts resting on a large boulder. This column finds its counterpoint in a massive gnarled maple trunk positioned within the house.

In material and detail, it is a modest cottage with a rigorous structure. Exposed Douglas fir framing and paneling, galvanized steel roofing, and raw concrete are left unfinished, revealing their basic nature.

Designed and constructed over a ten-year period, the cottage is a testament to the patient and thoughtful collaboration of the owner, the architect, and the builder.

ABOVE: *Porch detail.*
LEFT: *Entry.*
RIGHT: *The "face" of the house as seen through the forest.*

168

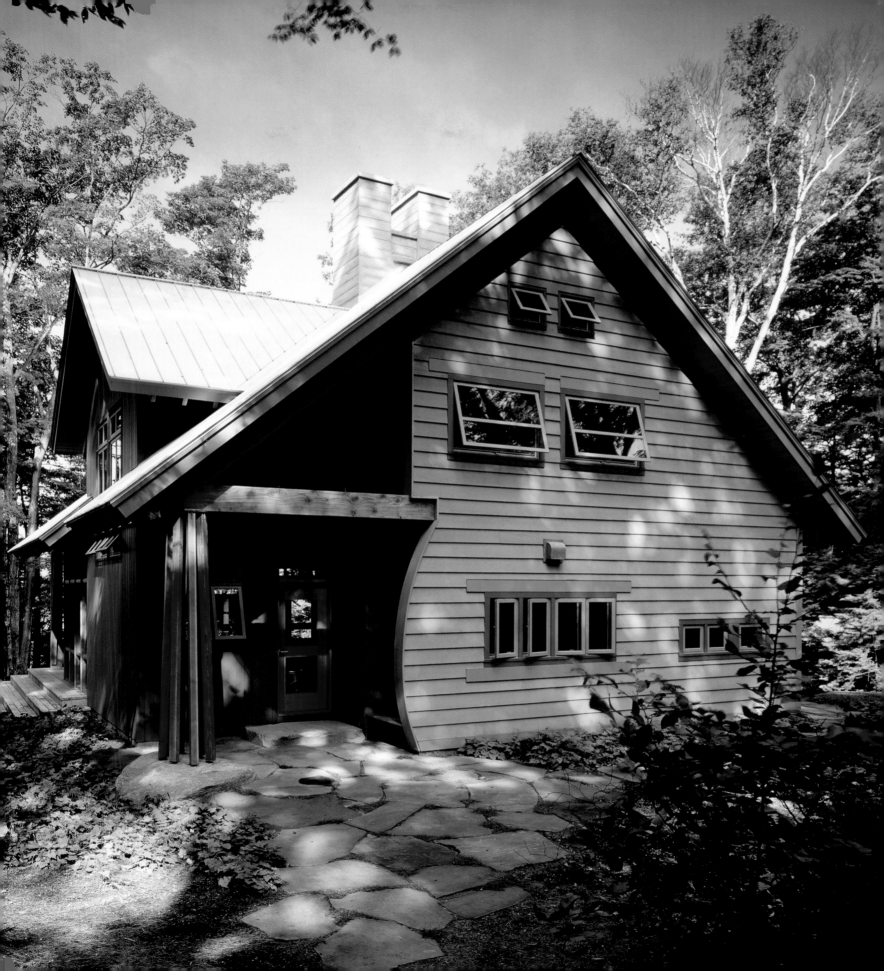

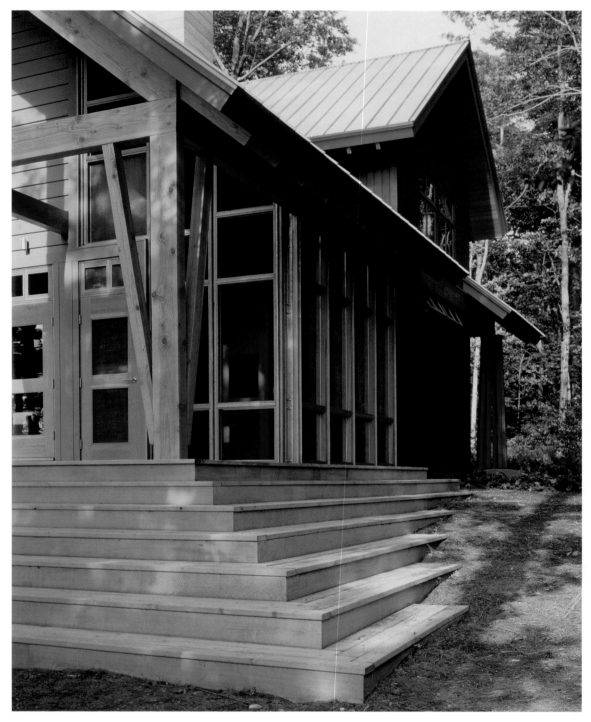

ABOVE: *The porch from the southwest.*
RIGHT: *The west porch faces the lake.*

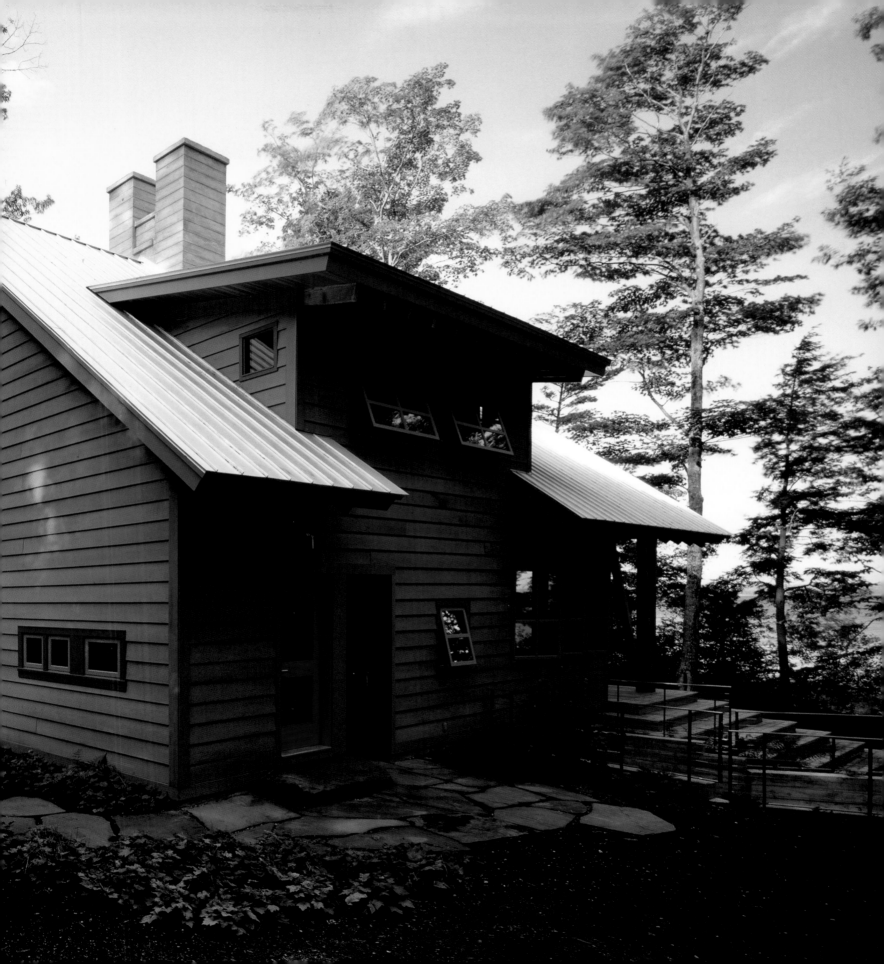

SECOND FLOOR

FIRST FLOOR

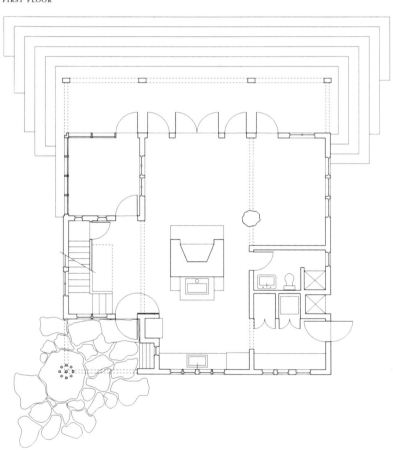

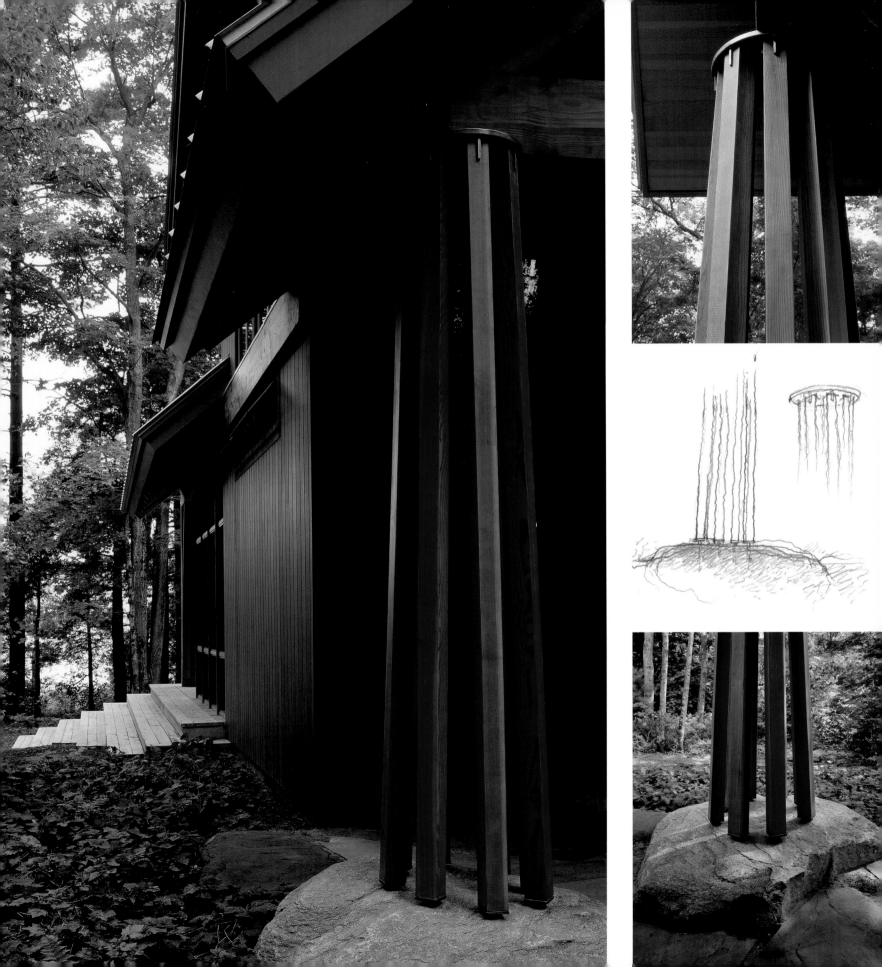

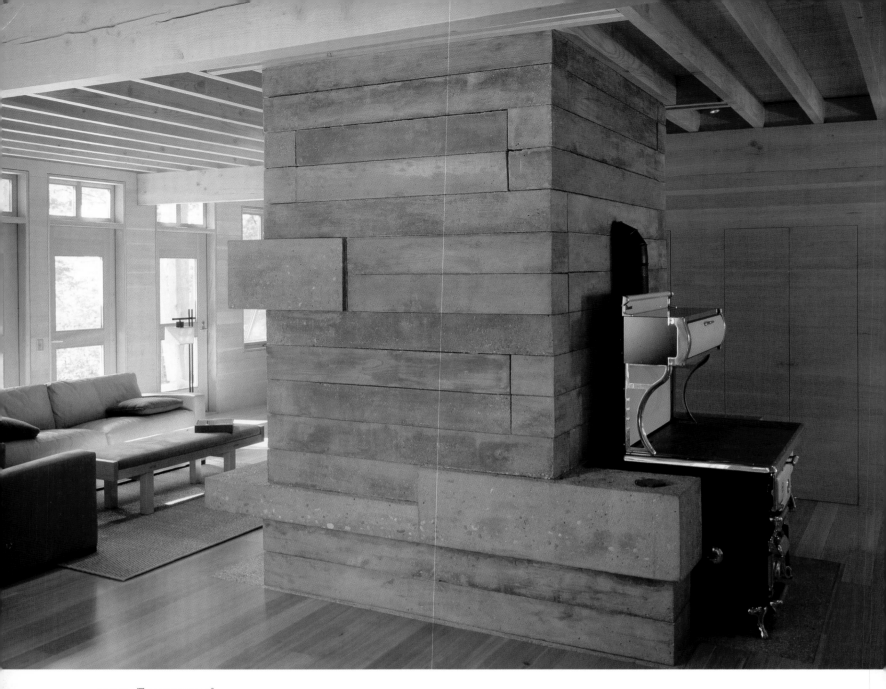

ABOVE: *The raw concrete of the fireplace is left unfinished, revealing the wood grain from the boards of the molds.*
RIGHT: *Detail of gnarled maple trunk with fireplace.*

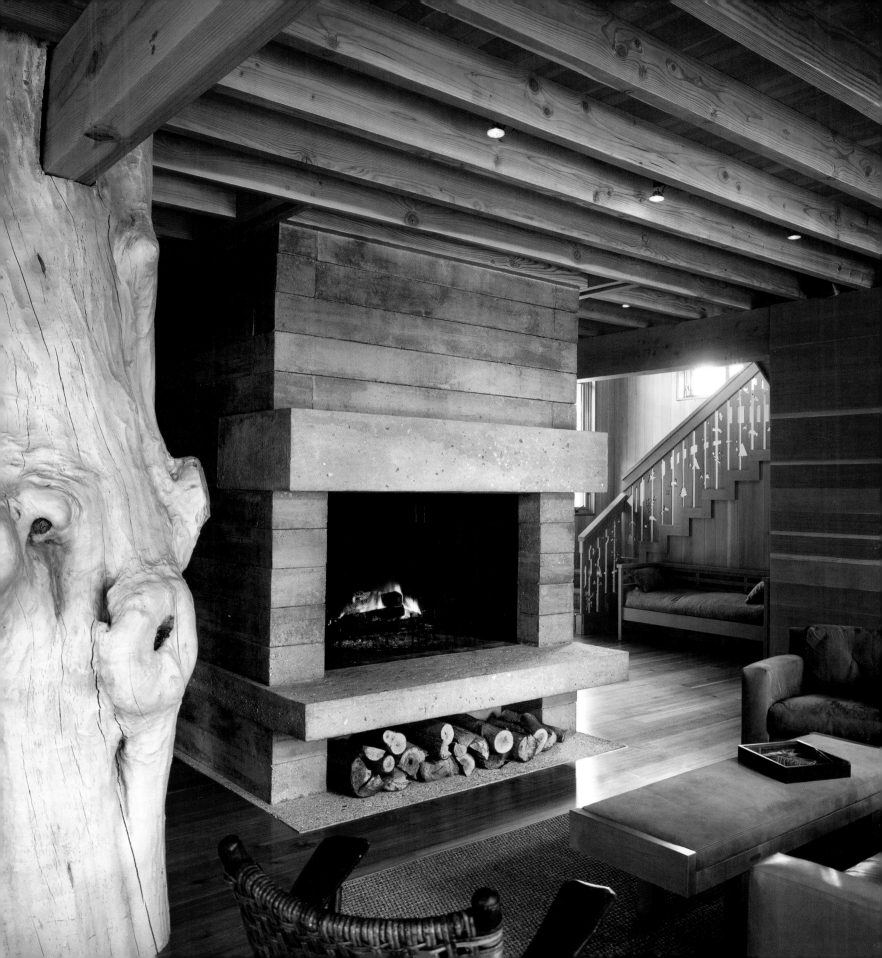

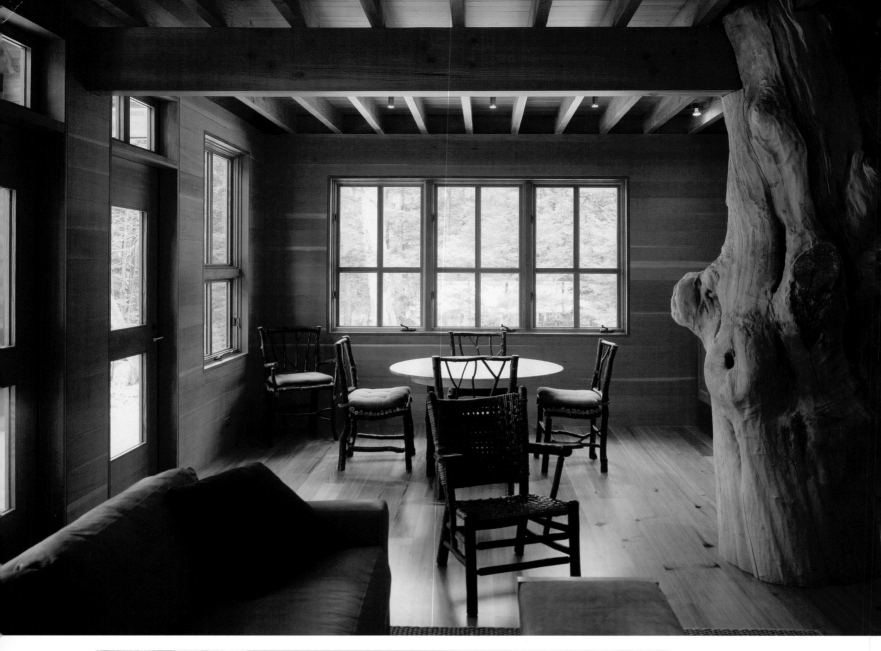

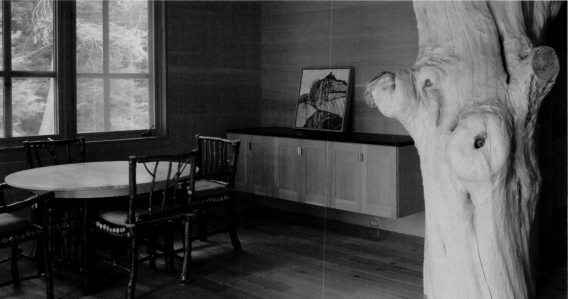

ABOVE: *View of the dining area.*
LEFT: *Dining area.*
RIGHT: *The clients designed the cut-outs in the stair balusters.*

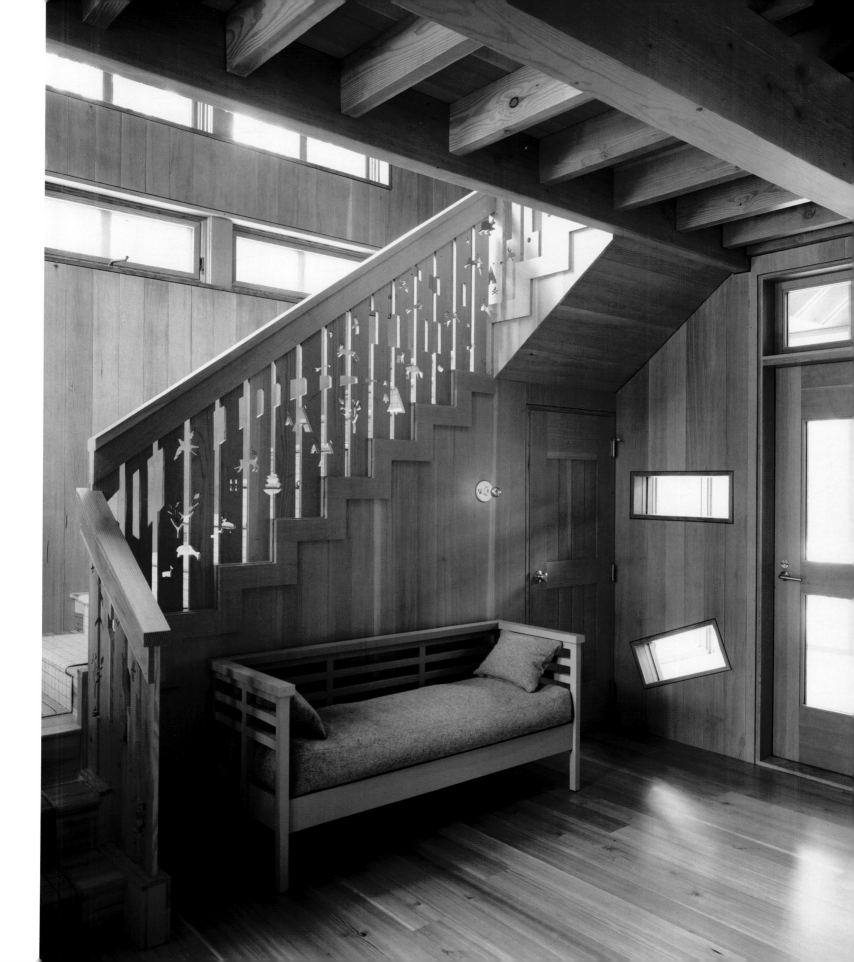

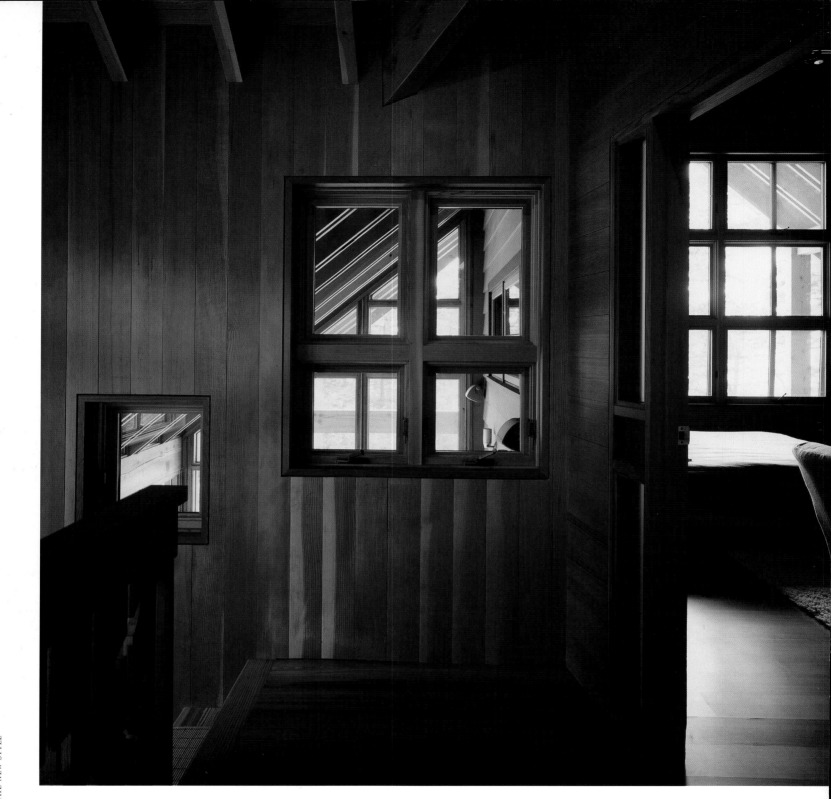

ABOVE: *View of second floor bedroom entry.*
RIGHT: *The fireplace in the master bedroom features the same raw concrete construction as the first-floor fireplace.*

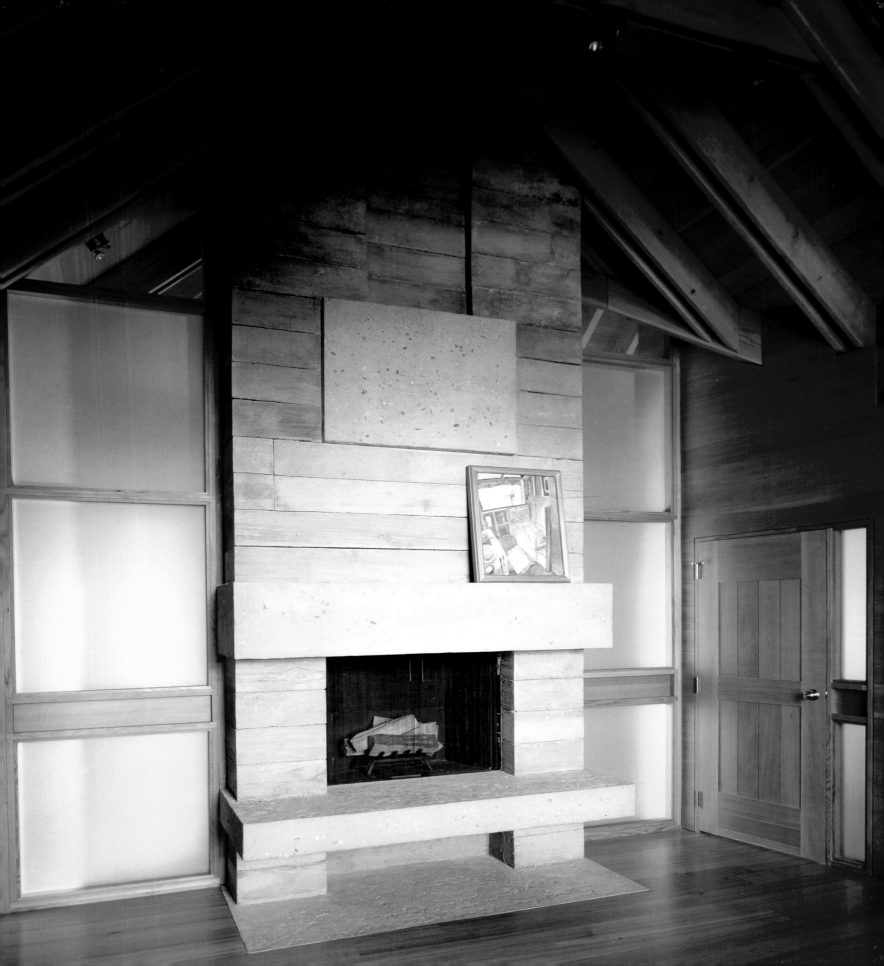

WENDEL / LYNDON

SEA RANCH, CALIFORNIA

Wendel House is a place to enjoy work and pleasure with special intensity. The simple volumes induced by the timber frame construction are adjusted and appended to capture the qualities of this particular site. There are two structures within this project, one with the principal living and study spaces and a second with a workshop and guest quarters. Linked by a fence, they frame a courtyard/garden which can be sequestered from deer and views from the road.

The larger building includes a lofty, light-filled space with places for lounging, dining and cooking, as well as three smaller, interconnected sleeping and working rooms on two levels. The kitchen and dining areas are at the center of the house. The kitchen counter fronts a benched eating nook with views of the meadow and views across the room of the wood stove platform and cushioned benches in the living area. A small tower to the eastern side of the kitchen holds a platform and soaking tub behind a sliding barn door. A row of tall posts marches enfilade along the length of the interior, ending at stairs which climb a few steps to a landing. There, an angled white wall catches the sun to illuminate a small office area. The stairs then turn and climb to the master bedroom which is lit by windows on three sides and opens to a balcony with views of the rolling meadow and the Pacific Ocean.

The wood timber construction of the house plays with the light falling on its interior surfaces making the resawn Douglas fir wood walls and tinted concrete floor glow with warmth. Skylights play an important role in bringing morning sun into the spaces and in balancing light throughout the day, so that views to the south and out to the sea and the meadow do not contrast glaringly against the dark walls.

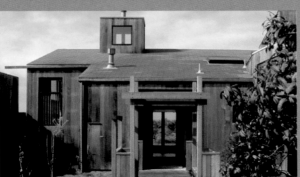

ABOVE: *Aerial view of the meadow.*
LEFT: *Entry pavilion.*
RIGHT: *Meadow façade.*

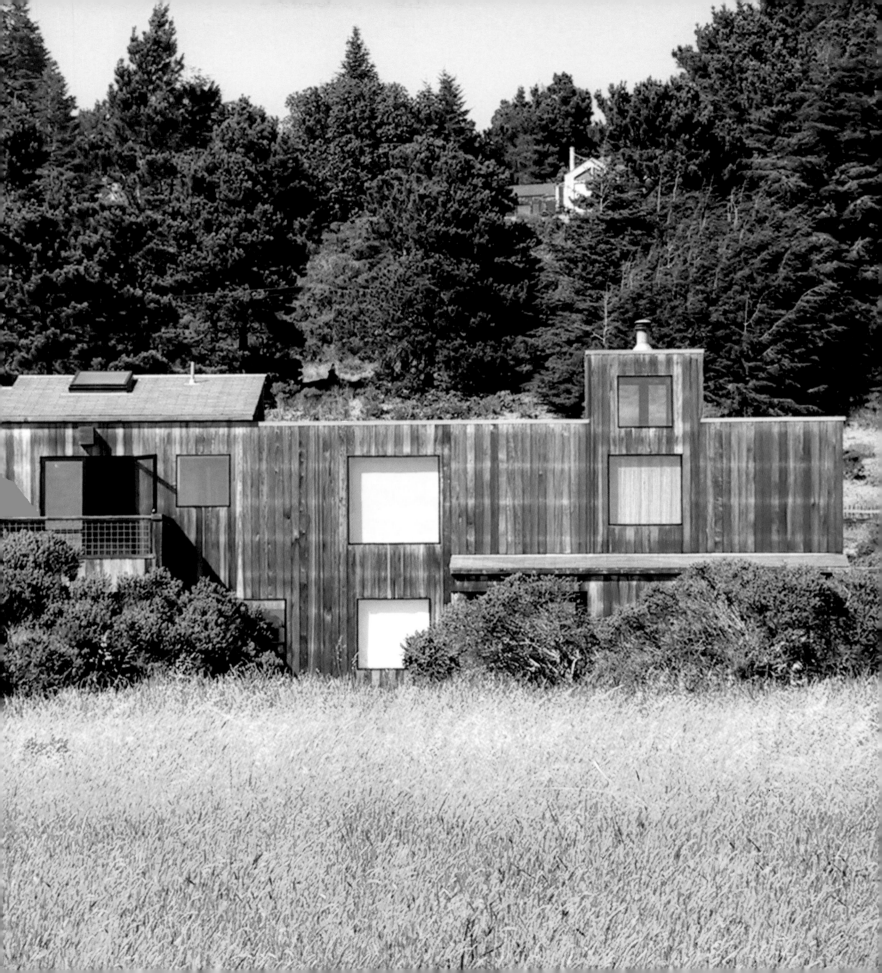

0 10' 50'

SECTIONS

EAST ELEVATION

WEST ELEVATION

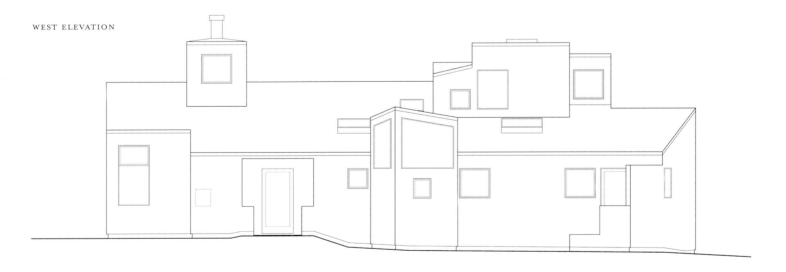

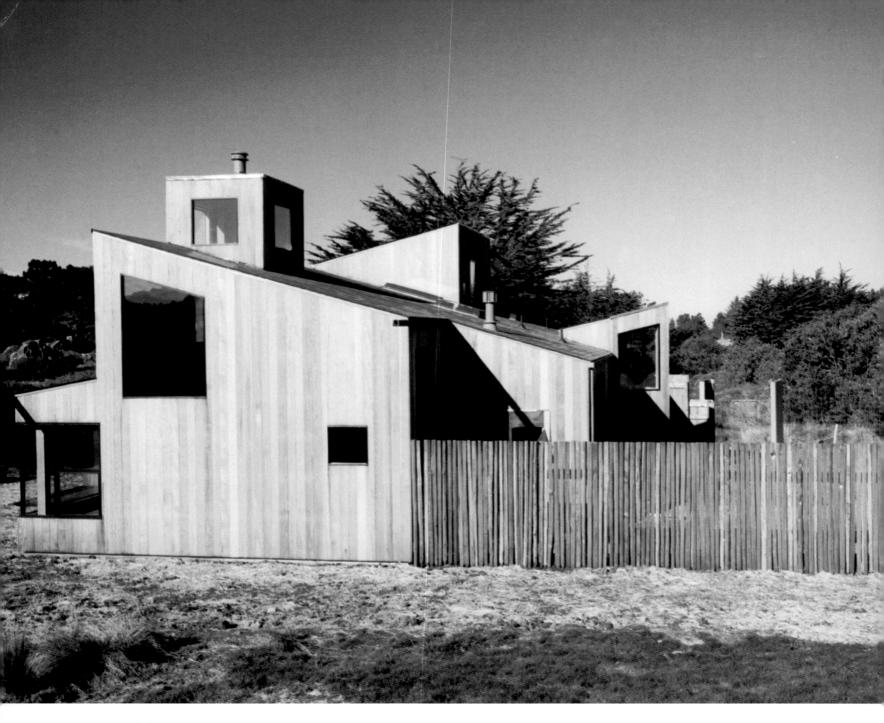

ABOVE: *South elevation.*
RIGHT: *West elevation.*
FOLLOWING PAGES: *View of the living and dining areas from the kitchen; view of the living area from the entry.*

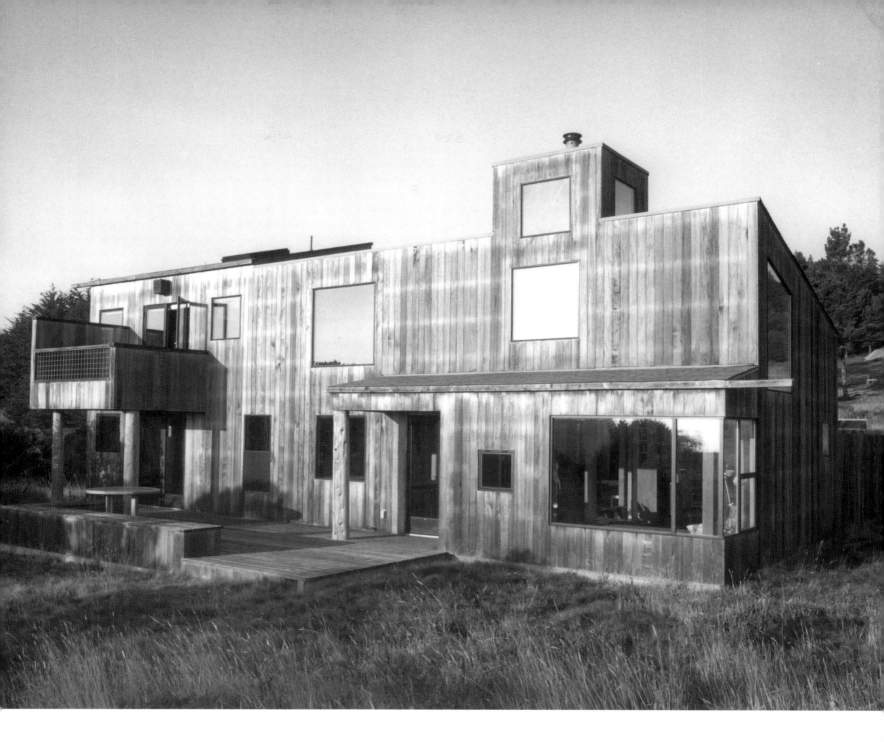

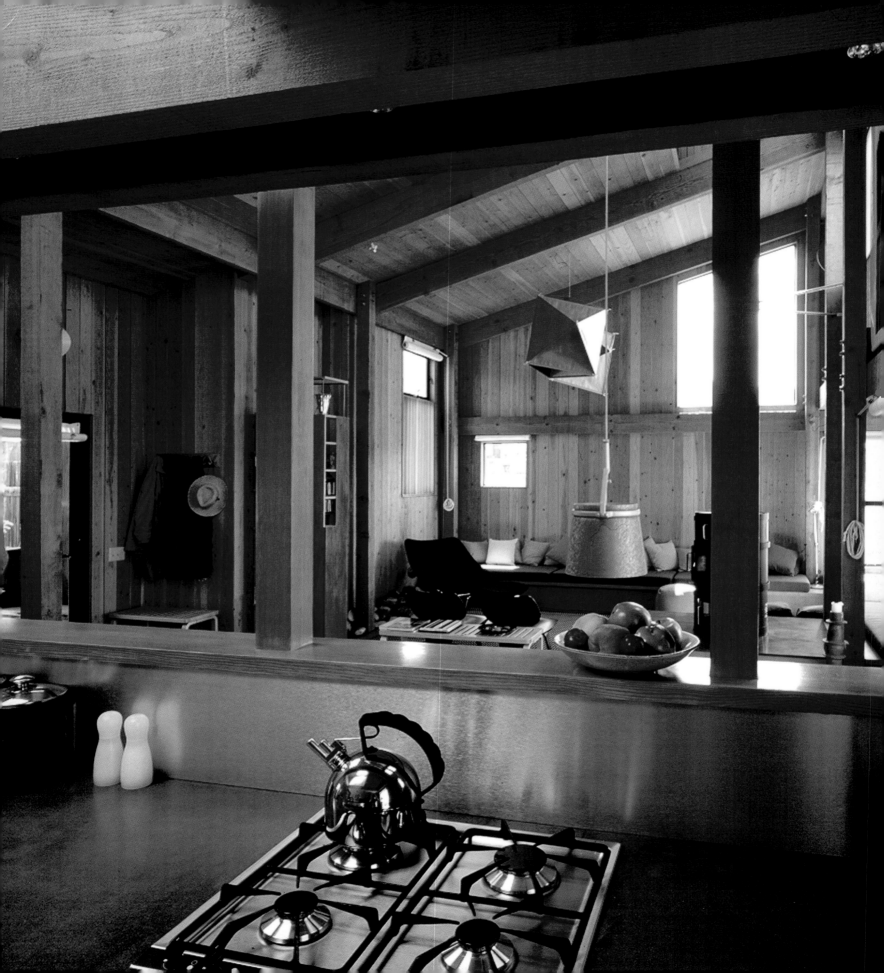

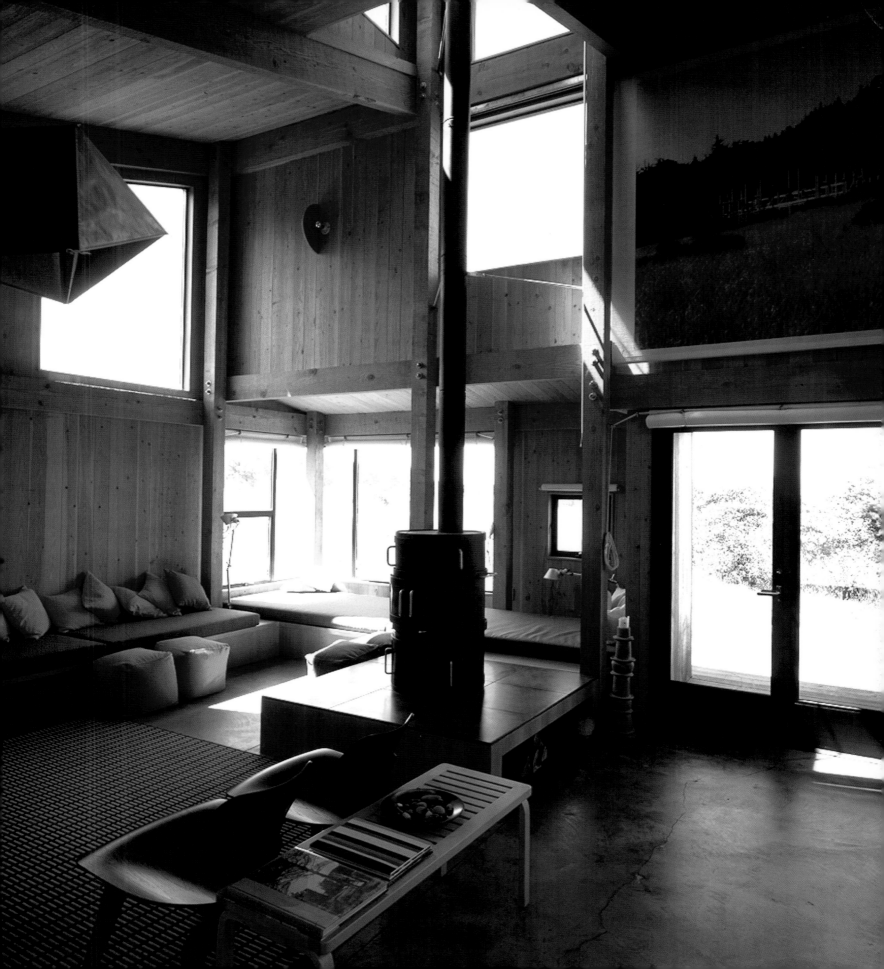

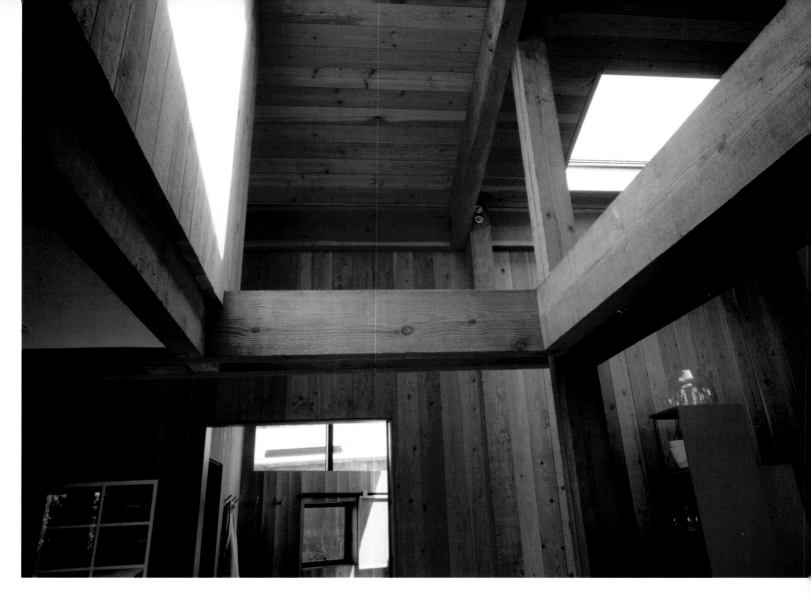

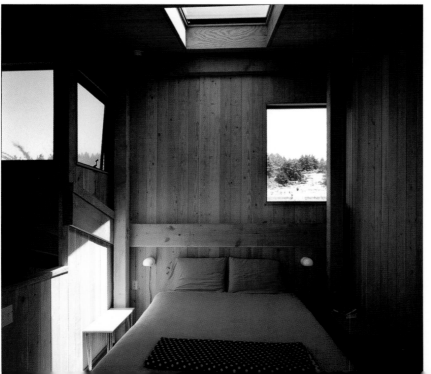

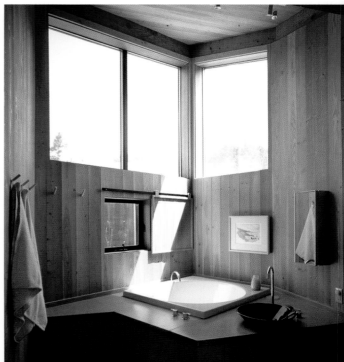

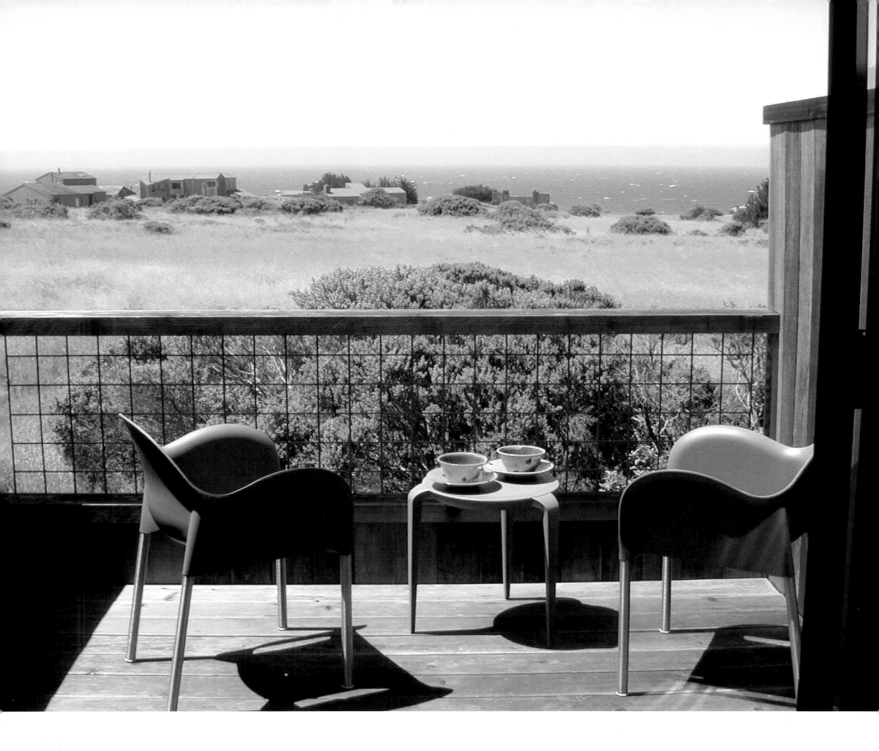

LEFT, CLOCKWISE FROM
THE TOP: *View towards the
bathing tower; the bathing
tower; the master bedroom.*
ABOVE: *Master bedroom
balcony with meadow and
ocean view.*

CREDITS

ARCHITECT: SAMELA ARCHITECT
853 GRANDVIEW AVENUE
DULUTH, MN 55812
PROJECT: BRANDENBURG RETREAT
PHOTOGRAPHER: PETER KERZE

ARCHITECT: FREDERICK PHILLIPS & ASSOC.
1456 NORTH DAYTON
CHICAGO, IL 60622
PROJECT: SUMMER COTTAGE
PHOTOGRAPHER: BRUCE VAN INWEGEN

ARCHITECT: PATKAU ARCHITECTS
1564 WEST 6TH AVENUE
VANCOUVER, BC V6J1R2
PROJECT: AGOSTA
PHOTOGRAPHER: JAMES DOW

ARCHITECT: McINTURFF ARCHITECTS
4220 LEEWARD PLACE
BETHESDA, MD 20816
PROJECT: COUCH COLLAGE
PROJECT: CREEK COTTAGE
PROJECT: WITHERS COTTAGE
PHOTOGRAPHER: JULIA HEINE

ARCHITECT: BOHLIN CYWINSKI JACKSON
8 WEST MARKET STREET, #1200
WILKES-BARRE, PA 18701
OTHER OFFICES: PITTSBURGH,
PHILADELPHIA, SEATLE, BERKELEY
PROJECT: GOOSEWING FARM
PHOTOGRAPHER: MICHAEL THOMAS
PROJECT: THE POINT
PHOTOGRAPHER: NIC LEHAUX, DAN BIBB
PROJECT: GEORGIAN BAY RETREAT
PHOTOGRAPHER: MICHAEL AWAD
PROJECT: WAVERLY
PHOTOGRAPHER: MICHAEL THOMAS
PROJECT: CONDON COTTAGE
PHOTOGRAPHERS: DAN BIBB, KARL BACKUS

ARCHITECT: OLSON SUNDBERG KUNDIG
ALLEN ARCHITECTS
159 SOUTH JACKSON STREET
6TH FLOOR
SEATTLE, WA 98104
PROJECT: THE BRAIN
PHOTOGRAPHER: MARCO PROZZO, MARK DARLEY
PROJECT: LAKESIDE CABIN
PHOTOGRAPHER: BENJAMIN BENSCHNEIDER,
MARK DARLEY

ARCHITECT: LAKE/FLATO ARCHITECTS, INC.
311 THIRD STREET, SUITE 200
SAN ANTONIO, TX 78205
PROJECT: LUCKY BOY RANCH HOUSE
PROJECT: SHRACK RESIDENCE
PHOTOGRAPHER: LAKE/FLATO, DEBRA QUINN

ARCHITECT: DONLYN LYNDON
(WITH LYNDON BUCHANON
ARCHITECTS)
2717 RUSSELL STREET
BERKELEY, CA 94705
PROJECT: WENDEL/LYNDON
PHOTOGRAPHERS: JIM ALINDER, DONLYN LYNDON